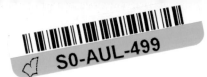
STREET ART CHILE

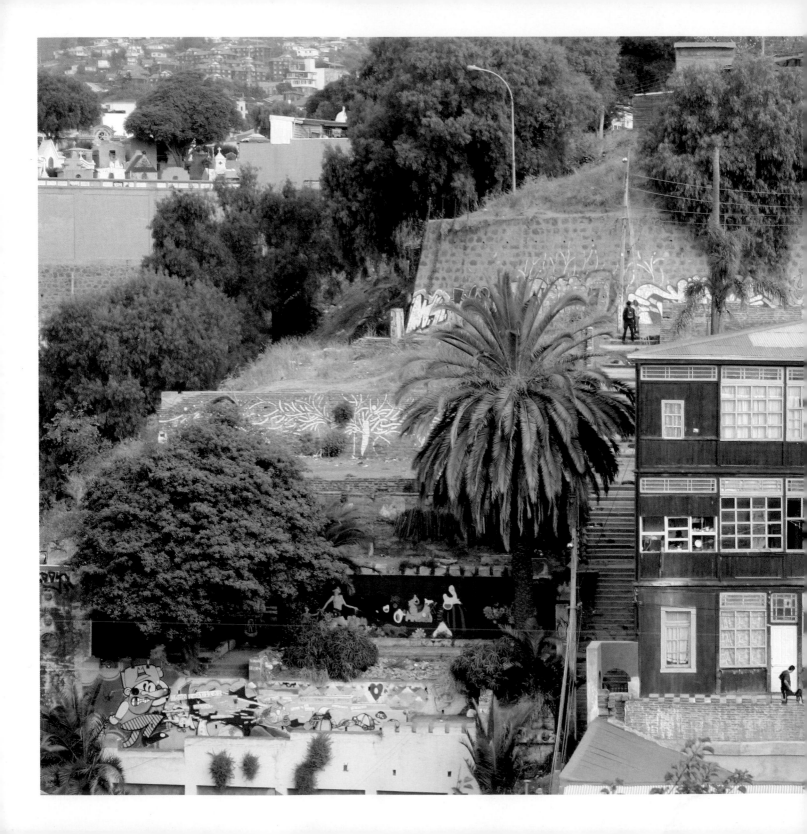

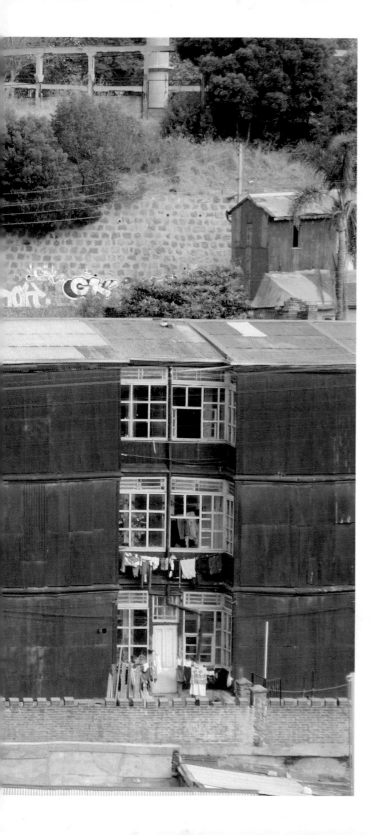

Rod Palmer

STREET ART CHILE

Gingko Press

Previous page: View of 'The Ruins'
below the 'Ex-Prison Cultural Park'
on Concepción Hill, Valparaíso.

Original version published in 2008 by Eight Books Limited, London

First Published in the United States of America, 2008 by
Gingko Press, Inc.
5768 Paradise Drive, Suite J
Corte Madera, CA 94925, USA
Phone (415) 924 9615 / Fax (415) 924 9608
email: books@gingkopress.com
www.gingkopress.com

The photographs in this book are included as a commentary on a social phenomenon and one aspect of street culture. All cover illustrations appear inside the book.

ISBN 978-1-58423-300-8

Printed in China

CONTENTS

INTRODUCTION

Right: Yisa painting *Wena Nati* on
Marín St., Santiago.
Below: Santiago. Andean crash
survivors by Inti and friends.

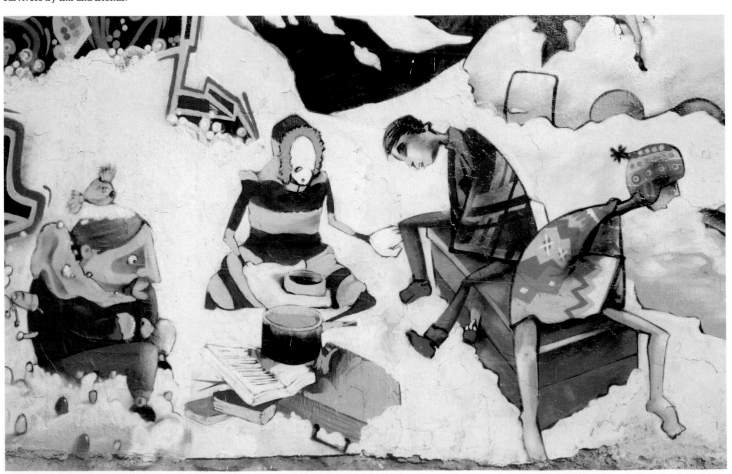

MUCH AS SPAIN WITNESSED A BOOM IN THE ARTS AFTER FRANCO, SINCE THE END OF PINOCHET'S DICTATORSHIP IN 1990, CHILE HAS EMBRACED AN ERA OF NEW FREEDOMS. AT A TIME WHEN LATIN AMERICAN STREET ART IS RECOGNIZED AS WORLD-LEADING,[1] CHILE CONSISTENTLY FEATURES IN OVERVIEWS OF LATIN AMERICAN STREET ART, AS ONE OF A HANDFUL OF COUNTRIES OF PARTICULAR INTEREST: IN PAINTING ALONGSIDE BRAZIL, VENEZUELA AND BOLIVIA;[2] FOR STICKERS ALONGSIDE MEXICO, PUERTO RICO, BRAZIL, VENEZUELA AND ARGENTINA;[3] AND, AS IN ARGENTINA, FOR STENCILS.[4] IN THE CHILE OF TODAY, LATIN AMERICAN TRADITIONS OF DIDACTIC ART FOR ALL MEET THE REBELLIOUSNESS OF WORLDWIDE GRAFFITI: THE OUTCOME IS ACCESSIBLE BUT ANARCHIC STREET ART.

MODERN CHILE

Chile's geographical position at the southwest edge of the world, separated for most of its length by the Andes from neighbouring countries, leads to cultural eccentricity. This eccentricity comes out in *chilenismos*: intentionally silly slang terms and double entendres unique to Chile. Less amusingly, though here too there is much black humour, Chile is marked by political extremism. At the same time as being marginal, Chile has mineral riches and a strategic coastal position which make it a focal point of economic and cultural interests, and of Latin American politics.

Turning to Chile's modern cultural history, poetry was the first medium in which Chileans made world-leading contributions. Vicente Huidobro's creationist experiments of the 1930s brought a cosmic dimension to Chilean culture. Huidobro's transcendental visions and then Pablo Neruda's erotic metaphors were largely rooted in Chile's landscape: Huidobro's in the sheer scale of the Andean *cordillera* and seemingly infinite Pacific horizon, Neruda's in the almost indecent fecundity of Chilean vegetation, especially its flora. For all its natural marvels, Chile did not initially foster Surrealist artists of note; in

comparison to Mexico. Chilean artists looked less to Europe than to Mexico itself, especially its muralism. In the later 1930s, Laureano Guevara created a mural painting department at the University of Chile's School of Fine Arts (Escuela de Bellas Artes). Huidobro's cosmic poetic and Guevara's social project became more intertwined than either would have envisaged in the work of Roberto Matta, the last great Surrealist, who either side of 1970 and again in the 1990s played a part in some of Chile's art teams.

Chile's most successful radical president of the 20th century was Pedro Aguirre Cerda, who headed a Popular Front government from 1938 until his premature death in 1941. Aguirre Cerda's friend Gabriela Mistral won the 1945 Nobel Prize in Literature. Since the mid-20th century women have played leading roles in all fields in Chile, where Michelle Bachelet is currently President. From the 1960s to the present, women artists have painted outside shoulder-to-shoulder with men, with each other, and on their own. Where Mistral was officially acclaimed, Violeta Parra achieved a more cult status. Parra was recognized in Paris for her painting; in Chile she is best remembered for having begun the protest guitar-based *nueva canción* (new song) movement continued by her protégé Victor Jara, and closely connected to its popular art.

MEXICAN INFLUENCES

Chile has been a leading Latin American centre of radical propaganda painting since David Alfaro Siqueiros, one of the great Mexican muralists and author of their *Manifesto*, visited in 1940. Siqueiros orchestrated his first great collaboration at the Escuela México (Mexico School) in Chillán, with his compatriot Xavier Guerrero and with Chilean artists including Camilo Mori, Gregorio de la Fuente and Fernando Marcos. Chillán became a point of reference throughout South America. In Chile itself, the Chillán experience was of seminal importance. Both Camilo Mori and Gregorio de la Fuente went on to teach mural painting at the University of Chile's School of Fine Arts; moreover, the Escuela México informs Chilean art education at a formative elementary level. The Escuela México is a primary school, Aguirre Cerda himself was a schoolteacher, and, ever since his government, pedagogy has been duly valued in Chile, where the visual arts enjoy a central place in the curriculum.

In 1943, the first Chilean state-sponsored mural, at Concepción train station, was entrusted to de la Fuente, who focused on southern Chile's indigenous Mapuche people and their suffering at the hands of the Spanish. In 1945 Fernando Marcos, Carmen Cereceda, Osvaldo Reyes and other mural painters at the School of Fine Arts formed the 'Group of Mural Painters of the Ministry of Education' (*Grupo de Pinturas Muralistas del Ministerio de Educación*). Their ambitious project, to paint murals in every school in Chile, only resulted in three murals, most famously at the 'City of the Child' (*Ciudad del Niño*), where in 1945–46 Marcos painted his *Homage to Gabriela Mistral and the Nitrate Workers*,[5] which recalls the heroic socialist realism of Diego Rivera. Pedagogical initiatives to involve children in murals have abounded in Chile since the 1950s, and primary and secondary-level programmes proliferate in the 2000s. These projects give technical grounding to young Chileans who go on to make street art.

In 1952 Fernando Marcos and Osvaldo Reyes wrote, and Rivera signed, the *Manifesto of Plastic Integration* (*Manifiesto de Integración Plástica*), a step in the Chilean left's recurrent pursuit of an art within reach of all.[6] Mexican muralist ideals of collaborative artistic action were realized with greater vigour and urgency in Chile than in Mexico itself. In Chile, official muralism in a Mexican vein, and the Chilean tendency for art on outside walls diverged from the 1960s. Both inform Chilean art of today: contemporary street artist Vazko respects and admires 'Mexican and Chilean lefty muralism', especially Rivera; and many of Vazko's peers look to street propaganda.

PROPAGANDA MURALS, 1963–64

Outdoor paintings, a quick and inexpensive way to cover large spaces, have been used as political propaganda since 1963, in the run-up to the 1964 election contest between Salvador Allende's Popular Action Front (*Frente de Acción Popular*, FRAP) and Eduardo Frei's Christian Democrats. The collaborative act of painting was itself a demonstration of popular action, both for FRAP and for the Christian Democrats who also considered themselves the people's party. The Christian Democrats used painting from the start of the campaign: in May 1963, Frei's nationalist star emblem appeared painted on the walls of cities the length of Chile.[7] The first propagandistic mural proper was pro-Allende, and painted at night in the Avenida España, the main artery between Valparaíso and Viña del Mar, by a team led by the painter Jorge Osorio, in July 1963. A second pro-Allende mural, an allegory of the struggles and hopes of the Chilean people, was soon painted, again in the Avenida España, this time near the Barón metro station (currently a street art zone) by a team led by Osorio. Thus began what has become known as 'the propaganda Battle of Avenida España'.[8] The Christian Democrat Party sent a team of painters from Santiago to paint a huge star with the legend '50,000 grants for poor children', next to which the Allendistas the following night painted Allende's 'X' emblem with the slogan 'In the Popular government there will be no poor children' (*En el Gobierno Popular no habrá niños pobres*). Pablo Neruda expressed his enthusiasm for this 'fine polychromatic action' (*bella acción policrómica*).

While the murals of 1963 had been clandestinely painted at night, in 1964, with permission from Viña's socialist mayor, the *Allendistas* painted the prominent Capuchins Bridge in Viña. Three separate teams worked on the 750 square metre wall space at the Capuchins Bridge, with help from so many locals that while the mural was in progress the area became the focus of a continuous popular gathering. This was part of the plan. Luz Donoso, who was a leading painter of propagandistic murals in Santiago in the mid-1960s, remembers: 'We realized that beyond the murals themselves the best propaganda was to be there, painting'.[9] The three sections of the Capuchins Bridge showed: workers and peasants carrying placards with Allendist slogans; the allegorical figure of a worker holding the world; and the children of an envisaged future Chile. By June 1964 *freístas* had destroyed the mural, prompting Neruda to broadcast a tirade on the radio: on the mural itself as pioneering Latin American propaganda, and its *freísta* destroyers as colonial fascists.

The first political murals in Santiago, which date from early 1964, were Allendist, and painted by Donoso, Carmen Johnson, Hernan Meschi, Pedro Millar and others in central residential areas: on the exterior walls of the Manuel de Salas secondary school in Irarrázaval Avenue in the Ñuñoa district, and in Larraín Avenue in La Reina. The biggest, and best, propaganda murals of the 1964 campaign were those on the banks of the Mapocho River: they were collaborations by, among others, Dinora Doudtchinzky, Héctor Pino, Osvaldo Reyes and his students at the Experimental Art School (Escuela Experimental Artística). The main mural, stretching 200 metres between the

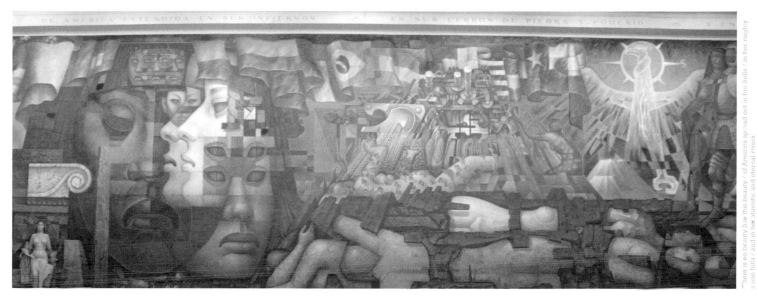

"There is no beauty like this beauty / of America spread out in her hells / in her mighty stone hills / and in her atavistic and eternal rivers"

Above: Concepción University. Jorge González Camarena with other Mexicans and Chileans, Albino Echeverría and Eugenio Brito, *Latin America*, 1964–65. At the top, lines from Pablo Neruda's *America*: '*y no hay belleza como esta belleza / de América extendida en sus infiernos / en sus cerros de piedra y podrerio / y en sus rios atávicos y eternos*'

Independencia and Recoleta bridges, combined portraits of progressive Chilean leaders with popular imagery; women featured prominently in a conscious effort to offset predominately masculine leftist iconography. As part of the same effort, all the main characters in Luz Donoso, Carmen Johnson and Pedro Millar's mural on Ñuble street were women.

Luz Donoso recalls that the need to produce propaganda murals quickly usually left no time for sketches, although the subject matter of each mural was agreed in advance. Propagandistic murals of the 1960s and '70s were done in water- and casein-based latex paints. Neruda in his radio speech on the destruction of the Capuchins Bridge mural in Viña had put the rhetorical question whether the Mapocho river mural 'will also be destroyed? Will it too be barbarously erased?' Neruda's intervention may have helped to preserve the Mapocho mural of 1964 for a time. Durability was not however a main criterion.

The first wave of Chilean propaganda murals had elements of verbal riposte, such as the dialogue on poor children in the 'Battle of Avenida España', but in the main text was anecdotal, complementary and secondary to imagery; in this regard, Chileans followed the Mexican precedents of Rivera and Siqueiros.

LATIN AMERICAN INFLUENCES AND CHILEAN INITIATIVES OF THE MID-TO LATE 1960s

Frei and the Christian Democrats won the election of 1964, but radical propagandistic art persisted, and continued to draw on initiatives elsewhere in Latin America. In 1964–65 the second-generation Mexican muralist Jorge González Camarena and assistants painted their *Latin America* mural in the art building of Concepción University (*see above*). On the left are huge American women's faces; on the right a fiery Aztec eagle, a naked *indigene* and an armed conquistador; at middle right,

Latin America's underground resources are built up into the tools of industry and war; and, at the top, in one sinuous frieze, the flags of the independent nations of Latin America. *Latin America* is as powerful as any mural in Mexico City, and strengthened by Neruda's verse above it.

By the later 1960s, the main Latin American referent for political murals in Chile was not so much Mexico as Cuba, especially Cuban revolutionary posters. From the mid-1960s, the posters of Waldo González and Vicente Larrea reflected their knowledge of Cuban propaganda and film posters, which circulated in Chile.

Not all Chilean open air art of the 1960 was overtly political. In 1965, Camarena and the *santiaguina* Maria Martner collaborated on the mosaic mural at the Tupahue lido on Santiago's San Cristóbal hill, and Martner went on to make further murals in southern Chile. In 1969, Francisco Méndez Labbé, founder of the School of Architecture and Institute of Art at the Catholic University, Valparaíso, and many of his students took the initiative to paint around 60 murals in the city. The 'pictorial' project was nonetheless perceived as an act of cultural politics, and was erased during Pinochet's regime, but revived soon after it as the *Museo a cielo abierto* (Open sky museum).[10]

THE RAMONA PARRA AND ELMO CATALÁN BRIGADES, 1969–73

In the lead-up up to the election of September 1970, the Communists and Socialists organized 'brigades' of mural painters. The Latin American politik of these brigades was informed by ideas from Mexico and Cuba. More than in Mexico and Cuba, in both of which there is a revolutionary consensus, brigades of propaganda mural painters have become a reality in polarized Chile – and, for the same reason of 'resistance' (*resistencia*) against a powerful right wing, in Nicaragua. Chile's most famous brigade is the Brigada Ramona Parra (BRP), founded in 1969 by the communist Danilo Bahamondes and named after Ramona Parra, a 26-year-old nitrate worker killed in a rally of 1946. The Ramona Parra Brigade, or rather Brigades – by 1970 there were 120 BRP collectives throughout Chile – worked in overalls handed down or stolen from factories. Each brigade was composed of 15–25

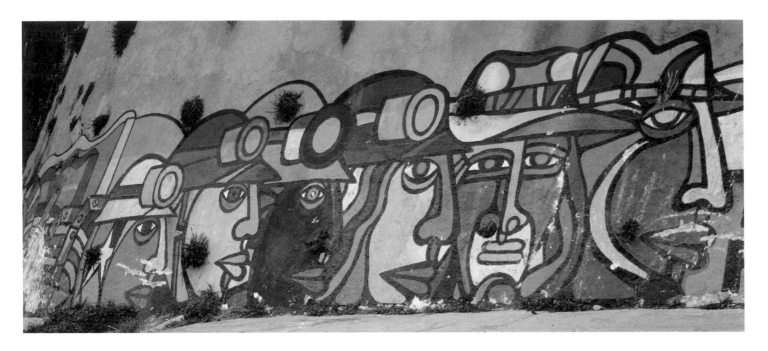

students, artisans and workers, each brigade member having a designated role. *Trazadores* (planners), responsible for the initial design, often doubled as *fileteadores* (outliners), who painted the final outline. *Fondeadores* (backgrounders) painted the background; and *rellenadores* (fillers) coloured the figures; *guardias* kept watch. The black outlines were key. As José Balmes explained: 'Black was used last of all, to separate the other colours, and this gave to all the designs the same very simple and direct style'.11 In the lead-up to the elections of 1970 BRP murals had to be rapidly painted. Their swift execution, and hence their directness, were compatible with their audience's requirements, even after Allende's 1970 victory.

The ambition of the BRP to operate the length of Chile was realized as far north as Arica; and to the south at least as far as Temuco. A recurrent topic of BRP murals is copper, and its ownership, which has long been a bone of contention in Chile, Neruda having attacked the US-owned Anaconda Mining Company in his *Canto general* of 1950.

The Chilean socialists organized a painting brigade to compete with the communists' BRP. The name of the young socialists' '*Venceremos*' (We will win) brigades was reminiscent of Cuban revolutionary '*Hasta la victoria*' rhetoric (as in Ñiko's '*HASTA LA VICTORIA SIEMPRE*' silk screen portrait of Che Guevara of 1968). The '*Venceremos*' brigades were renamed the Brigada Lenin Valenzuela, after the 18-year-old Pedro Lenin Valenzuela, who in 1970, influenced by Cuban revolutionary ideology, hijacked an internal Chilean flight to take it to Havana, but was shot dead by Chilean agents at Santiago airport. The first Lenin Valenzuela mural was on a wall of the State Technical University (Universidad Técnica del Estado), now the

University of Santiago, in Via Matucana, Santiago. In July the Young Socialists decided to change the name of the brigade from Lenin Valenzuela, who had after all been a terrorist danger to his compatriots. The brigade was renamed Brigada Elmo Catalán (BEC) after the Chilean journalist Elmo Catalán who had joined Che Guevara's guerrilla army in Bolivia, where he was killed in June 1970. Reflecting this legacy, the BEC wore a uniform of olive green shirts, jeans and berets.

As the election approached, the BRP, BEC and other brigades joined forces in support of Allende's Popular Unity coalition; the slogan 'with Allende we will win ¡Popular Unity!' was painted 15,000 times on the walls of Santiago in one night alone. Following his election victory in September 1970, Allende nationalized the Chilean copper industry. The ultimate aim of Allende's government was to bring about a peaceful cultural revolution. The 'Communist Youths of Chile National Commission of Propaganda' sent out printed bulletins, such as *La Revolución en los Muros* (The Revolution on the Walls);12 the black-and-white illustrations of these bulletins were designed to propagate large-scale reproductions by different brigades throughout Chile. During Allende's government, the BRP and BEC continued their activities. Hasty political propaganda gave way to more aesthetic murals. The most famous of these was the swimming pool at La Granja, on the outskirts of Santiago, in which Roberto Matta was involved, both in the design, and by his own account as a *rellenador* of red.13

Alejandro 'Mono' González, put in charge of the BRP by Allende in 1971, observed in the same year that spectators demanded rapid spontaneity. González was also clear that it did not matter that latex murals were perishable, because it was their messages that counted. Since their messages had to keep pace with events, the BRP often painted over their own murals.14 José Balmes recalled: 'Sometimes a wall that was already painted would be repainted two weeks later with a new design … this is a very generous, spontaneous attitude.'15

BRP and other leftist imagery of the early 1970s was open to pop culture generally; for example, González acknowledged that the graphics for The Beatles' *Yellow Submarine* influenced BRP designs. While open to all pop innovations, in the early '70s the Chilean left's main frame of reference was Cuba. Allende's closest political ally in the Americas was Fidel Castro, who spent November 1971 in Chile. Murals by the BRP were characterized by the use of primary colours, especially red and blue, outlined in black, and in both these regards are reminiscent of posters by the leading Cuban revolutionary artist of the 1960s Raùl Martínez, and thence of the direct appeal of Pop Art that Martínez exploited. Also in common with Cuban revolutionary posters, lettering played a leading part in the second wave of Chilean propaganda. Gracia Barrios, like Luz Donoso a professional artist as well as muralist, saw emotion in 'CHILE' and in words generally, and liked to include words as a formal visual element.[16] Roberto Matta explained how words induce a more perceptive way of seeing: 'To see should not be only that which the photographic camera or microscope does. To see as though reading a word is to see something grow, to see how it goes on changing, to see it in the space in which it exists'.[17] This idea was not itself new: the Cubists, and then in post-war France the *Lettristes*, had explored words' plastic potential. The novelty was that such ideas were so widely understood in Chile. They still are: Piguan and Yisa are just two contemporary Chilean street artists who appreciate letters and words for their own sake, and incorporate them, sometimes as meaningful phrases, sometimes as *incoerencias*, into their paintings.

Like Cuban propaganda posters, both the BRP and BEC used capitals. BRP letters were generally of even width – that of the brush with which they were painted. BEC letters distinguished themselves by being stretched outwards at their bases so each letter tends towards a vertical wedge or quoin (*cuña*). In the paintings of both the BRP and the BEC, lettering and imagery alike were extended horizontally, a trait accentuated on walls alongside major roads, in order to be legible to those travelling in cars and buses.

In the polarized and fractious atmosphere of 1973, propagandistic murals became a focal point of clashes, and by April 1973 BEC murals in southern suburbs of Santiago were the sites of continuous confrontation between leftists and those enraged by food shortages and other hardships resulting from the Allende government's precipitous redistribution of wealth. Tensions rose further over the following months, as Allende lost the confidence of many sectors of Chilean society including the military; on 11 September 1973 General Augusto Pinochet made his successful coup.

THE PINOCHET YEARS, 1973–90

The murders of Victor Jara and thousands of other freethinking Chileans in the first year of military rule drove many artists into exile. Murals made during the 1970–73 Popular Front government, including artistic ones at La Granja and the Open Sky Museum, Valparaíso, were erased. However, art did not just stop in Pinochet's Chile. Mario Carreño (Havana 1913–Santiago 1999) stayed in his adopted country, and in 1980 painted a mural at the Hospital del Trabajador, Concepción, in which he borrowed the BRP symbols of the miner, the spade and the guitar, associating the last not with Victor Jara, but with the Quinchamalí figurines of woman guitarists made in Region VIII.

In 1984, Eugenio Dittborn (Santiago 1943–) sent his first Airmail Paintings (*Pinturas aeropostales*) from his native city. They were

enthusiastically received worldwide, including at the ICA, London. For present purposes, the point about Dittborn's Airmail Paintings is that they were large-scale works made on paper, which could then be folded into a small package, to be unfolded at their destination. A few years later, the Chacón Brigade used paper analogously for *papelógrafos*, which were rolled up, and then unrolled and glued onto Santiago's walls.

Named after the communist militant Juan Chacón Corona, the Chacón Brigade also had a precedent for their strategy of making protest art behind closed doors, and then quickly unfurling it in the street. The first sign of organized artistic resistance to the dictatorship was the emergence, in 1979, of CADA ('Colectivo Acciones de Arte') Art Actions Collective. *Cada* also means 'every', and CADA addressed all Chileans, most successfully when in 1983 they displayed and photographed a banner on the bank of the Mapocho River. In the mid-1980s, amid a surge in street protests, the BRP re-emerged, painting murals on the walls of *lugares liberados* ('liberated places'): at first in underprivileged areas of Santiago, and, in Region VIII, in the Lorenzo Arenas estate at Concepción, and in Chillán and Lota. In the mid-1980s, the BEC resumed activity in its heartland, the 'liberated' southern suburbs of Santiago, especially Villa Francia and La Victoria. A Popular Painting Workshop (*Taller de Pintura Popular*) was set up in Villa Francia in 1985. The BEC mural of 1986 at Villa Francia, *The present is a time of struggle! The future is ours*, has proved a self-fulfilling prophecy remaining intact decades after the fall of the system that provoked it (*see overleaf*).

In the mid-1980s the BEC combined their distinctive lettering and imagery with the spray painting techniques pioneered in the black and Latin ghettoes of North American cities since the 1960s. The face of popular culture's martyr to the coup d'état, Victor Jara (*see overleaf*), became part of radical Chilean imagery in the 1980s. Anti-Pinochet propaganda had hitherto been confined mainly to the suburbs of Santiago, alleyways in Valparaíso, urban pockets of Region VIII; in the run-up to the national plebiscite of 5 October 1988 the Luis Corvalan, Laura Allende and dozens of other new brigades sprung up to support the anti-Pinochet 'NO' campaign.[18] The 'NO' campaign, its emblem a rainbow, overcame ludicrous disadvantages, and on Pinochet's loss of the plebiscite, the BEC's distinctive triangular lettering advocating '*LUCHA POPULAR*' (popular strife) was openly painted on the wall of the Bernardo O'Higgins metro station in Santiago.

Later in 1988, the BRP intervened on the lower level of Bernardo O'Higgins station. The BRP mural showed cartoon-like figures unprecedented in Chilean mural painting flanking the letters 'BRP', the four circumscribed zones of the latter formed by five-pointed red stars. Thus the BRP made the star of Chile, hitherto an emblem of the right, their own. Also in 1988, the BEC, in a show of defiance against the dictatorship, encouraged mass participation in their mural painted in La Bandera park, Santiago. Spray paints were again used, this time to depict fantastic hybrid creatures reminiscent of the exiled Matta's sci-fi imaginings. A lively sci-fi theme has run through Chilean street art ever since. In 1989, a long *papelógrafo* was posted on the corner of the Alameda, in the heart of Santiago, with a red star, and the legend 'Chacón'. It was the first of many *papelógrafos* by the Chacón Brigade, which was initially led by Danilo Bahamondes. The brigades' propaganda also stimulated a new wave of apolitical street art: seeing political murals from the school bus, 'Horate' started in 1989 to make his own graffiti and stencils.[19]

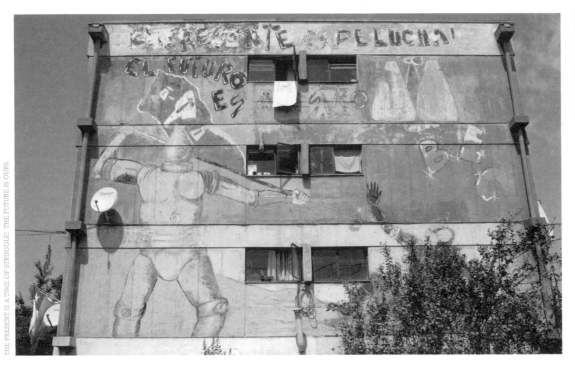

Left: Tenement block, Villa Francia, Santiago. BEC, *El presente es de lucha! El futuro es nuestro*. The Latin American Socialist emblem of the hammer superimposed on the shape of Latin America, seen on the red banner here, has been part of Chilean Socialist imagery since at least the 1930s.

THE PRESENT IS A TIME OF STRUGGLE! THE FUTURE IS OURS.

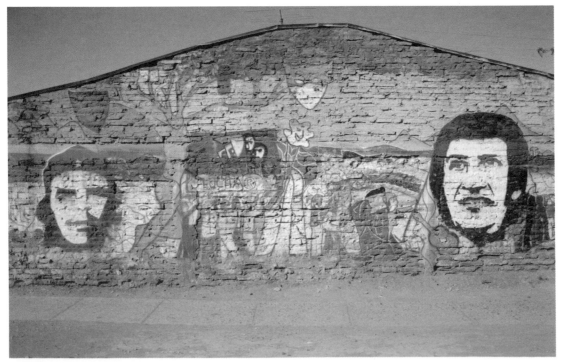

Right: Open Sky Museum, Valparaíso, 1991–94. Mario Toral.

Left: Departamental Avenue, Santiago. Che Guevara is an iconic hero in Chile; Victor Jara, to the right, even more so.

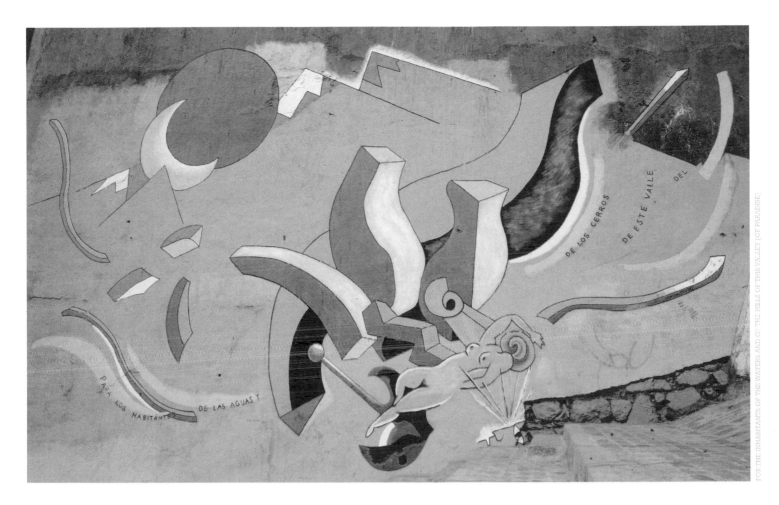

INNOVATIONS AND REVIVALS OF THE 1990s

The brigade activity that contributed to Pinochet's downfall continued after it: the BEC remaining active until 1993, and both BRP and Chacón to this day. The dictatorship over, many exiled artists returned. In 1991, Francisco Méndez Labbé and Nemesio Antúnez reinitiated Valparaíso's Museo del Cielo Abierto (Open Sky Museum), with the support of the Catholic University there. They decided to concentrate the 'museum' on Valparaíso's Bellavista hill, where it was created anew between 1991 and 1994 by a score of leading Chilean artists, most of whom were returned exiles from the dictatorship. As well as Roberto Matta, other cosmopolitan Chilean participants included Antúnez, who had taught at the RCA, London (1978–1982), Rosa Bru (Barcelona 1924–), the Cuban émigré Mario Carreño, and José Balmes (Montesquieu, Catalunya 1927–).

The mural by Mario Toral (Santiago 1934–) spells out Valparaíso's meaning 'Valley of Paradise' (*see above*). Toral's woman is a symbol of liberation; the female nude and inscription both recall the erotic metaphors of Pablo Neruda, several of whose works Toral illustrated. Toral went on to paint, with assistants, the monumental Visual Memory of a Nation (*Memoria Visual de una Nación*), 1994–99, in Santiago's University of Chile metro station. Here, yet again, the word is prominent in a public Chilean art work: in the Mapuche and Diaguita epigrams in the ancient inhabitants' section of 'the past' at the western end of the platforms, and in the 'homage to poetry' section of 'the present' at the other.

The Open Sky Museum typifies how, rather than enter a museum, many Chileans who enjoy art prefer to do so outside. A radical statement of Chilean disrespect for museums was Alejandro Delgado's huge stencil of May 2007, occupying an entire lane of the road opposite the entrance to Santiago's Museum of Fine Arts and reading '*MUSEO MAUSOLEO*' ('MUSEUM MAUSOLEUM'). Perhaps because it calls itself 'museum', the Open Sky Museum has never been venerated. Instead, the Open Sky Museum has succeeded in provoking many unofficial additions. By the 1990s, the most innovative wall painting in Chile had little to do with official mural commissions.

GRAFFITI CREWS AND STREET ART COLLECTIVES SINCE 1991

The dictatorship over, in 1991 crews of graffiti artists such as NCS (*Niños con spray*) started to work in Santiago. Where political murals of the 1960s–80s had aimed at being accessible to a wide audience, hip hop graffiti was at first aimed at a hip hop audience. In Chile, as elsewhere in the Americas, 'hip' has since the 1940s been a term for being creatively 'in the know', 'wise', and anti-establishment.[20] In 1996,

13

São Paulo's Os Gêmoes visited Santiago for the first time, to paint and breakdance. Chileans call Paolista urban art *De La Vieja Escuela* (Of the Old School). Zekis of Santiago, a frequent visitor to São Paulo, opened the shop *Otra Vida* (Other Life) at Lastarria St., central Santiago, and, pre-internet, it was at *Otra Vida* that Fisek, Alme, and other young *santiguenos* of the 1990s formed an attachment to *La Vieja Escuela*, of which they have become prime exponents – in São Paolo and Santiago.

By the later 1990s, *santiaguino* crews' ever more self-aware activities were reflected in their names, such as ODC (*Obsesión diaria crítica*: Daily critical obsession), QM (*Que miras?*: What are you looking at?), CEC (*Come explicare crew*: How to explain crew) and recently PeKa (*Paranoia Kritika*: Critical paranoia). A significant landmark was the formation in 1995 of the all-female crew MDA (*Musas de arte*: Muses of art). Hip hop counterculture and aspiration to artistic status became compatible, as evidenced by the AEB (*Artista escritor bombardero*: Bombardier artist 'writer').[21] In the mid-1990s, hip hop graffiti sprung up in Viña, and then elsewhere in Chile. Many hip hop graffiti artists grew up on childhood memories of anti-Pinochet propaganda painting. Old school muralists perceive a fundamental difference between themselves and contemporary *graffiteros*, on the basis that the latter lack their team spirit. However, the late ACB was explicit about her aim of involving members of the community in her work.[22] Unlike the brigades, most contemporary street artists sign their work with their individual names or tags, but outstanding individuals habitually collaborate. There are actual collectives such as the Duck-Hen Art Collective (*see above*); and plenty of collaborative crews. The personnel of any given crew varies at any given time (as did the brigades') but members of, for example, Viña's 25 Crew have roles whose names were coined by the BRP: *fileteadores*, *rellenadores* and *guardias*. Contemporary Chilean graffiti and street art have inherited much of the generous spirit, emotional force and didactic intent of the brigades' propaganda murals; and the habit of using text.

TWENTY-FIRST CENTURY CONTINUITIES AND DEVELOPMENTS

Since 2000 politically engaged street propaganda has cross-fertilized with youth art to create a multi-faceted and rapidly developing panorama of didactic and ironic street art: in painting, stencils and stickers. Outside mural painting is more than ever encouraged in 21st-century Chile from school age on. The practice of political mural painting remains entrenched in Villa Francia and La Victoria, where it reflects cultural and sartorial relaxations post-Pinochet.

Brigade activities continue: indeed, new outfits such as the Claudia López brigade operate in provincial Chilean cities, and the *Cuba vencerà* (Cuba will win) brigade in Santiago. At any given time, several Chacón brigade *papelógrafos* are to be seen on and nearby the central

14

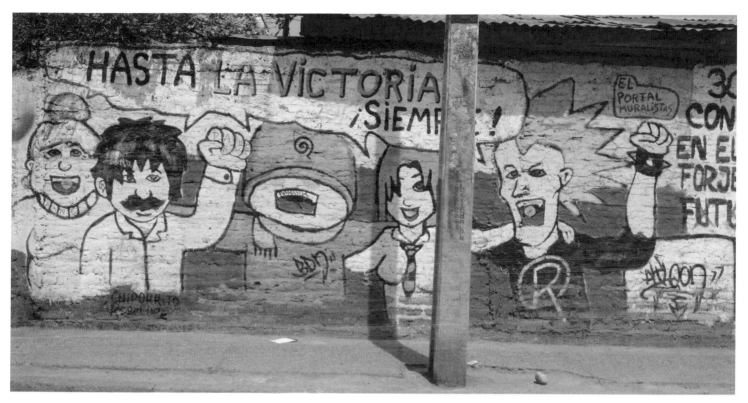

Left: Valparaíso, outside Ex-Prison. *Collectivo Artistico La Patogallina.*

Above: Unidad Popular St., La Victoria township, Santiago. Pop culture informs murals as well as vice versa.

S. Lucia stretch of Santiago's Alameda. Chacón *papelógrafos* have stayed true to the aesthetic of black letters in the same font as used in the '70s by the other great communist brigade, the BRP. The BRP renews its murals in cities the length of Chile. Chacón aim to stimulate historical memory and critical reflection on the present; their commentary from the wall spaces that they have over the decades made their own is broadly cultural not just political. Chacón's messages are anti-advertisements: they sell nothing, just stimulate critical awareness. One prevalent topic is TV, on which Chacón has opined: 'Bad vibe! A dark-haired country with blonde TV'.23 TV is also a main target of independent stencillists; the stencils shown in this book that propose switching off your telly and turning on your life are just some of many. At the same time, Latin American TV icons, especially the Argentine cartoon character Mafalda and Mexican Roberto Bolaño's farcical Chapulin Colorado appear as stencils.

The relationship of 21st-century street painting to TV is also ambivalent. The 'characters' of Charqui Punk, Dana Pink, PSF, Siek, 25 Crew and others reflect the childrens' TV with which they grew up: for instance, the animation of Chile's favourite comic *El Condorito* (The Little Condor) and, again, *Mafalda*, also based on a comic, and now as popular with Chilean children as *El Condorito*. While *El Condorito* is Disneyesque in its 3D style, *Mafalda* looks to more planar Japanese-style animations, and the latter inform infantile street art in Chile. With

exceptions such as Dana's Pink Panther character, most of the infantile figures seen on the walls of Chilean streets are only generically related to those actually on TV. The intention is to engage a younger TV-watching audience: not to send them back to their TV sets, but awaken them to Chile's amazing nature, especially the colourful flowers of its cities as much as its countryside.

Hip hop, punk and other pop sub-cultures are frames of reference for most contemporary Chilean crews. In Chile, as elsewhere, hip hop graffiti was initially characterized by 'tag' signatures 'written' for a closed audience of those in the know. In 1998, Zekis painted an artfully perspectival but clearly legible *flop* in Santiago's Italia Square.24 Since 1998, Fisek's and others' *graffiteros' flops* have become more legible. For years, 25 Crew's '25' tag has been accessible to all in Viña, and the same is true of BBN in Huasco, OFIS in Iquique, the artist CROC and the crew ART in Arica.

ART crew encapsulates the tendency of many hip hop painters these days to think of themselves as artists, and Zik's work on a wall in Antofagasta is inscribed: 'Graffiti is art' (*see overleaf*). Not all *graffiteros* agree. Fisek shuns the idea of street art. While an accomplished painter, Grafisek will always consider himself a *graffitero*. It could be argued that ART crew and Zik, working in northern Chile, are relatively naïve, and Fisek's attitude is more hip; on the other hand artists in northern Chilean cities are more familiar than their counterparts in

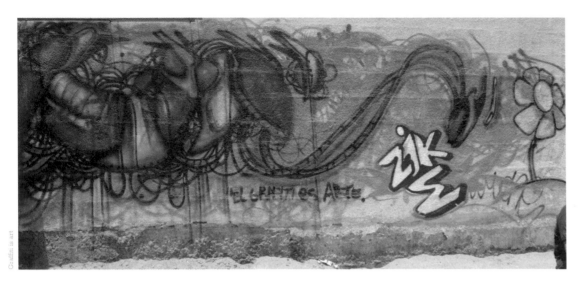

Santiago with developments in Peru, Bolivia and other Andean countries, and Zik *et al* are the emerging generation. Fisek and others of the *Vieja Escuela chilena* resist the arty overtones of *nueva figuración*. Nonetheless, they are integral to its story: some of them were, in parallel with Vazko, among the first in Chile to develop the 'cartoon style' now mainly associated with *nueva figuración*.25

Irrespective of whether its makers promote themselves as artists, or reject the idea of street art, Chilean street art offers carefully planned visual and verbal jokes, strategies and techniques derived from an array of historical and contemporary sources: from Catalunya, Britain (and of course from other European countries!), the US, Brazil, and from Chile's neighbouring countries:

Catalunya: Picasso, Miró, Dalí, 21st-century street art in Barcelona
Britain: Francis Bacon, Gilbert & George, Iron Maiden graphics, YBAs, Stewart Home, Banksy
United States: Warhol, Lichtenstein, Basquiat, San Francisco and New York subway art
Brazil: *pichaçao*, Vitche, Herbert Baglione, Os Gêmoes
Argentina: stencils
Bolivia: alpaca hats and carnival masks
Peru: photorealism

Many artists and crews combine several of the above influences. For instance, the PeKa crew cite influences Precolumbian (especially the Diaguitas from the Elqui valley in northern Chile), Polynesian, modernist (Duchamp, Picasso, Dalí); propagandistic (BRP); postmodern (Basquiat) and contemporary Latin American (Os Gêmoes). Of the Europeans above, Picasso (often spelt 'Pikasso'), Dalí, and now Banksy, are echoed again and again on Chilean walls. Vazko considers Picasso 'the Maradona of art', because he changed the rules for all who followed. Primitivist but clever Picassoid design, combined with BRP outlining, lends itself to a contemporary Chile ever more sympathetic

at grass roots level to its Mapuche, Diaguita and Chinchorro indigene populations. In a country where modern European art is known almost only in reproduction, Dalí's enduring success is unsurprising. Grin has long painted Dalíesque landscapes on Santiago's walls; Dalí's melting clock crops up on walls from Talcahuano to Antofagasta, where it is the centrepiece in an allegory of global warming; in Valparaíso Bomber West summons Dalí up out of nowhere, because he was a comedian. Still on the subject of Catalunya, Valparaíso feels a cultural affinity to Barcelona, at both official and rebel levels. Miss Van, a star of Barcelona street art in the early 2000s, visited Santiago in 2006, and left examples of her work both on the streets and with Sergio Valenzuela, who makes Miss Van and others available via Ekeko's museum, website and stickers.

Chileans have looked favourably on unruly Brits, ever since 'the pirate' Drake: Sir Francis Drake looted Incan and indigenous Chilean treasure from a Spanish galleon moored at Coquimbo in 1578, and the *pirata* still appears on Coquimbo FC shirts, and in *Coquimbano* graffiti. These days, Inti looks to Francis Bacon, Yisa likes Gilbert & George, Drew the Chapman brothers, and Rick Terror is well versed in Stewart Home, mentor to Banksy. The walls of Concepción and Valparaíso have an increasing number of Banksy-like stencils; in Santiago, Heroestencil and his audience admire Banksy as *fresco*: both fresh and cheeky.

Most well-informed Latin Americans look to some degree to the US: *graffiteros* and street artists such as Bomber West still enjoy hip hop badmouthing, music and art. Warhol and Lichtenstein provide templates for 'Neo' and 'NoPop' stencils. Compared to Cuba, where the love side of the love/hate relationship with the US embraces baseball and vintage cars, young Chileans' engagement with US popular is more selectively limited to US counterculture, especially hip hop.

Chilean artists look to Brazil, and this is a two-way street: Os Gêmoes, Herbert and other *Paulistas* have visited Chile; and Chilean artists São Paulo. The most widespread Brazilian ingredient in Chilean, indeed Latin American street art, is *pichaçao* lettering. Pablo Aravena

Left : Antonia López de Bollo St., Bellavista, Santiago. Heroestencil.

considers *pichaçao* a characteristic of South American street art, much as *wildstyle* is of North American graffiti. *Pichaçao* is especially relevant to Chile, because it came about in the 1980s in protest against Figueirido's dictatorship. Chilean *pinchazon* is not simply borrowed from *pichaçao*, but has other sources, for instance the album covers of Iron Maiden, who are big in Chile. There are parallels with Brazil, but as Vazko puts it, 'Santiago has a very different story from São Paulo'. In contrast to Brazil's, Chile's aesthetic is Andean – and cold.

Chileans are participating in the current wave of Argentine stencil activity. Alpaca hats feature in Alme's, Inti's and Elodio's art, as emblems of Andean solidarity. Peruvian photorealism finds a response, especially in northern Chile, and also as far south as Concepción.

BEYOND POLITICS?

Artists working today on Chile's streets have inherited much from the history outlined above. Pussyz Soul Food (PSF) recalls having grown up among reproductions of BRP murals in her exiled parents' European home, and acknowledges the BRP as a key formative influence. More widely, the statement made by 'Mono' González in 1971, that 'all artistic expression of the past and of the present has an ideological connotation',26 holds true for some of today's street artists. Fis and Fran understand this, and are very clear about where they agree and disagree with their visual sources. Equally, they are adamant that their work was post-political. PSF also considers her activity to be post-political; and Gigi and Inti, from Viña del Mar, make painterly contributions to the streets of Valparaíso, but have little time for Valpo's more anarchic overtones.

Some Chilean street artists eschew political art, precisely because they were brought up on it. A better reason for moving 'beyond politics' is the singer Manu Chao's view that 'politik kills'. Much Chilean street art agrees with, and next to none disagrees with, the anti-war consensus of graffiti worldwide. ACB was, and Dana Pink and Pussyz Soul Food are, 'post-political' but socially engaged painters. Their

infantile style is largely aimed at children. It is motivated by a pedagogical strategy for the future. Other street artists express a bleaker view of impending ecological calamity: Mona, Nao and others through eco hell landscapes; and an anonymous mural in Arica incorporates actual garbage.

Many Chilean *graffiteros* of the 2000s, while remaining 'hip' in Dizzy Gillespie's sense of 'in the know', and aware, now address a wider audience. Hip hop visual culture elsewhere has deemed it 'arty farty' to communicate with the public in accessible pictorial style;27 but in Chile, with its strong tradition of propaganda painting, it is not uncool for street artists to address their fellow citizens. Helping to overturn a redundant nationalistic prejudice, Yisa, in Santiago, and Snoki, in Iquique, spell out their friendly admiration of Bolivia. Yisa also likes porn, and is a good example of how in Chile being politically engaged does not at all entail being politically correct. Permissiveness matters in Chile, and provides the basis for variety. Neoliberal conditions allow a spectrum of political and apolitical art: from BRP to Vazko.

CONCLUSION

For all its variety, three generalizations can be made about the imagery on Chile's streets today. The first is that, while abreast of developments in North America and Europe, Chilean street art is principally Latin American, unlike the enduring orientation of continental European graffiti to New York subway art (as exemplified by the welcome given to train travellers arriving at Rome's Termini train station to 'Roma York'). Secondly, because of its Latin American orientation, and its roots in propagandistic murals, in comparison to the work of Catalunyan street artists, Banksy and others, which chips into culture much as advertising does with brief witty messages, many images in contemporary Chilean cities address major social issues very directly (even if often ironically).

Thirdly, whereas there is a 'graffiti subculture' abroad, and North American and European street art appears uninvited like a gatecrasher

Art. 'Pursuit of all' without class differences ... WOOW!

Left : Ossa Avenue, Antofagasta. Zike and Sien, <i>Arte "Alcance de Todos" sin diferencias de clases …WOOW!</i>

alongside railway tracks and suspended from tramwires, in Chile street art is at the heart of the urban fabric. While graffiti has become a vital ingredient in its two most celebrated capitals worldwide, New York and Barcelona, in neither has it quite won itself an established position in the cities' main arteries, Broadway and Las Ramblas. Indeed, graffiti and street art are now largely discouraged in central Barcelona (and instead spring up elsewhere in Catalunya). In Santiago, propaganda art has for more than quarter of a century made its own high profile spaces on the Alameda, especially opposite St Lucia hill; and for miles along the Alameda to well beyond the Central Station, shop fronts are a chaos of spray paint. Santiago's Mapocho River has long been a space for protest art, and is now also a fast-moving kaleidoscope of pictorial interventions. Santiago's equivalent to London's Soho, Bellavista, is a riot of anarchic contributions, and every *santiaguino* suburb boasts its local nuance of painted and stencilled self-expression. Valparaíso in many ways surpasses the capital as a radical centre of Chilean and Latin American open air art; which is hardly less prevalent, but quite distinct, in contingent Viña, and so on. The catchphrase for the whole of Chile is 'from Arica to Punta Arenas', and one measure of how graffiti has won official respect the length of Chile is that the local governments of both Arica and Punta Arenas actively encourage it. In Punta Arenas – where the architect-street artist Fernando Padilla Arrau, Tagkiador's Synus Crew and others operate – the municipal council agreed in 2007 that 'graffiti is a cultural manifestation, scenery which makes walls attractive and vital' (*graffiti es una manifestación cultural cuyos paisajes dan atractivo y vitalidad a muros*), and that existing street art should be emulated in other parts of the city (*se repita por otros sectores de la ciudad*).28 Punta Arenas' council has since financed a 400-metre long mural alongside the city's De Las Minas River. In such conditions, the walls of every Chilean city, small provincial town, fishing village even, offer up new surprises.

Through lively affirmations of political and personal freedom, and in a spirit of resistance against commercial ads, contemporary graffiti in Chile merges its two main currents of radical propaganda and 'hip' self-expression. By doing so, without ever taking itself too seriously, and careless that its filthier jokes might offend, Chilean street art creates an exhilarating sur-reality 'within the reach of all'.

NOTES

1 For example Venezuelan Carla-Ly won top prize in the first international sticker awards of 2005: *Stickers* 2006, pp 305–09, 317–20.

2 Ganz 2006, p. 16.

3 *Stickers* 2006, 'Latin and South America', pp 279–376.

4 Indij 2006; Indij 2007; Campos and Meller 2007.

5 Castillo Espinoza 2006, pp 57–61.

6 Bellange 1995, p. 22; Castillo Espinoza 2006, pp 62–63.

7 Sandoval 2001, p. 27.

8 Castillo Espinoza 2006, p. 64: '*Batalla de propaganda de la Avenida España*'.

9 Castillo Espinoza 2006, p. 70: : '*nos dábamos cuenta la mejor propaganda era estar ahí. pintando*'.

10 Méndez Labbé 2003, p. 15.

11 José Balmes interview with Gilles Arnould, Paris 1974, in *Chile venceremos!!*.

12 Castillo Espinoza 2006, p. 106: 'COMISION NACIONAL DE PROPAGANDA JUVENTUDES COMUNISTAS DE CHILE'.

13 Sandoval 2001, p. 40.

14 González, manuscript notes towards a talk on the Ramona Parra brigades, in Castillo Espinoza 2006, pp 102–05, esp. p. 104.

15 José Balmes interview with Gilles Arnould, Paris 1974, in *Chile venceremos!!*.

16 Gracia Barrios interview with Gilles Arnould, Paris 1974, in *Chile venceremos!!*.

17 Matta in Eduardo Carrasco, *Matta: Connversaciones*, cit. Sandoval 2001, p. 10: '*Ver como verbo, es decir: ver la cosa creciendo, ver como ella va cambiando, verla en el espacio en que está.*'

18 Sandoval 2001, pp 46–47 on the Luis Corvalan, Laura Allande and other '80s brigades.

19 *No Gratos*, # 4, May 2006.

20 Dizzy Gillespie, *Dizzy. To Be Or Not To Bop. The Autobiography* (1979), Quartet Books, London 1982, p. 297; see Lewis MacAdams, *Birth of the Cool: beat, bebop and the American avant-garde*, The Free Press, New York 2001, p. 51.

21 Figueroa Irarrázabal 2006, pp 218–19 for a glossary of crews of Santiago.

22 Ganz *Mujer* 2006, p. 20: 'involving people from the community' (*que participan personas de la comunidad*).

23 Sandoval 2001, p. 77: '¡*Mala onda! Un país moreno con television rubia*'.

24 Figueroa Irarrázabal 2006, fig. 5, p. 100.

25 Figueroa Irarrázabal 2006, figs 14–17, p. 102.

26 González, 1971 notes on BRP, in Castillo Espinoza 2006, p. 105: '*Toda expresión de arte del pasado y del presente, está ligada a una connotación ideológica*'.

27 On the arty farty or 'artsy fartsy', see Macdonald 2001, p. 168; Rahn 2002, p. 92.

28 Punta Arenas, Concejo Municipal, 10 January 2007.

MAP

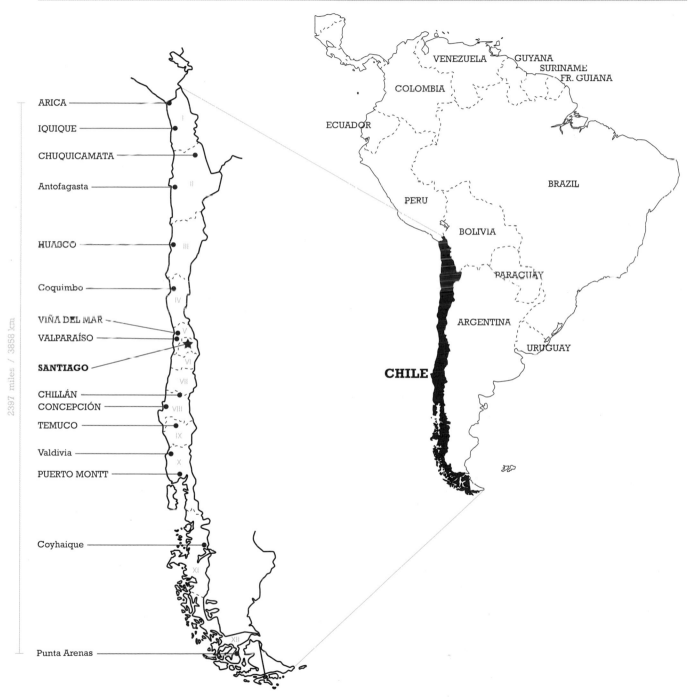

ARICA

IQUIQUE

CHUQUICAMATA

Antofagasta

HUASCO

Coquimbo

VIÑA DEL MAR

VALPARAÍSO

SANTIAGO

CHILLÁN
CONCEPCIÓN

TEMUCO

Valdivia

PUERTO MONTT

Coyhaique

Punta Arenas

2397 miles / 3858 km

VENEZUELA GUYANA
 SURINAME
 FR. GUIANA
COLOMBIA

ECUADOR

PERU

BOLIVIA

BRAZIL

PARAGUAY

ARGENTINA

URUGUAY

CHILE

Names in capitals refer to places covered in the Zones section

MAPOCHO

The Mapocho River runs through central Santiago. The Patronato stretch of the northern bank between Padre Hurtado and Patronato bridges has since the 1960s hosted a succession of leftist propaganda art. The BRP paint murals there to mark occasions such as Fidel Castro's 80th birthday (August 2006). The same stretch is also used by more militant organizations that have made spaces for themselves between the Recoleta and Cal y Canto bridges, where, like BRP, they continually renew their messages. There is also, as throughout Chile, much criticism of Chile's last two presidents, the Socialists Ricardo Lagos and Michelle Bachelet. Not all propaganda on the Patronato bank is party-political; there are also large slogans on local issues, for instance against the garbage plant planned for Santiago's Quilicura commune. For street artists prepared to face the dangers posed by the few desperate people who live down at the Mapocho, the Bellavista stretch, from Recoleta Bridge to Purísima Bridge, provides a window to a wide public. The Púrisima and other bridges and quaysides of the Mapocho attract stencils and stickers.

Below: Just east of Purísima bridge, Nicole, Grin, Ceris, Siek and Derik as *DUE CREW* (two crew). The painted bridge is illusionistic – the bow of the boat is on a buttress of the riverbank.
Right top: Between Padre Hurtado and La Paz bridges. Collective painting by members of Communist party of Santiago's S. Joaquín commune, remembering Allende's Popular Unity government at the expense of Lagos' Socialist one.
Right bottom: Just west of Purísima bridge. The PeKa crew participate in TOKO's tag. To the left, both do *pichaçao*.

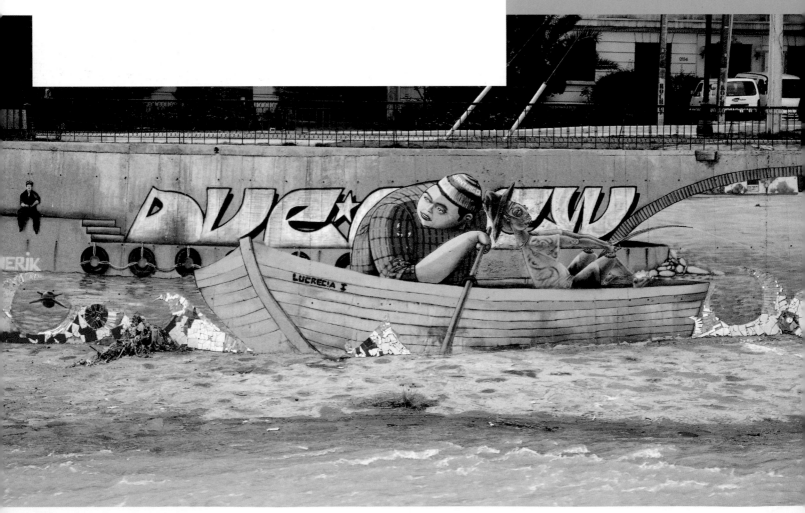

AGOS. I WILL ALWAYS BE WITH YOU. MY LEGACY WILL BE THAT OF A DECENT MAN WHO WAS LOYAL TO THE NATION. Cesar Cerda commune – S. Joaquín

BELLAVISTA

Bellavista, the area of Santiago across the river from the capital's political and financial institutions, has long been the centre of the capital's night life, and bills itself not just as Santiago's bohemian *barrio* but as the whole of Chile's. Several murals in Bellavista have a drug-fuelled or an otherwise fantastic quality and can turn nightmarish when their subject is environmental catastrophe. The western part of Bellavista, belonging to La Recoleta commune, has for many years been one of Vazko's preferred areas. It has several Dana Pinks, also Jehkses, and is visited by artists and crews from suburban Santiago, Concepción, and abroad. In Bellavista's village-like atmosphere, artists from different places meet and collaborate: Mona of Santiago with artists from Viña and Concepción. In Bellavista-La Recoleta, street art is tacitly encouraged; actively so on the last block of Rio de Janeiro St., renamed after the comedian Carlo Helo. On this side of Bellavista, Yisa is king; in the slightly more bijou streets towards the river, Piguan and TDV prevail. Walls are repainted in quick succession in Bellavista, which is a frontline in the tussle for supremacy between *nueva figuración* and hip hop *flops*. Bellavista attracts some of Chile's most sophisticated stencils and stickers.

Below top: 196 General Ekdahl St. A neat 'new wave' mural by Don Kelp, March 2007.
Below bottom: 196 General Ekdahl St. Infantile-psychedelic mural by Antisa (of Concepción), Gigi, Mona and 'ACB' on behalf of her friends, September 2007.
Right top: S. Filomena St. Five pill-popping aliens, on good and bad trips.
Right bottom: Dardignac St. A satire on the effects of insecticides by Degra and Nao from Concepción; insects by Mona.

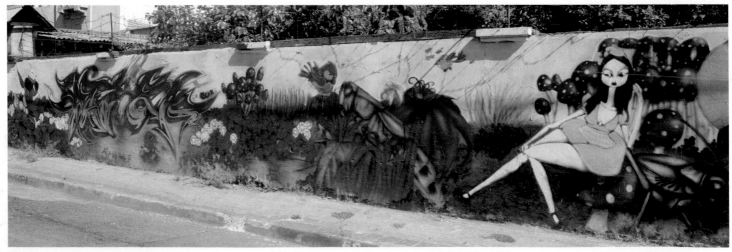

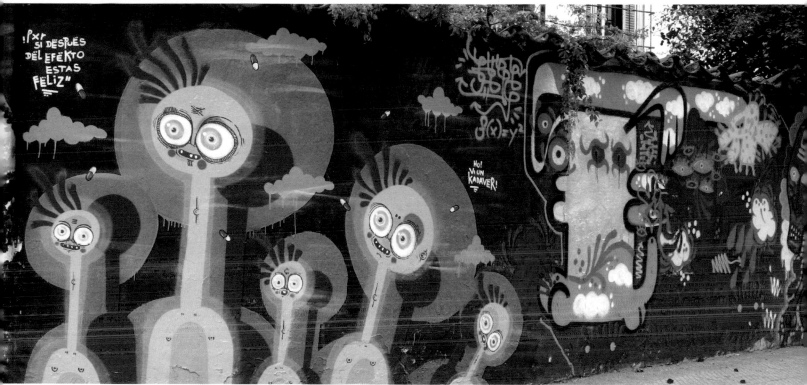

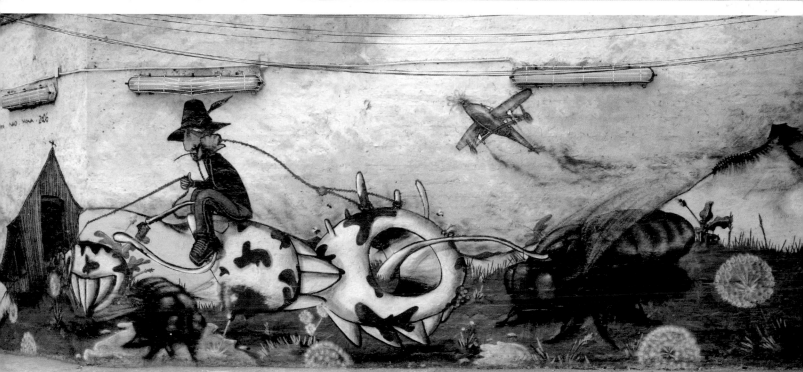

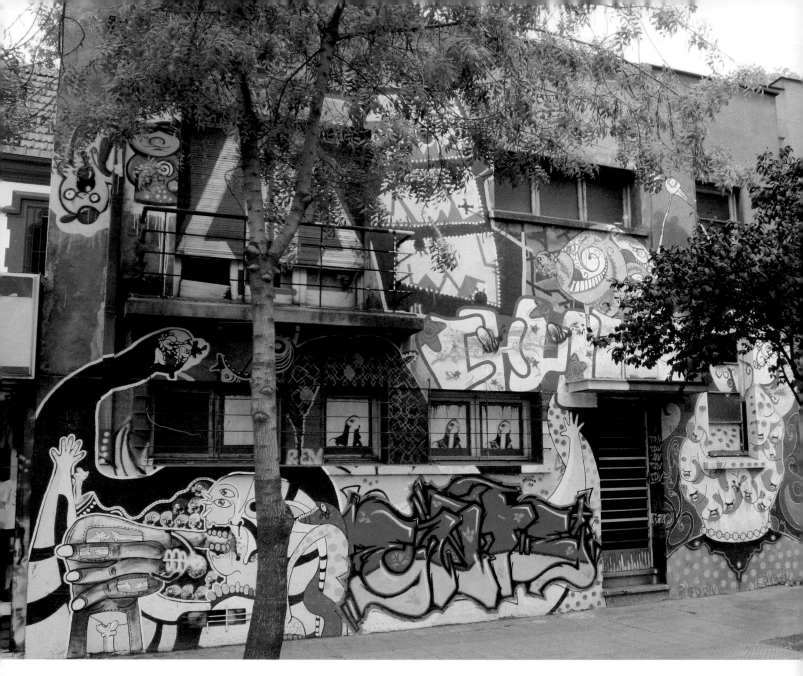

Above: Antonia Lopez de Bello St.
Piguan, Merilan et al.

Right top: Rio de Janeiro St. Elm,
Mono and Power: cyber punk and
dog to the left, cartoon-style figures
to the right.
Right middle: Humorista Carlos
Helo ex Rio de Janeiro St. Wall by Ha
Crew: diaphanous dancers, the man
gross-out.
Right bottom: Humorista Carlos
Helo ex Rio de Janeiro St. The title of

Yisa's '*REWAIND*' is a *gringoismo*.
Yisa, when painting over, does not
obliterate but works with what he
finds, in this case a blocky blue *flop*.
Far right top: Loreto Avenue.
Character by NOM. The tattoos
combine Brazilian and Peruvian
topics. '*NINHO DE BARRO*' is
'neighbourhood kid' in Portuguese.
AYAHUASCO is an Incan

psychotropic root, comparable in
strength to LSD, but of opposite
effect: it turns attention inwards,
and empowers.
Far right bottom: S. Filomena and
Loreto Sts. Jehkse and Cines: the
cartoon-style figure to the left is his,
the *flop* hers.

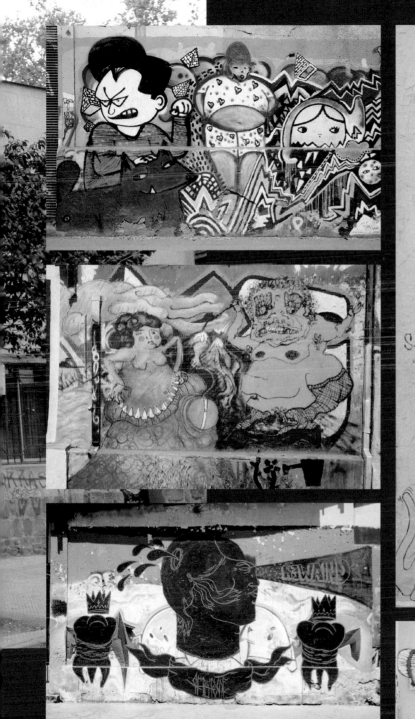

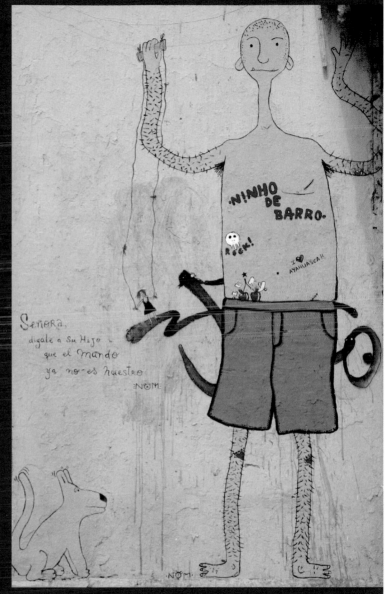

LA FLORIDA

La Florida is the residential southeastern area of Santiago made up of Bellavista La Florida and suburbs further south along Vicuña McKenna Avenue and the Puerto de Puente Alto end of metro Line 4.

Where Bellavista is slightly punk, La Florida is definitely hip hop. La Florida has many hip hop *flops*. Some of these have inscriptions as militant as any political propaganda. One on Nonato Coco Avenue invokes the spray can as weapon of resistance and its inscription reads: 'Hip hop is not just a thing: cans up, strong voices, firm arms … organize!!' (*Hip hop no es solo una cosa. Latas arriba, voces fuertes, brazos firmes … organizate!!*). Equally anarchic, but much more playful, are the unauthorized stencilled alterations to the names of even La Florida's leafier streets; and stencils also proliferate on many of La Florida's walls. La Florida is home to artists who have a profile in central Santiago and beyond including, here, Fis and TOKO. Nor is La Florida just a breeding ground. The 'Kite Workshop' (*Taller de Volantine* or TDV), based in Bellavista, operate in La Florida.

Right: La Florida Avenue. Fis (*left*) and, influenced by Vitche, Tennue Wow (*right*).
Below right: La Florida Avenue. An early work by Fis, with influences from Picasso and Vasko.
Below far right: A figure by TDV at Nonato Coco Avenue.
Background: Rivadavia Street sign. The lettering has been erased but the first 'R' is still visible. Renamed 'SERGIO GÓMEZ 12 YEARS'.

Below: Meliquina Passage, Nonato Coco Avenue. The first 'O' in TOKO's tag is gangsta style; the second 'O' recalls Salvador Allende.

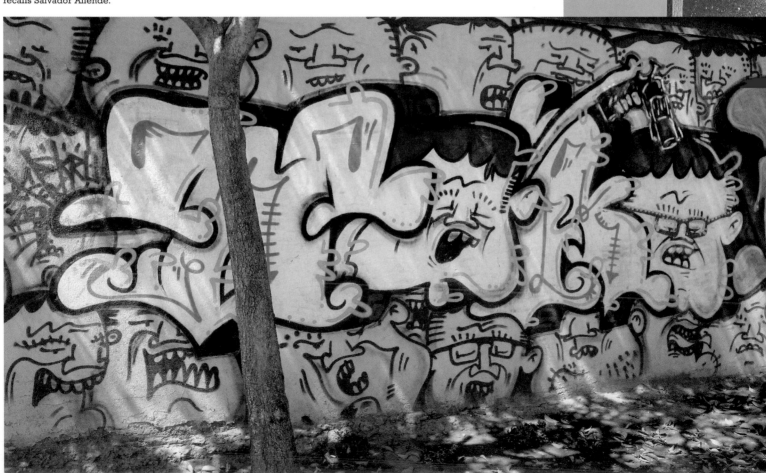

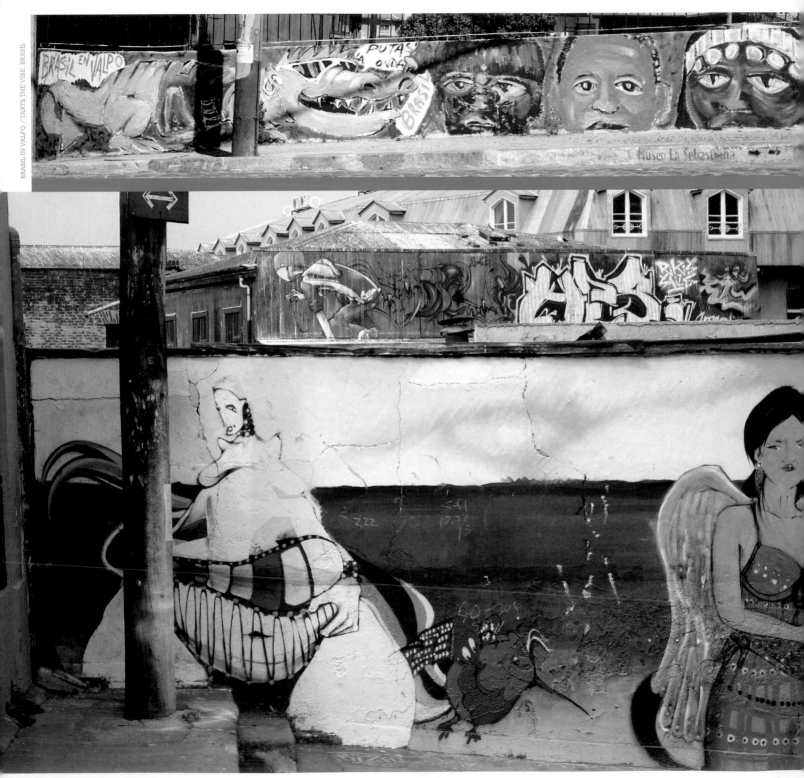

BRASIL IN VALPO / T'ARTS THE VIBE. BRASIL.

VALPARAÍSO

Valparaíso, birthplace of Allende and Pinochet, is the cradle of many aspects of Chilean culture. Since the *Winnipeg* docked in September 1939 with refugees from Franco's Spain, Santiago's port has been the Chilean city most hospitable to foreign rebels – and most responsive to avant-garde ideas. Valparaíso's identity has long been contested, all the more so since in 2003 the port and historical centre, but not the rest of the city, was made a World Heritage Centre. Many *porteños* disagree with UNESCO's perception of the city, and of culture itself.

Porteños generally encourage locals' and outsiders' murals, graffiti and stencils. Alme chooses Valparaíso for pictures in support of Chile's indigenous peoples. Fisek and other Santiago *graffiteros* like Valpo's laid-back acceptance of spray paint. PeKa enjoyed Valpo's 'mad infrastructure' (*infrastructura loca*). Vazko finds Valparaíso 'the most beautiful and piss-smelling city in Chile, cheap, pretty, fun and easy to paint'. Elodio of Concepción has left his mark. Artists also visit from elsewhere in Latin America, for instance Nestor Del Pino of Porto Alegre, Brazil. Valpo's graffiti and stencils move at an amazing pace. Many walls change almost daily; and, increasingly, Valpo's roofs are part of the unruly scene.

Left above: Plazuela S. Luis, Alegre Hill. Nestor Del Pino, *Brasil en Valpo*. The croc's *chilenismo* bubble is in the tone of Bomber West.

Left below: In the foreground Inti's albino, Gigi's hummingbird and Charqui's troubled angel; behind them, a roof in Fischer Passage.

Right above: Ex-Prison. Charqui's cats and Inti's albinos.

Right: Wasteground on the edge of Concepción Hill. Alme.

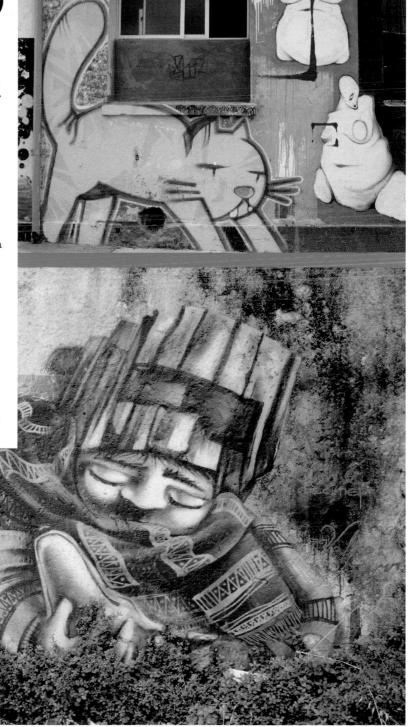

BARÓN
METRO STATION

Barón metro station, on the seafront of Valparaíso towards Viña del Mar, was a focus of propaganda murals in the 1960s. In the 2000s, Valpo's and Viña's *graffiteros*, and visiting artists from Santiago and further afield, have revived Barón as a zone for street art. In 2007, the recently privatized Valparaíso Metro invited Charqui Punk, Inti, Dana Pink, Alme, Pussyz Soul Food and others to paint there. Some of them rebelled: Charqui with an allegory of the metro, which is now too expensive for many locals to use, as a politicians' plaything; Dana Pink, from whom something sweetly childish might have been expected, by adopting less infantile personas: 'Crazy Draw' and 'Dada P*n*': the latter open to interpretation as 'Pink,' 'Punk' or *Pene* (penis).

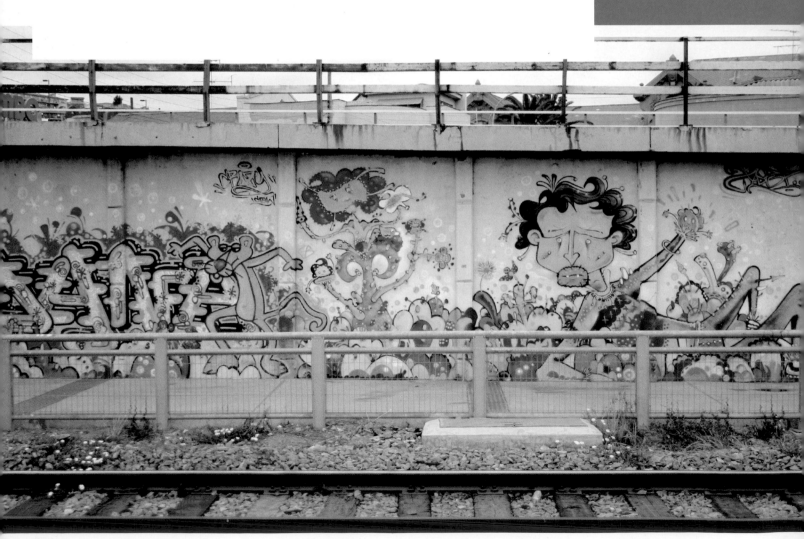

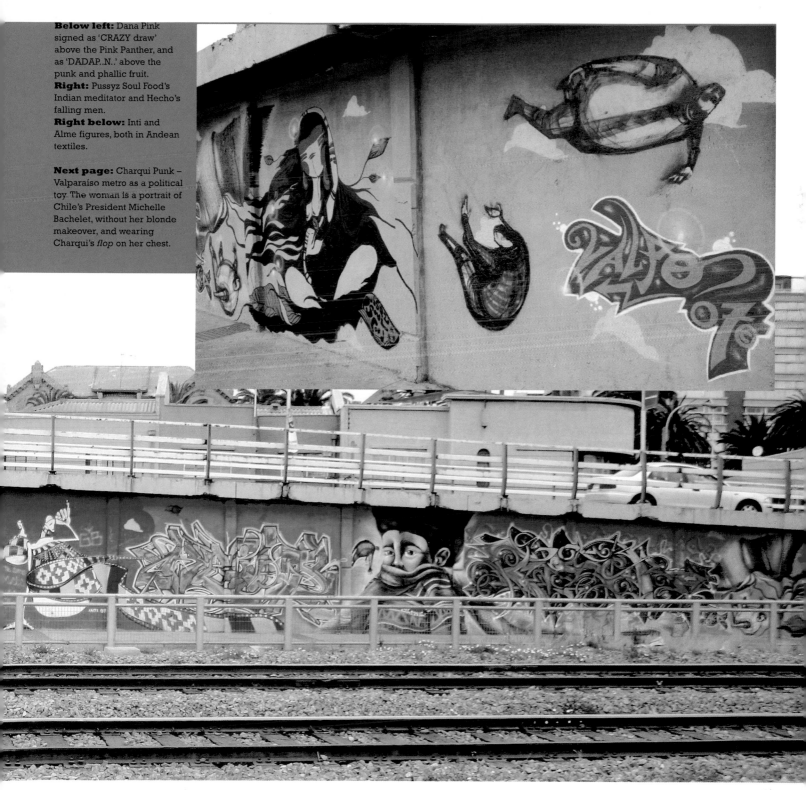

Below left: Dana Pink signed as 'CRAZY draw' above the Pink Panther, and as 'DADAP..N..' above the punk and phallic fruit.

Right: Pussyz Soul Food's Indian meditator and Hecho's falling men.

Right below: Inti and Alme figures, both in Andean textiles.

Next page: Charqui Punk – Valparaíso metro as a political toy. The woman is a portrait of Chile's President Michelle Bachelet, without her blonde makeover, and wearing Charqui's *flop* on her chest.

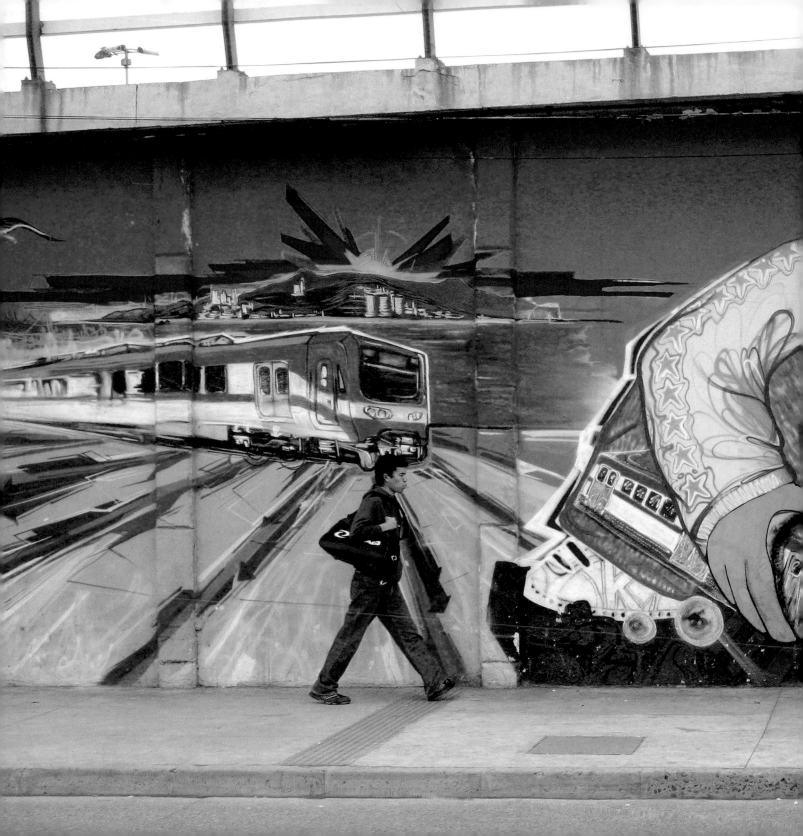

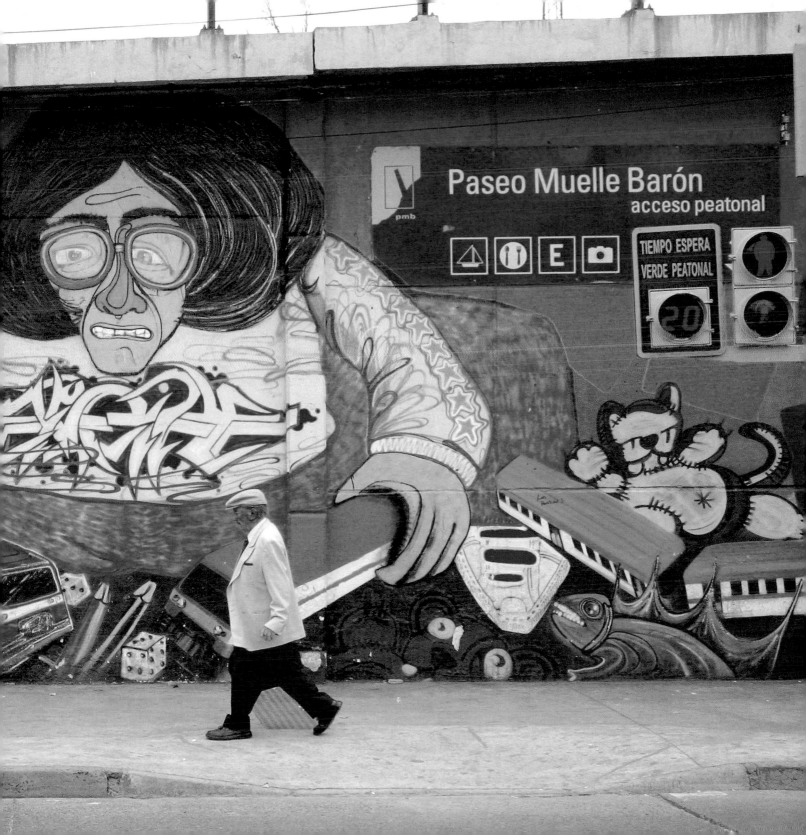

EX-PRISON HILL, VALPARAÍSO

Valparaíso's colonial prison building has long been a site of protest painting, and a 1973 BRP mural of anxious faces survives in its prison exercise yard. In 1999, Valparaíso's prison population was moved to a new site on the city's outskirts. The vacated site was 'reclaimed' in 2001, and has since hosted the diverse and fractious 'Ex-Prison Cultural Park'. Radical outfits that have intervened there include the La Pincoya Collective, named after a shantytown on the northern outskirts of Santiago. Many of the paintings on the wall spaces of the ex-Prison provoke reflection on Chile's problematic historical memories. 2007 saw a flurry of activity there by street artists and stencillists.

The terraces on the the ex-Prison, known as *Las Ruinas* ('The Ruins': a sailor is said to have returned home there to find his wife with another, and burnt it down never to be rebuilt), were recovered as a public space by Nancy Gewolb and her University of Playa Ancha students in the early 2000s. In 2008 *Las Ruinas* were also a hotspot of art, music and hedonism.

Below: Part of the 2003 collaborative painting of the ex-Prison's outer wall, including works by Charqui Punk.

Right: View of 'The Ruins' from Concepción Hill. Charqui and Inti works can be seen.

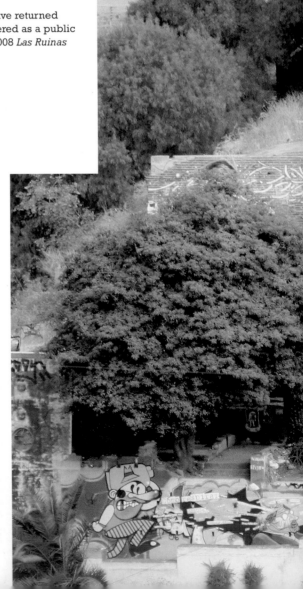

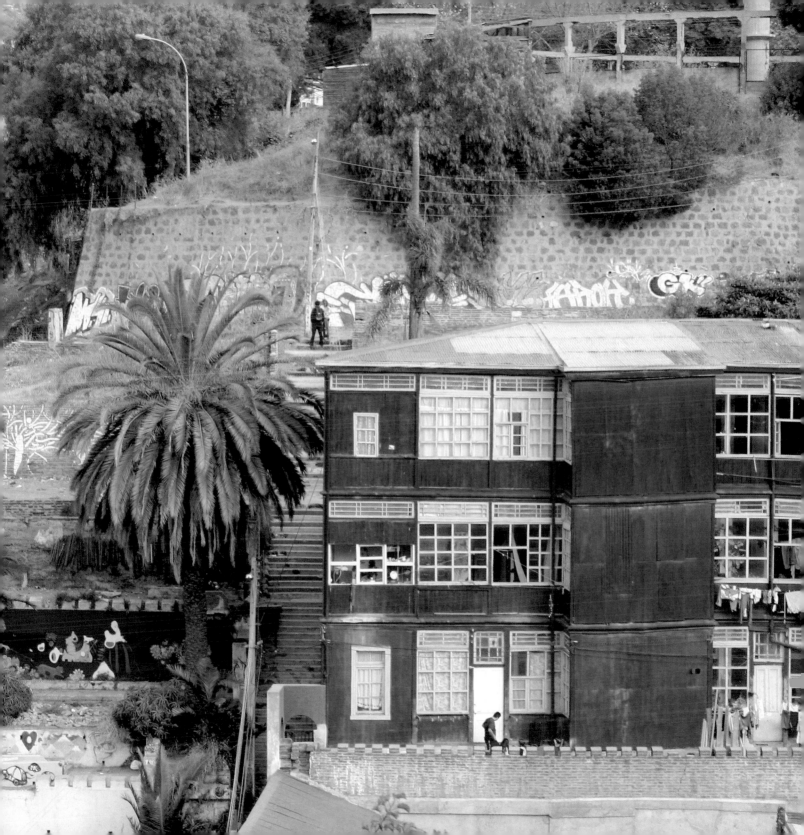

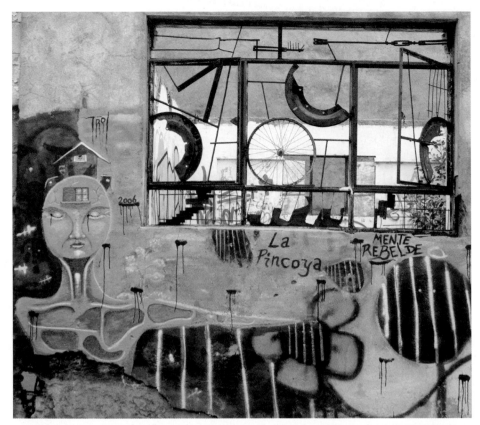

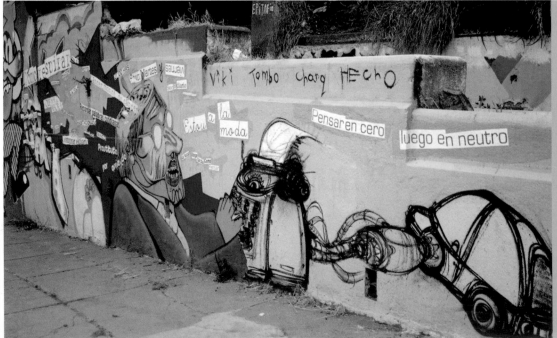

Above: A detail of the outer wall.
Left above: Painting and a glassless window composed of found objects embody La Pincoya Collective's *mente rebelde*, or 'rebel mind'.
Left: 'The Ruins'. Charqui Punk, the itinerant Canadian Hecho and other young painters collaborated on this wall, its text a near-*incoerencia*.
Right above: Since this photograph was taken in March 2007, this wall has been covered by a tag and a rash of stencils.
Right: The ruin itself, with comical recreations of its décor and its denizen, the ghost of the sailor's wife, who retired to a nunnery. The *graffitero* El Efecto Peña has inscribed the column.

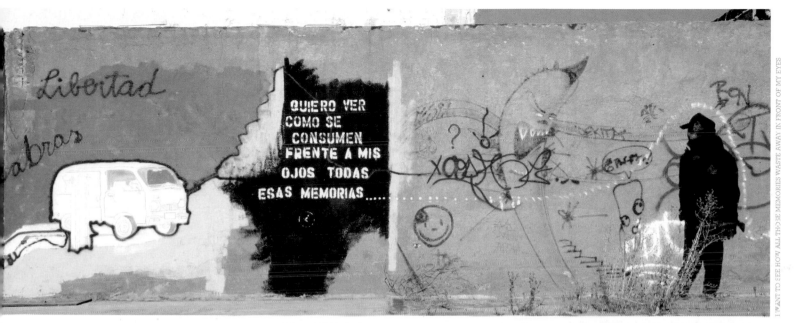

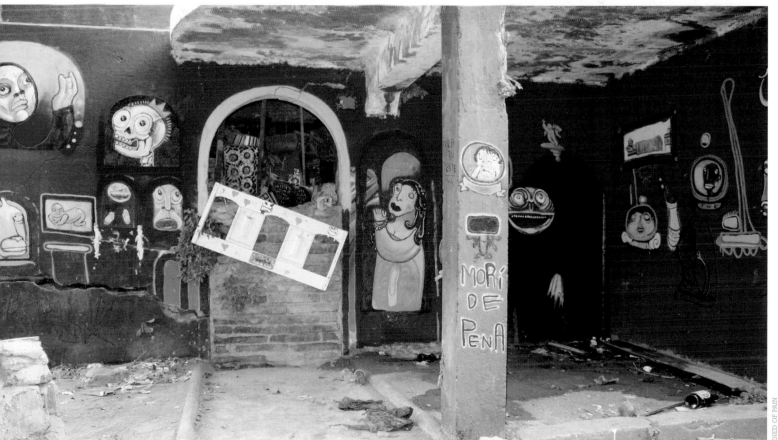

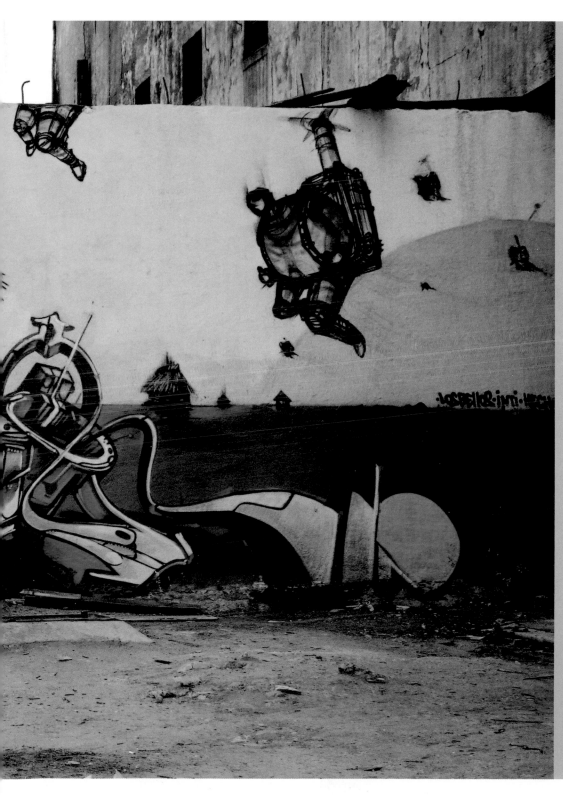

Left: The wall of a side courtyard in the ex-Prison. Unfazed by the different registers of each other's work, Hes (the *flop* on the left), Inti (the albino mutant) and Hecho (the airborne figures), collaborated on this wall which, for all the disparateness of its parts, convinces overall, as a response to its ramshackle site.

FISCHER

Fischer Passage, off Urriola St. in central Valparaíso, is a steep, shady shortcut between the port and Concepción hill. Due to its central position and pedestrian access, Fischer was a site of anti-dictatorship graffiti. Fischer remains a bastion of freethinking rebels and idealists. The conceptual El Efecto Peña ('The Rock Effect'), Fome and Rick Terror have all made pictorial statements in Fischer and the alleys just above it. Since the experimental art space 'Espacio G' moved to 25 Fischer in late 2004, Fischer has become ever more of a nexus for street art. During Pussyz Soul Food's *Miraquí* ('Look here') *graffiteros'* event at Espacio G in 2007, works by PSF, Fisek and others overflowed into the street. Artists visiting Valpo from Regions VIII and IX such as, here, Elodio and Cezo, have worked in Fischer.

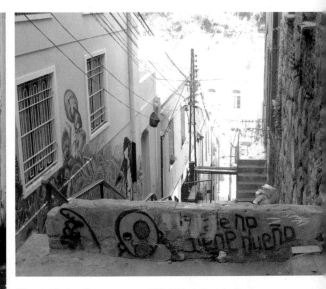

Above: Fischer Passage from above. The green figure in the foreground is by El Efecto Peña. His message is: *LA CALLE NO TIENE DUEÑO* ('the street has no owner').
Left: Cezo knows her Barça street art.

Right top: Urriola St. at Fischer. Elodio's figure is disproportioned as though seen through the bottle he holds.
Right below: Alme, Oesis (the fish) and Hecho (robotic head above fish) all aboard a Fisek *flop* that tumbles down Fischer.
Far right: Pussyz Soul Food's figure at the head of the same flop. Her inscription is to residents of Fischer who were watching her paint.

CeZo 06'

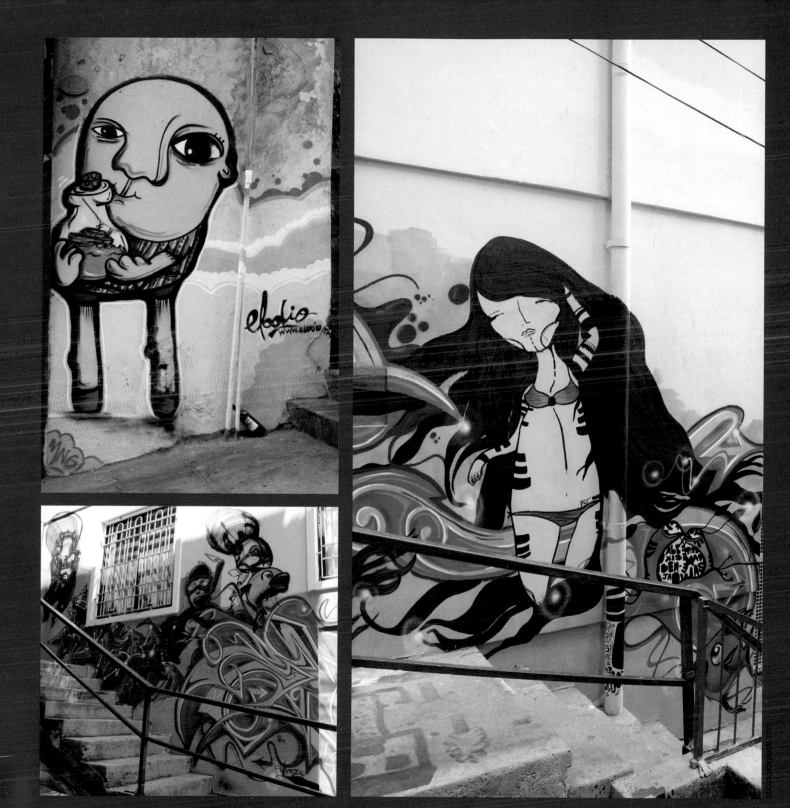

VIÑA DEL MAR

Viña del Mar has long been part of the same urban conglomeration as Valparaíso. Viña, favoured seaside resort of Chileans and Argentines, is perceived as Chile's most glamorous city. Although Viña and Valparaíso themselves connect, Viña's street art differs from Valpo's. Viña's boulevards and beaches invite bigger and often brighter art than that found in Valparaíso. Where Valpo has fostered a punk ethic and Latin American style 'new figuration' (*nueva figuración*), Viña is more hip hop and the walls of its beaches offer generous spaces for *flops* evolved from North American style tags. Viña's beaches, especially the Caleta Abarca, attract the best painters from towns inland such as Quillota and La Calera, and *graffiteros* such as Caos, Hes and Mason from Santiago. Caos's *flops* have moved on from *wildstyle* to aesthetic *freestyle* abstraction. Hes opts for lurid legibility. 25 Crew live and operate in Viña; they, Siek and Faiser have executed sharp, eye-catching murals, made to be intelligible from a distance, at Recreo beach.

Below: Caleta Abarca beach. The tag is by Zade, the head by Smart, both of 25 Crew.

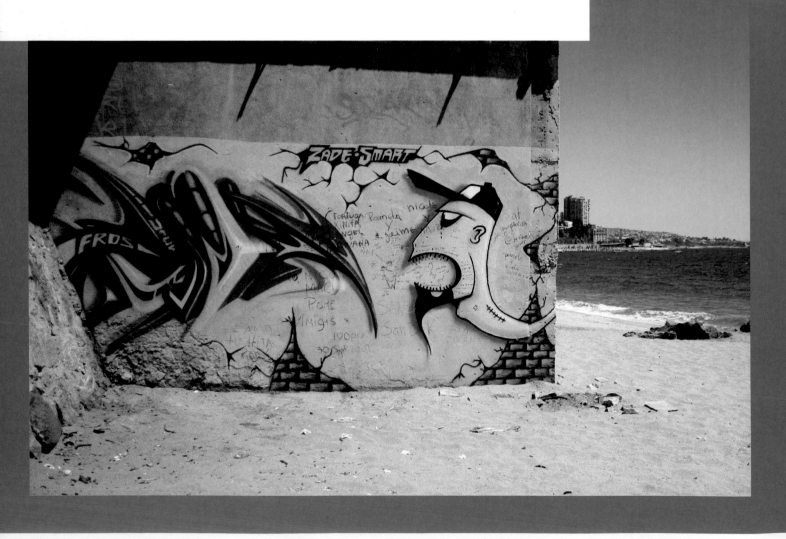

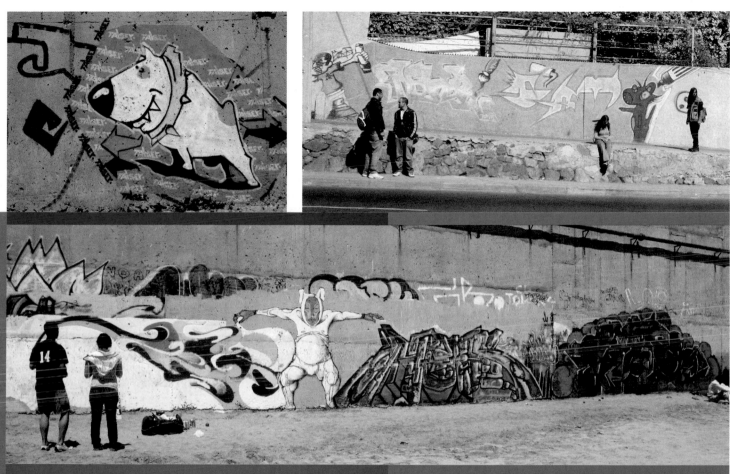

Top left: Recreo beach. The angular design, and use of primary colours and black and white, make Faiser's dog stand out from a distance.

Top right: Bus stop, at Agua Santa St. Jona's 'analytical *flop*' between cartoon-style characters.

Middle: Caleta Abarca beach. *Flops* by, from left to right, Caos, Hes, Mason; the figure is by a painter from La Calera. To the left, Caos and companion discuss his *freestyle flop*.

Left: Caleta Abarca beach. Flying dismembered robot by Hecho.

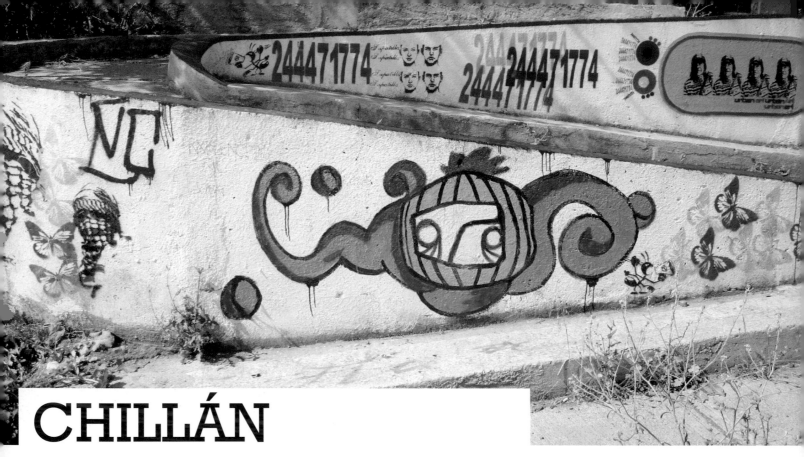

CHILLÁN

The Escuela México, a big elementary school in central Chillán, has excellent murals by the Mexicans, D. A. Siqueiros, Xavier Guerrero and their Chilean *compañeros*; so Chillán is well attuned to political art. Capital of Chile's VIII Bío-Bío Region, Chillán is on the Bío-Bío River, which has a river walk the walls of which attract graffiti and stencils. The Bío-Bío marks the frontier of Mapuche territories. In Chillán, a classic instrument of propaganda art, the *papelógrafo* (painted poster), is used in the Mapuche cause. There are at least half a dozen BRP murals in the area around Chillán's Bío-Bío University alone, of which 'Angelini is shitting on us' is one of the funniest BRP murals in Chile. Similarly, Chillán's graffiti outfits such as G5, Hisbers and Taxi aim for comic effect. Urban art attack's paintings-cum-stencils look to Os Gêmoes and Bansky. They express pro-Mapuche, anarchic and more loosely egalitarian sympathies with NeoPop, or NoPop, freshness.

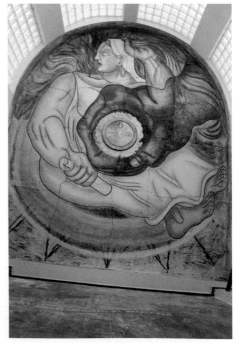

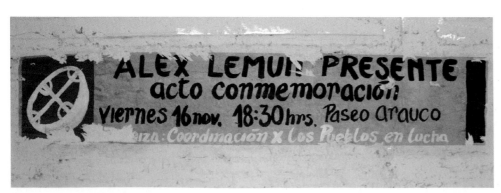

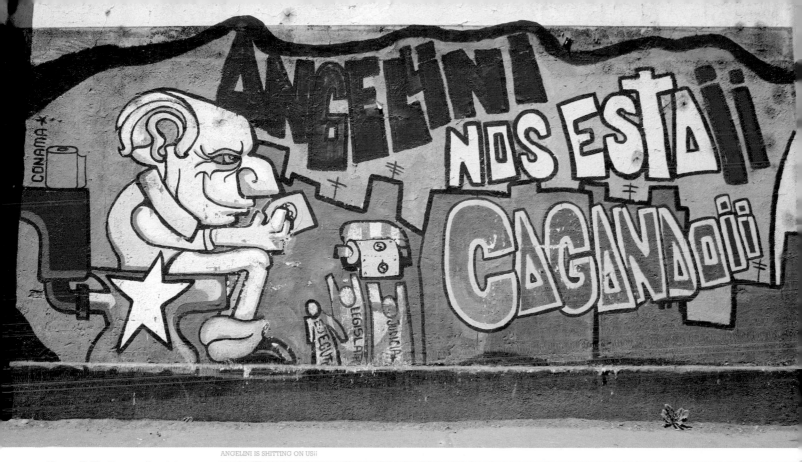

ANGELINI IS SHITTING ON US!!

Above: Collín Avenue. Anacleto Angelini (Ferrara, Italy 1914–Santiago 2007) was demonized, partly on account of the Grupo Angelini's usurpation of woodland in southern Chile.

Right: Brasil Avenue. Fittingly, Urban Art Crew look to Os Gêmoes.

Top left: Bío-Bío river bank, Chillán. Urban Art Crew. A pumpkin-head in Andean balaclava, with an ensemble of stencils ranging from anarchic to NeoPop. 244471774 is Urban Art Crew's fotolog number.

Left: Escuela México, O' Higgins Avenue. Stairwell: Guerrero's *History and Humankind*.

Far left: Libertad Avenue. A *papelógrafo* (painted poster) commemorating the death of an activist. Alex Lemun died aged 17 on 7 November 2002 in a collaborative effort to reclaim Mapuche territory from a forestry company.

45

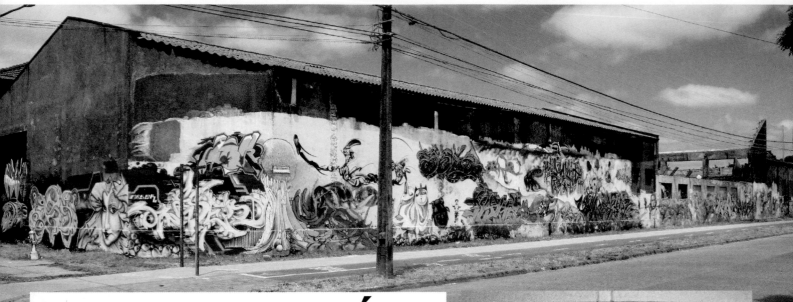

CONCEPCIÓN

Concepción is Chile's third largest city, site of Jorge Camarena's *Latin America*, the most impressive mural in Chile (*see p. 9*), and the country's stencil and sticker capital. With an autonomous University; a tradition of protest art in radical areas such as the Lorenzo Arena commune; and a big Mapuche presence; Concepción's street art is highly self-aware and politicized. Since 2005, Conce has hosted annual events with graffiti and street artists, in which ACB, Inti, Jehkse, Mona, PSF and Bomber West have collaborated with local artists Antisa, Maher and Tio MSE.

The main protagonists of Conce's *La Manga* ('The Sleeve') crew are Elodio, El Pera and Gator. *La Manga* combine BRP outlines with more recent techniques. They combine painting and stencils, as does El Pera's protégé Ingapock.

The University's art department supports stencilling in the streets of central Concepción. Some of these stencils are multi-coloured, and individually or collectively signed, by El Pera, the Mapuche artist El Peñi, and the anarchist collective *La Conciencia*. *La Conciencia* works from a squat in a township between Conce and Talcahuano. *Penkista* street art is not limited to Concepción itself, but embraces the surrounding area, Tio MSE's portraits being seen along the road from Conce, through Coronel, to Lota.

Top: Angol Avenue, aka 'Lo Graffiti' Avenue. Joint wall by Inti, Mis Marz, Mona, Tio MSE, Bomber West and others.
Above right O' Higgins Avenue. Ingapock's four figures are, from left to right: painting, stencil, painting, stencil.
Right: Ongolmo St. *La Manga* combines trad outlines with stencils on the cap, and a background *pichaçao* text.

Far right top: 23rd of May Avenue, end of an apartment block in the Lorenzo Arenas commune.
Far right middle: Padre Hurtado Avenue at Santo Tomás University. Joint wall by ACB, PSF, Maher, Jehkse and others.
Far right bottom: Larenas St. UMLEM (*Unidad Muralista Luchador Ernesto Miranda*). Cartoon-style protestors with a list of martyrs to radical causes, and a call-to-arms.

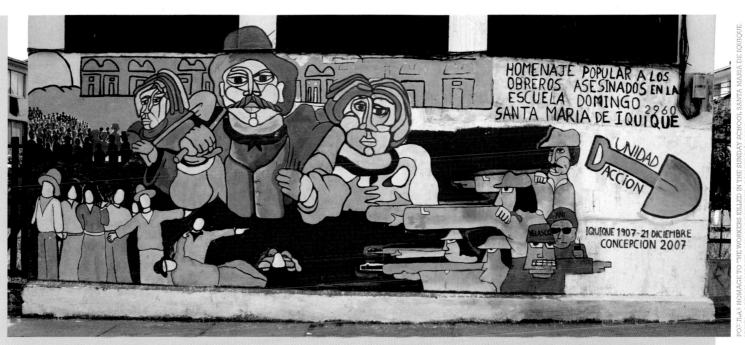

HOMENAJE POPULAR A LOS
OBREROS ASESINADOS EN LA
ESCUELA DOMINGO 2960
SANTA MARIA DE IQUIQUE

UNIDAD
ACCION

IQUIQUE 1907-21 DICIEMBRE
CONCEPCION 2007

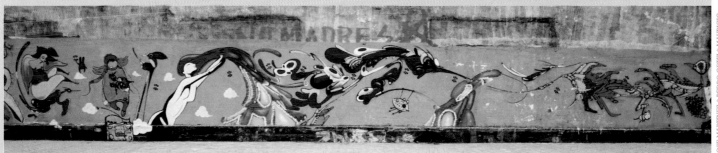

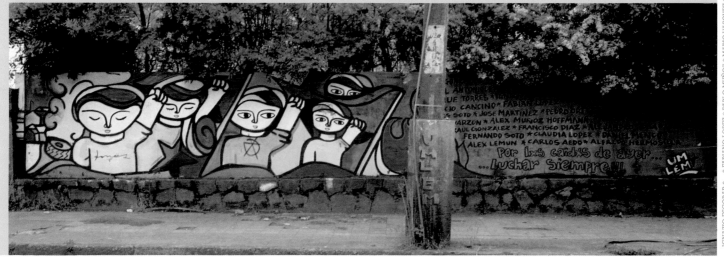

Por lxs caídxs de ayer...
...Luchar Siempre!!!

UM
LEM

POE ILA'S HOMAGE TO 'THE WORKERS KILLED IN THE SUNDAY SCHOOL SANTA MARIA DE IQUIQUE
UNITY / ACTION. IQUIQUE 1907–21 DECEMBER CONCEPCIÓN 2007

...IGNAZIO ESCOBAR * ... * FABIANO LOPEZ * PABLO MUÑOZ * MARIO VÁSQUEZ * ... * JOSE MARTINEZ * PEDRO ORTIZ * MAURICIO
GOMEZ * ... ALEX MUÑOZ HOFFMANN * NORMA VERGARA * YURI URIBE * RAÚL GONZALEZ * FRANCISCO DIAZ * ALEJANDRO SOSA *
FERNANDO SOTO * CLAUDIA LOPEZ * DANIEL MEMCO * ALEX LEMUN * CARLOS AEDO * ALFREDO HERMOSILLA. / For yesterday's
fallen ... Fight Forever!!! / UMLEM*

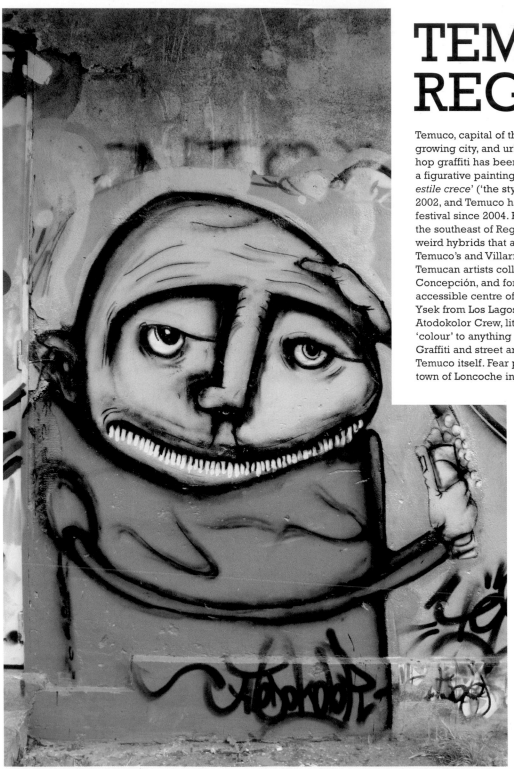

TEMUCO & REGION IX

Temuco, capital of the agricultural IX Region, is a rapidly growing city, and urban art is developing quickly with it. Hip hop graffiti has been practised in Temuco since the 1990s, and a figurative painting by Robin, dated 2000, announced '*lo estile crece*' ('the style grows'). Zekis painted in Temuco in 2002, and Temuco has hosted an annual Japanese animation festival since 2004. Fear of Temuco, and Maher of Villarrica in the southeast of Region IX, have developed a local idiom of weird hybrids that are surprisingly marine-looking given Temuco's and Villarrica's inland geographical positions. Temucan artists collaborate with their counterparts from Concepción, and for painters from further south Temuco is an accessible centre of nationwide importance. The 20-year-old Ysek from Los Lagos in Region X's lake district does so as Atodokolor Crew, literally 'to-all-colour crew', and to give 'colour' to anything means to enhance or exaggerate it. Graffiti and street art of Region IX are by no means limited to Temuco itself. Fear painted one of his best pieces in the small town of Loncoche in the southwest of Region IX.

Top left: Aldunate St. Detail of a joint wall by Antisa, Cezo, Abs, Eney, Maher, Fear, Ormak, of Temuco and Concepción. Caterpillar by Antisa.
Top right: Aldunate St. These flayed faces have jet black hair as do the many Mapuche in Temuco; Maher's monster combines mollusc and crustaceous forms.
Right: Balmaceda St., Loncoche. *Fear* by Fear.

Left: Matta St., Temuco. Atodokolor Crew.

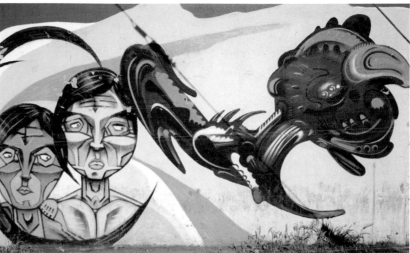

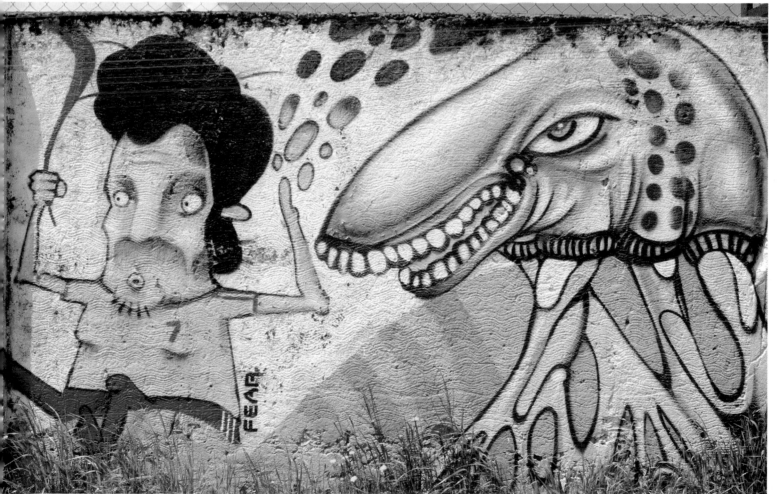

PUERTO MONTT

Puerto Montt (pronounced 'Puert Mon') has in the past fostered wall painting. Under usually grey skies, its greyish walls are transformed by some bright street art. Araucana Avenue, the main highway into the city from the north, has a 600-metre long municipal mural relating to Puerto Montt's history from indigenous times to the first high-speed locomotive.

Today, Puerto Montt has lively graffiti, sticker and stencils, especially on the seafront and its skateboard park and, inland, in the Kennedy township and nearby Ecuador Avenue. North American style *flops* are joined by cartoon-style works by the likes of ATU and Micho. ATU's character in floppy cap is cartoon-style not just in his resemblance to cartoons, but also in the economy of his gestures. Micho, painter of toothy ginger cats, works in Puerto Montt's 'Enrique McKool' video store. In the Kennedy township's Filadelfia St., two of ATU's worried cartoon characters are dwarfed by the big POSH *flop*, with its nice and superfluous bubble, summing up the interplay of cartoon-style *nueva figuración* and old school *flops* on contemporary Chilean walls. Stencil crews active in Puerto Montt include El Disturbio (The Disturbance).

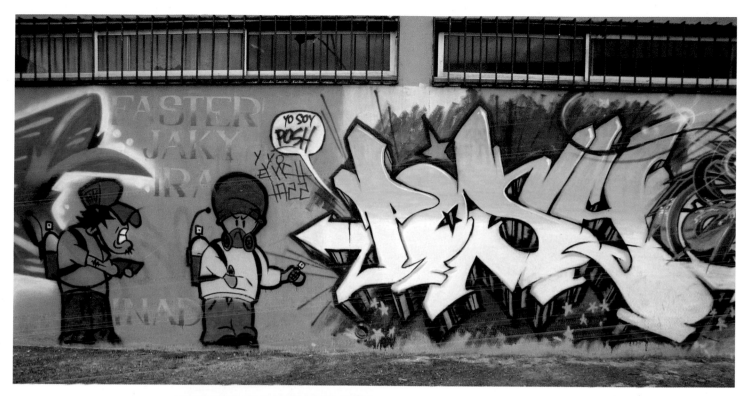

Above: Filadelfia St., Kennedy township, Puerto Montt. ATU and Posh.
Right: Ecuador Avenue, Puerto Montt. Micho and ATU.
Left: Portales Avenue, Puerto Montt. One of Micho's cats in front of Puerto Montt's skateboard park and seafront.
Far left top: Ecuador Avenue, Puerto Montt. ATU character at bus stop.
Far left bottom: Portales Avenue, Puerto Montt. ATU, Micho and others.

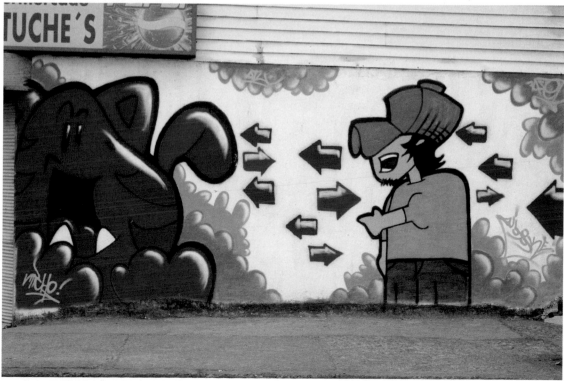

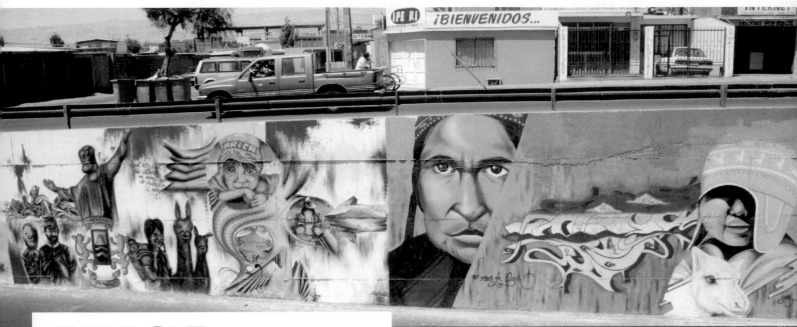

ARICA

Arica has a record of fostering BRP and other leftist art, both publicly and privately. Arica's progressive *Municipio* (town government) puts its name to big pictorial statements, these days mainly on ecological topics, also a main concern of autonomous artists. Arica's encouragement of contemporary graffiti is writ large on a bridge over Diego Portales Avenue, the main road into the city from the south (i.e. from the rest of Chile): *EL MUNICIPIO Y LOS JOVENES EMBELLECEN LA CIUDAD* ('THE MUNICIPALITY AND THE YOUNG EMBELLISH THE CITY'). Below this bridge, tags connect figurative paintings, many to do with the Chinchorro inhabitants of Arica's Azapa valley from 7000 BC. A main concentration of independent graffiti is found around the Arica–Tacna train line to the north of town. Arica is just over 10 miles from the Peruvian border. Peru's proximity is felt in *Ariqueño* cuisine; and in photorealist paintings of women's faces. Peruvian naturalism rubs off on *Ariqueño* painters who incorporate architectural drawings of buildings, notably Eiffel's Arica cathedral, into their *flops*.

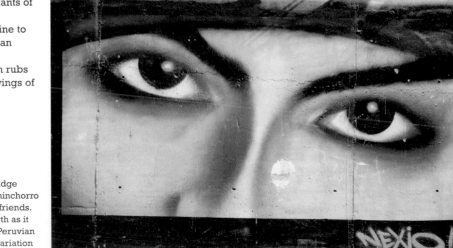

Top: Municipally-sponsored wall on Portales Avenue, mainly of Chinchorro and other indigenous subjects.

Right above: Beneath a bridge under the train line near Chinchorro beach. A wall by Dase and friends.
Right: On the train line north as it passes Chinchorro beach. Peruvian Nexio's painting is a lurid variation of Liman photorealism,

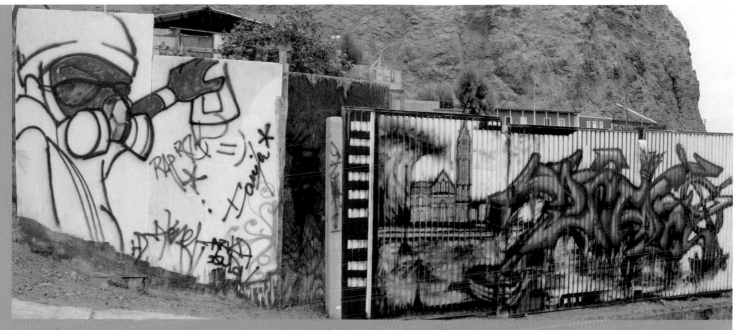

Above: Between Tanja's self-portrait and *flop*, a drawing of Arica Cathedral under a huge *tsunami*.
Right: A house in Lauca Park, S. José neighbourhood, with a BRP mural to the left and homage to Neruda on the right.
Below: Portales Avenue: The anonymous mural *Garbage* ('Basura') reads 'Welcome to Arica 2027 / Your comfort produces "garbage"', and incorporates actual garbage.

Neruda, S. José salutes you

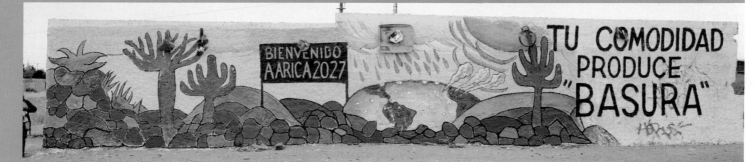

IQUIQUE

Iquique, Aymara 'place of rest', is on a peninsula stretching out from huge sand dunes into the Pacific. Its seafront is a surfers' paradise. Brava ('Naughty' because of its big waves) beach is frequented by tag crews, especially OFIS. Cavancha beach and cove boast many analytical and *freestyle flops*, and some light-hearted pieces: comic inscriptions are an *Iquiqueño* speciality. In Iquique, 'multicultural' refers not only to the hedonistic encounter of local youth and bikini-wearers on its beaches. Challenging the notion that for historical reasons Chileans and Bolivians should remain enemies, on Cavancha Cove local boy Snoki and his visitor from the *altiplano*, Droms, signed their joint tag 'DROMS BOLIVIA, SNOKI CHILE, 2007'.

Inland, the area around the Aymara cultural centre, the market (scene of one of Chile's unhappiest historical memories, a massacre of striking nitrate workers) and the perimeter wall of Iquique's cemetery are all sites of street art.

Right: Brava Beach, tags. Mauve one to the right is by OFIS.
Far right: Apartment block next to Caleta Cavancha (Cavancha Cove). 'From Marce, with a stutter, to her brother.'
Below right: Perimeter wall of cemetery. ETP mural showing modern-day street artist and Indian. The 'roots' (*raíces*) are literally represented. The Indian recalls the Brazilian mythic figure 'Zé Arrigo'.

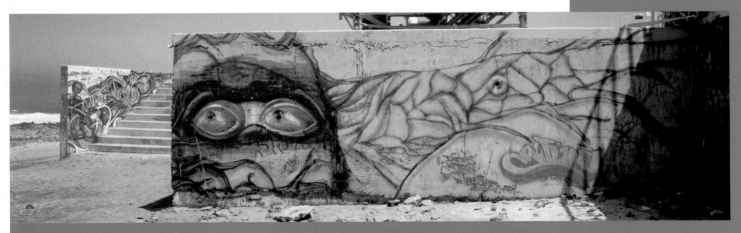

Above: Cavancha beach. In the foreground, Danes' and Kiros' *flop* combines historic *outline* and contemporary *freestyle* styles; at background left, Sirak and Snoki.
Left: Detail of wall at Balmaceda Avenue, near Cavancha Beach.

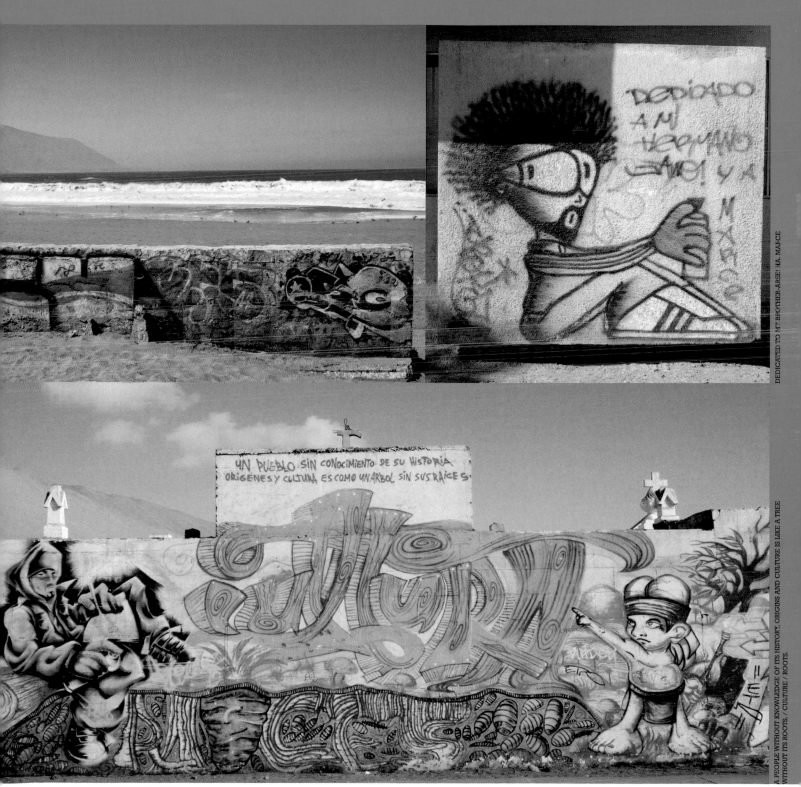

DEDICATED TO MY BROTHER-AREE! H.A. MAECE

A PEOPLE WITHOUT KNOWLEDGE OF ITS HISTORY, ORIGINS AND CULTURE IS LIKE A TREE WITHOUT ITS ROOTS. / CULTURE / ROOTS.

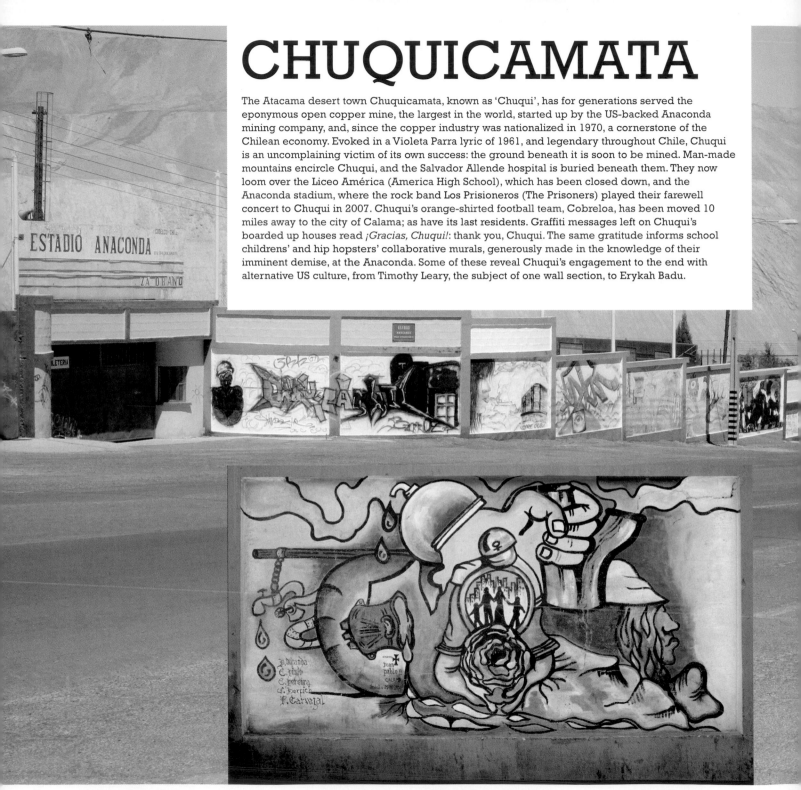

CHUQUICAMATA

The Atacama desert town Chuquicamata, known as 'Chuqui', has for generations served the eponymous open copper mine, the largest in the world, started up by the US-backed Anaconda mining company, and, since the copper industry was nationalized in 1970, a cornerstone of the Chilean economy. Evoked in a Violeta Parra lyric of 1961, and legendary throughout Chile, Chuqui is an uncomplaining victim of its own success: the ground beneath it is soon to be mined. Man-made mountains encircle Chuqui, and the Salvador Allende hospital is buried beneath them. They now loom over the Liceo América (America High School), which has been closed down, and the Anaconda stadium, where the rock band Los Prisioneros (The Prisoners) played their farewell concert to Chuqui in 2007. Chuqui's orange-shirted football team, Cobreloa, has been moved 10 miles away to the city of Calama; as have its last residents. Graffiti messages left on Chuqui's boarded up houses read *¡Gracias, Chuqui!*: thank you, Chuqui. The same gratitude informs school childrens' and hip hopsters' collaborative murals, generously made in the knowledge of their imminent demise, at the Anaconda. Some of these reveal Chuqui's engagement to the end with alternative US culture, from Timothy Leary, the subject of one wall section, to Erykah Badu.

Left: The perimeter wall of the Anaconda stadium, from which all the photographs on this page are taken.

Left inset: By five pupils of John Paul II School, Calama, whose names appear at bottom left. The black outline and right-hand profile show the BRP's influence.

Right top: A naïve depiction of Chuqui on the brink of destruction, with a loving valedictory message.

Right middle: The black-and-red shape mid-right is a memento of the Liceo América's emblem. Oddly, given her skin colouring, the scarved woman is Erykah Badu.

Right bottom: A mining truck, by Barr, meets a tag.

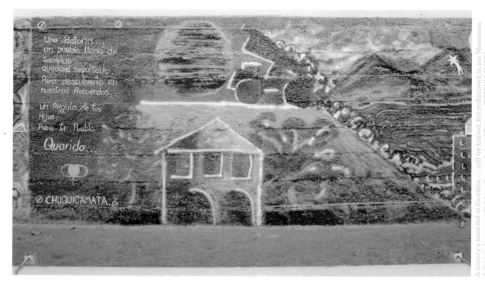

Una Historia...
un pueblo lleno de Sacrificio
quedara sepultado
Pero descubierto en nuestros Recuerdos...

Un Regalo de Tus Hijos
Para ti Pueblo

Querido...

Ø CHUQUICAMATA. Ø

A history a town full of Sacrifice ... will be buried. But rediscovered in our Memories. A Present from your Children. For you Beloved Town ... CHUQUICAMATA

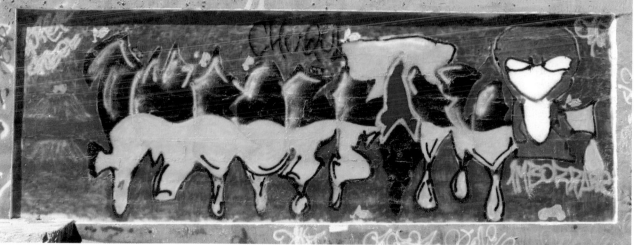

INEFFABLE CHUQUI

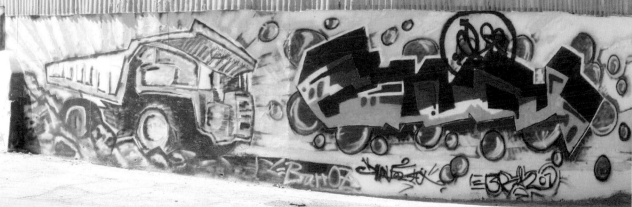

HUASCO VALLEY

The Huasco valley exemplifies how communal murals and unsolicited graffiti flourish in Chile's smaller cities, towns and even villages. On the main road into Vallenar (pronounced 'Viyenar-r-r'), a large mural expresses pure love for the city. Central streets of Vallenar abound in official and unofficial propaganda. There are long painted inscriptions backing Chile's President, Michelle Bachelet; and more radical political art by the Claudia López Brigade and smaller outfits. The poor Los Carrera township is rich in graffiti. Vallenar's Riverside Walk ('*Paseo Riberero*') has innumerable *flops*, including several psychedelic pieces. Huasco itself has many crews, first and foremost BBN, who have 'bombed' Huasco from the seafront to outlying townships. Between Vallenar and Huasco, the village of Freirina hosts one of the BRP's most beautiful, and urgent, paintings (*see p. 61*): against the gold mine, planned for Pascua Lama at the top of the valley, which threatens northern Chile's only unpolluted river.

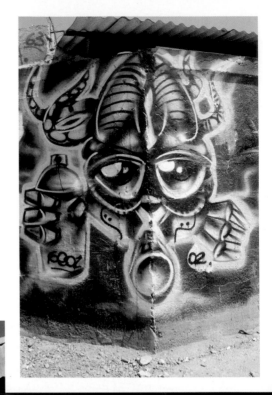

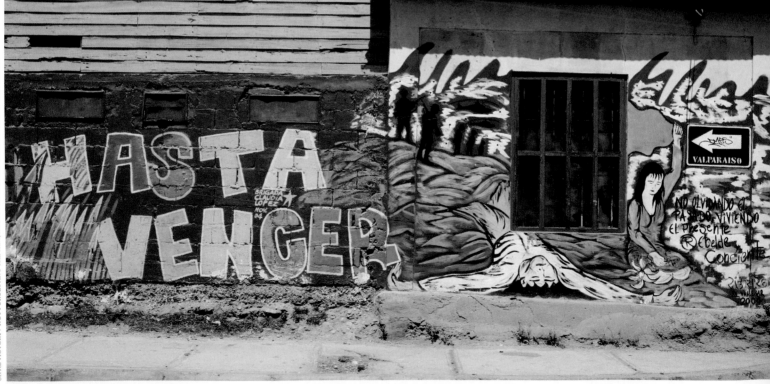

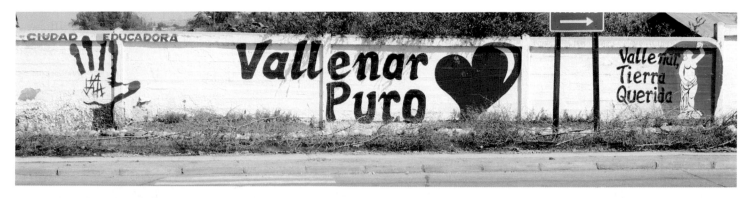

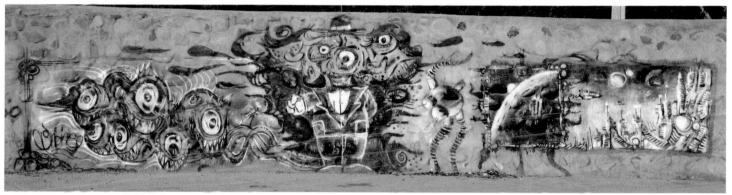

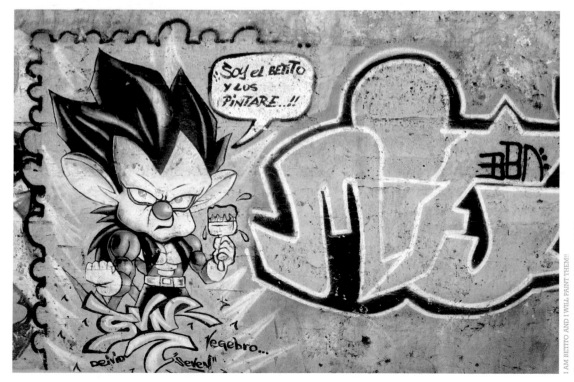

Far left top: Honorio Pérez St., Los Carrera township, Vallenar. A masked, and more unusually, horned spray painter by Geoz.
Far left bottom: Valparaíso St., central Vallenar. The Claudia López Brigade and Riz Red.
Top: Matta Avenue, Vallenar: 'EDUCATING CITY / Vallenar Pure Love / Vallenar Beloved Land'
Middle: Riverside Walk, Vallenar.
Left: BBN Crew, schoolyard, seafront, Huasco.

BRP

The communist BRP (Brigada Ramona Parra) have operated from 1969 to 1973, and from 1988 to the present, in several collectives throughout Chile. BRP have retained their method of drawing an initial outline, filling it with one colour assigned to each respective *rellenador*, and then painting the black outline last. Latterday BRP murals are instantly recognizable: for their outlines, their BRP logos often incorporating stars, and because of their fidelity to '70s imagery. This includes indigenous faces in profile, the star, the fist holding a paintbrush, the spade, protest singers' guitars, miners and the ownership of Chile's copper resources. In the '70s BRP stuck mainly to primary colours, especially yellow and red; post-dictatorship, BRP palettes are much more varied, perhaps as a consequence of the anti-Pinochet 'NO' campaign's rainbow emblem. BRP maintain didactic conventions over the decades. Because embodying a progressive spirit, as a rule the action in BRP murals moves forwards from left to right, and faces in profile nearly always face right. BRP are admired by many street artists – especially Elodio, PeKa, PSF and Yisa. They help lend purpose to Chilean street art. BRP brigades are active at local level, and at a national level in the Huasco valley.

Below left: Communist Party HQ, Brasil Avenue, Chillán. The two broken guitars evoke Violeta Parra and Victor Jara.

Below: Communist Party HQ, Mendoza St, Los Ángeles. This detail of a 2007 mural shows, from top down, Allende's spectacles; workers with spade and pick; a Mapuche face and *cultrum* drum; and a revival of starry BRP lettering.

Right top: Lota, on the left the Communist Party HQ. The miner has something of the Indian mystic.

Right middle: At Freirina, Huasco Valley, by University of Valparaíso BRP. The river's weeping but strong-armed protector, and her dove, are threatened by the American eagle: plans for a gold mine up valley at Pascua-Lama are US-backed. The mural aims to help stop these plans, so left-to-right progression is here dropped.

Right bottom: General Ibañez del Campo Park, Arica. This is an example of rainbow-coloured post-1989 BRP mural. The placard just to the left of the passers-by remembers the *desaparecidos* who disappeared during the dictatorship.

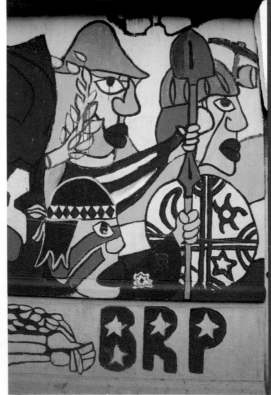

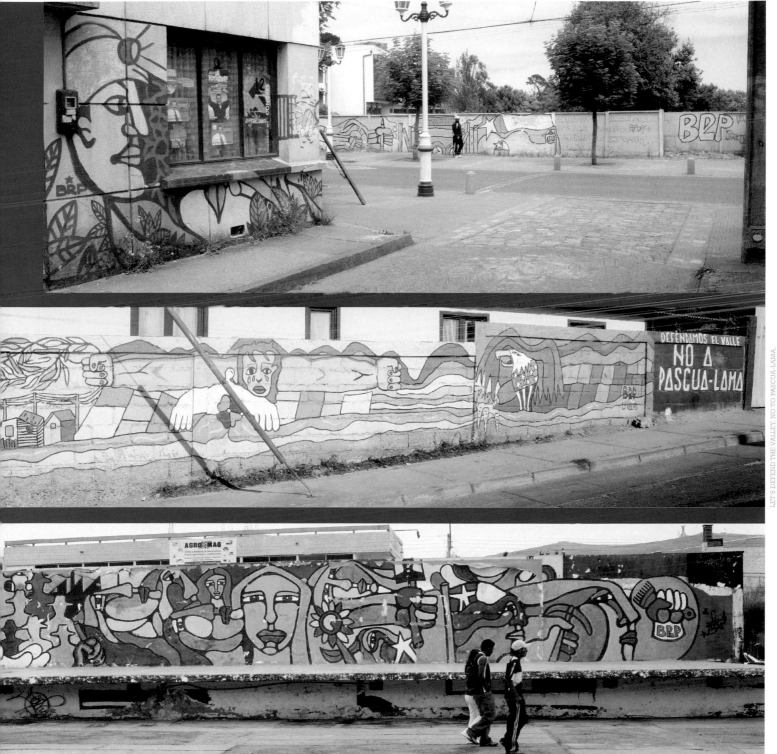

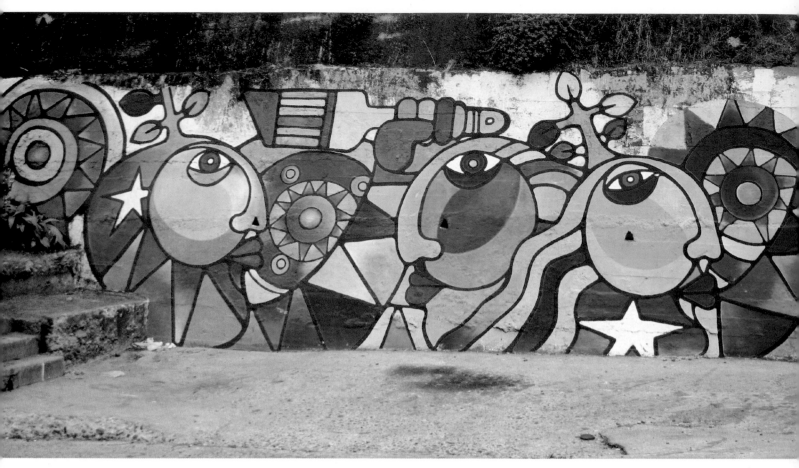

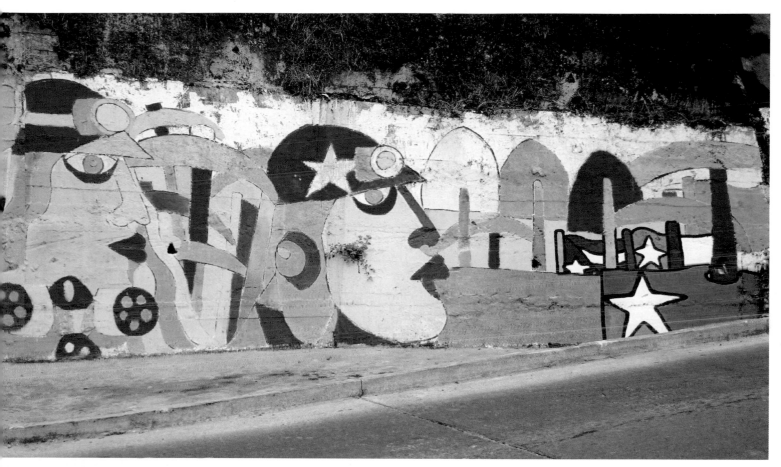

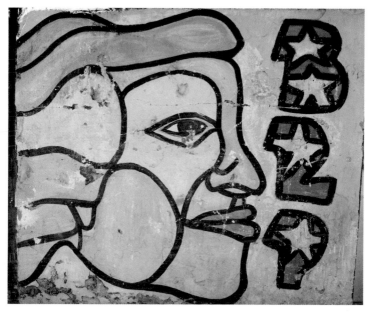

Above: The main road leading up to Monjas Hill, Valparaíso. The unfinished section reveals BRP's method of applying black outlines last, working from the edges in towards the centre. On the right, the Chilean flag in front of that of Cuba.

Far left: North bank of the River Mapocho, Santiago, between Recoleta and Patronato bridges. Gladys Marín (d. 2005) led Chile's Communist Party, and the campaign, still ongoing, to overturn laws introduced by Pinochet that exclude radical and indigenous groups from aspects of the political process.

Left: A bakery (*amasandería*) on the corner of Los Toros and Depilación Sts., La Florida, Santiago. This detail of the Los Toros wall shows a vintage BRP profile and logo.

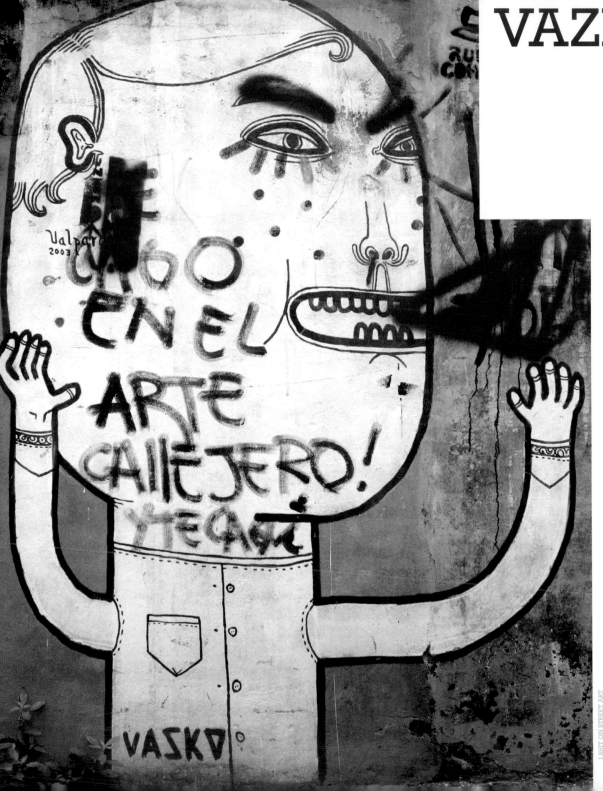

VAZKO

Vazko/Basco (José Riveros; Santiago 1984–) has painted in the street since, aged 14, he saw reproductions of Vitche's works. Vazko's earlier graffiti of huge-headed figures provoked hostile responses, and influenced Fis and Piguan. Basco's full-length figures are painted in latex – with a careful dexterity that resists others' superimpositions. Vazko's subjects often have stitches and tattoos: he himself had 200 stitches after being savaged by a dog as a child, and his best friend Gabriel is a tattooist. Based in Santiago, Vazko is also part of the *Paulista* scene: a rare non-Brazilian on the 'lost art' web page, and friends with Herbert. Basco considers Herbert's underwater pieces were 'the best graffiti ever', but Herbert's recent work too 'decorative'. Vazko's wetsuited figures are uncomfortably contorted. Vazko lived in the US for three years, and has exhibited in California, with Vitche, and solo. In New York, he responded less to 'overrated' Basquiat than to Rothko's scale, Motherwell's drips – and to New York punk. He quotes The Cramps line 'you ain't punk you punk' to explain his receptivity, from one moment to the next, to punk and to Reggaeton; to classic literature; to Miró; and to *High Heels*. Although a studio artist, Vazko paints outdoors every week and plans to go on doing so: because art in the street is 'pure' and 'uncensored'. Vazko finds 'disorganized' Chile most amenable to graffiti.

Far left: Alegre Hill, Valparaíso. In one of the alleyways above Fischer, the flat surface of the head of one of Vasko's early personages has attracted a crude response.
Below: S. Filomena St., Bellavista, Santiago.

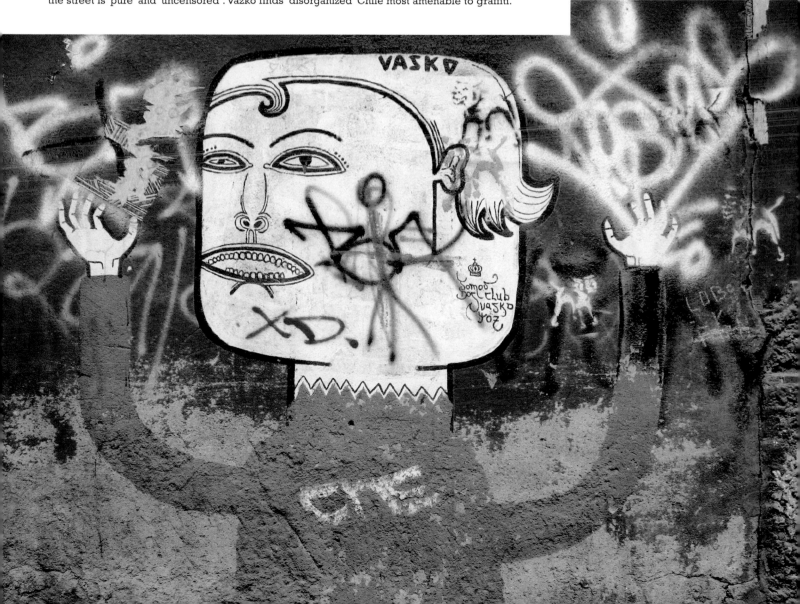

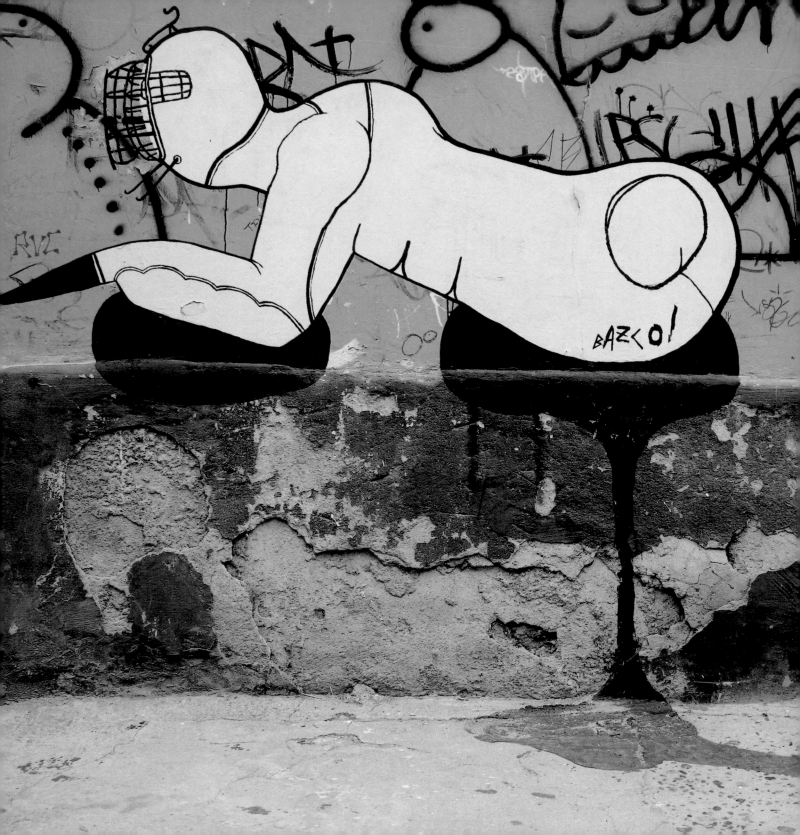

Tattoos: on hand 'LA MANO DE DIOS' (The hand of God); on shoulder 'LO FATAL' ('I am lethal)

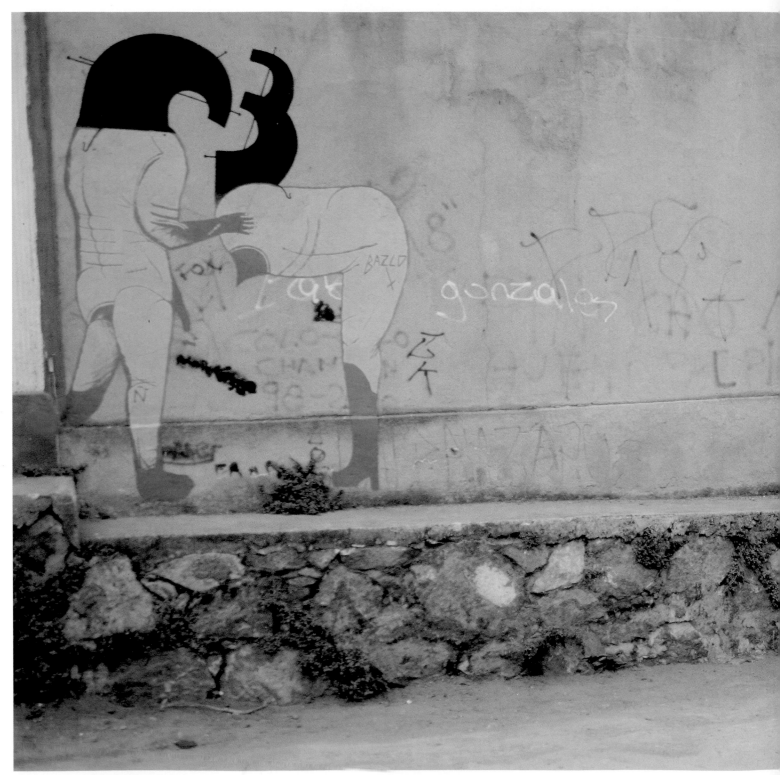

Below: Urriola St., Valparaíso. Head of a woman (the adjacent shop posts ads on this wall).
Left: Capilla St., Concepción Hill, Valparaíso. The amputated arm of the female hybrid has the tag of the Valparaíso-and-Santiago graffiti crew PRS (*Perrea Reggaetón para Siempre*: 'Reggaetón Dogdance for Ever'), this one by Pedro Lomboy.

Previous pages:
Left: Ex-Prison hill, Valparaíso. Vazko shows off his mastery of both outlined and drip techniques.
Middle: Painting on blocked door of 13 Dardignac St., Bellavista, Santiago. The tattooed texts refer to Diego Maradona, and to Rubén Darío's sonnet on the human condition, *Lo fatal* (*The inevitable*).
Right: Reina Victoria St., Valparaíso. Figure of a woman.

CHARQUI PUNK

Charqui Punk (Sebastian Navarro) lives in Valparaíso. 'Charqui' is a dried horse meat; the *chilenismo* verb *charquear* means 'to trash'. Charqui's epithet 'Punk' does not refer to punk music: Charqui is a hip hop DJ. Charqui's 'punk' signals his disdain for establishment values, especially those of the Catholic Church, which he resists with aloof insouciance – hence his cats. In the early 2000s, Charqui was, along with Vazko, one of the first Chilean artists to develop a *flop*-free cartoon style. In 2005–06, Charqui designed cat baseball caps and stickers, putting the latter on street signs. When adopting his other artistic persona of Kizio, Charqui looks towards cyber-punk animations. Charqui's art is well respected in Valparaíso. Many of the paintings here reproduced date back several years – a long time in the rapidly developing panorama of street art. Like Vazko's, Charqui interventions remain unerased for years, but in contrast to some of Vazko's, they remain untouched by subsequent antagonistic additions. Charqui has also worked in Lima and in the later 2000s spent periods working in Coyhaique and nearby Puerto Aisén. He is thus instrumental in connecting Chile's remote south with developments in Valparaíso, and thence elsewhere in South America.

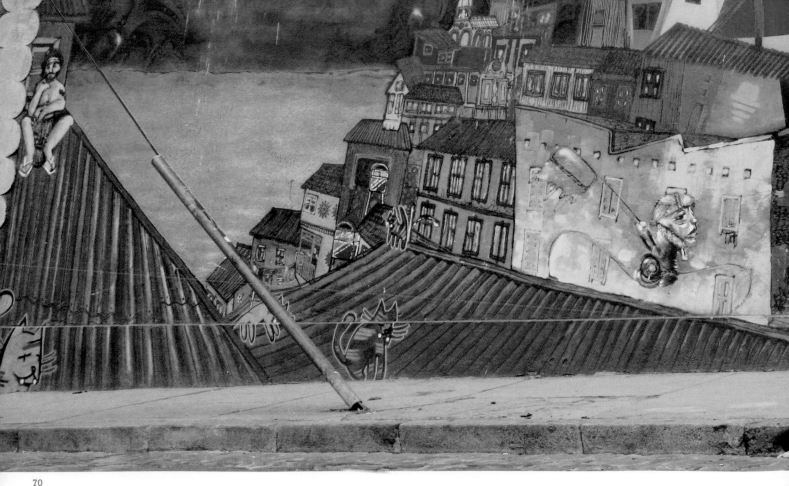

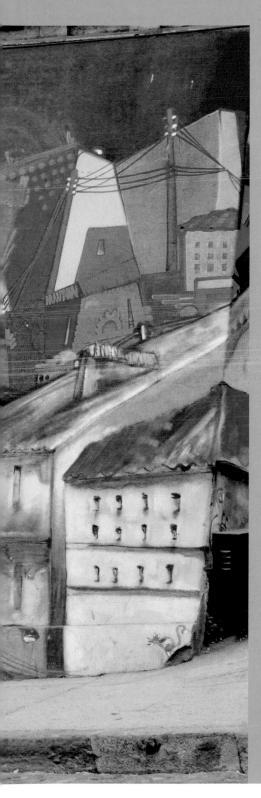

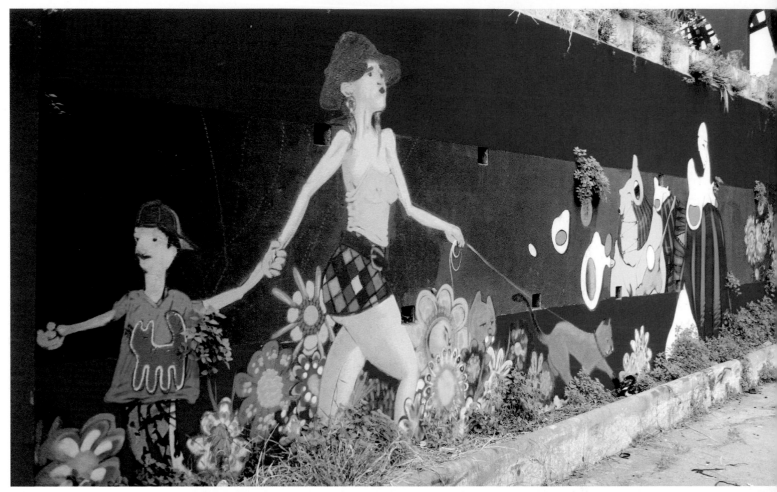

Previous page left: Urriola St., Valparaíso. A townscape with Charqui cats, by Inti and others.
Previous page right: Staircase on Monjas hill.
Above: 'The Ruins', ex-Prison hill, Valparaíso. A woman being led in one direction by her hip hop boy and in the other by her cat.
Right: Alemania Avenue. Cats by Charqui (as Kizio) stand either side of a PRS (*Perrea Reggaeton Siempre*) crew cat and tag (*see also p 69*).
Opposite page clockwise from top left: Charqui cats at 'The Ruins'; a cat above Fischer passage; a Charqui portrait on Alemania Avenue (the 'SW' [Santiago Wanderers] letters on his face fuse Iron Maiden and *pichaçao* alphabets).

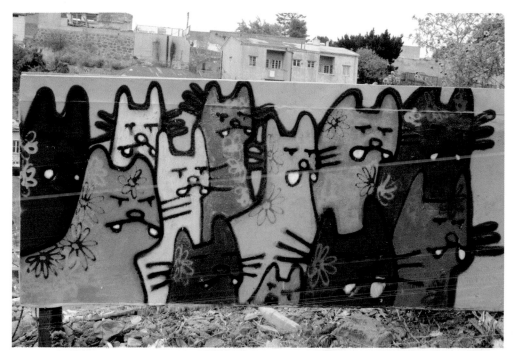

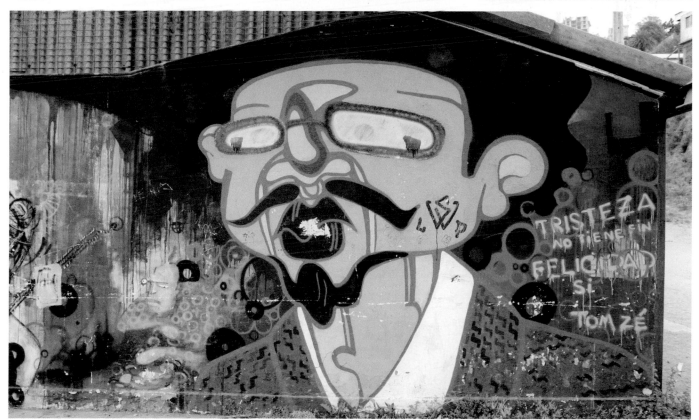

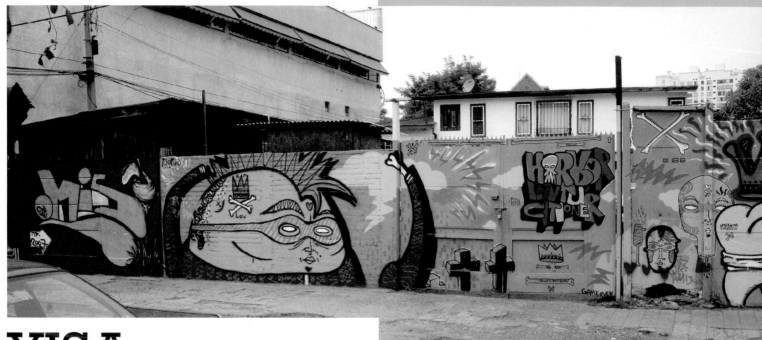

YISA

Yisa (José Cacahuate; Arica 1984–) works in Bellavista, Santiago, and has systematically 'bombed' his local area. In late 2007, he stayed with young art activist 'Mr Trafic' in the S. Isidro neighbourhood of central Santiago, where Yisa also left his mark. Yisa is candid about the paradoxes in his art. A Latin Americanist and, with Sergio Valenzuela, co-founder of 'Ekeko'. Yisa looks to Brazil for *pichaçao* (to Spanish Americans '*pinchazon*') lettering and to Oruro, Bolivia, for Carnival masks. Other Yisa masks are sourced from sex shops. Yisa applauds the schoolgirl 'Nati', whose web footage of her pleasuring her man became Chile's favourite download. Though not a Christian, Yisa likes crosses, and is a devotee of Latin America's protector, the Virgin of Guadalupe. Yisa is against US economic and cultural influence in Chile; hence the *gringismos* in his art, and the pyramids referring to those on dollar bills. But he uses crowns in an intentionally North American way, to boss his part of Bellavista. Yisa's diamond is a symbol of endurance; and his tooth one of universal suffering.

Above: S Filomena St., Bellavista, Santiago. '*Harder Lov Tour Citi One*' is a *gringismo*.
Right: S. Marin St., S. Isidro, Santiago. *Wena Nati* in progress. The lettering is *pichaçao*, but its *chilenismo* wording, '*WENA NATI*', just legible.

Following page left: S. Isidro St., Santiago. The stigmata and upside-down cross are both ambivalent.
Following page right: S. Isidro St., Santiago. Bolivia rules; and an *incoerencia* in *pichaçao* lettering.

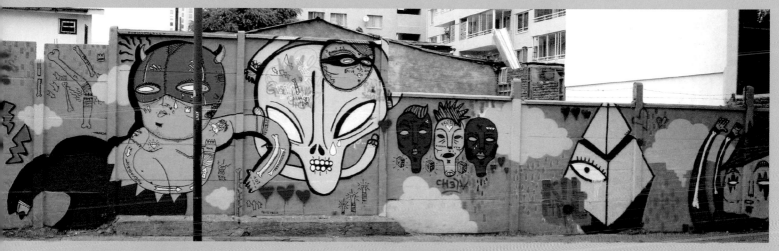

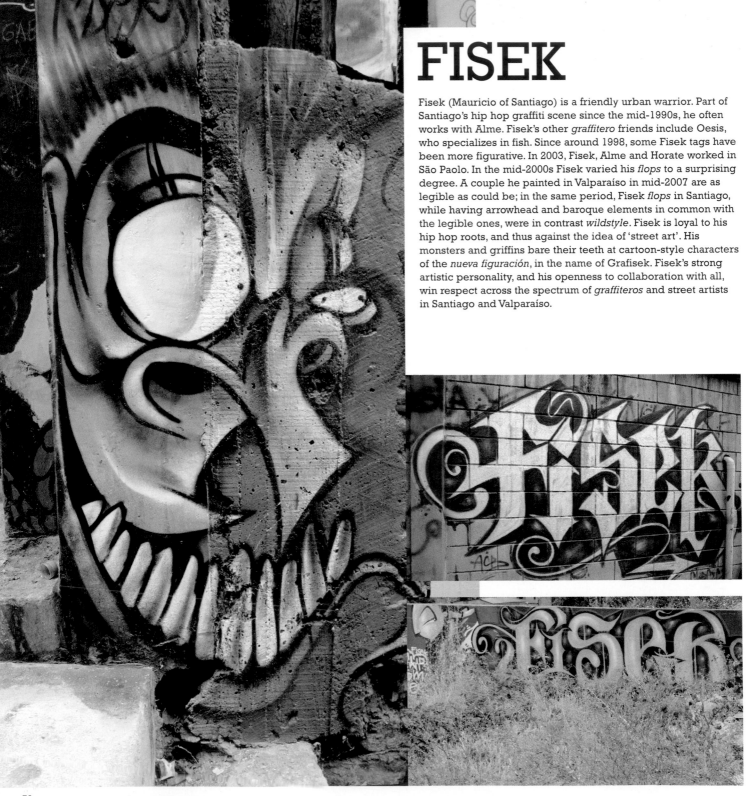

FISEK

Fisek (Mauricio of Santiago) is a friendly urban warrior. Part of Santiago's hip hop graffiti scene since the mid-1990s, he often works with Alme. Fisek's other *graffitero* friends include Oesis, who specializes in fish. Since around 1998, some Fisek tags have been more figurative. In 2003, Fisek, Alme and Horate worked in São Paolo. In the mid-2000s Fisek varied his *flops* to a surprising degree. A couple he painted in Valparaíso in mid-2007 are as legible as could be; in the same period, Fisek *flops* in Santiago, while having arrowhead and baroque elements in common with the legible ones, were in contrast *wildstyle*. Fisek is loyal to his hip hop roots, and thus against the idea of 'street art'. His monsters and griffins bare their teeth at cartoon-style characters of the *nueva figuración*, in the name of Grafisek. Fisek's strong artistic personality, and his openness to collaboration with all, win respect across the spectrum of *graffiteros* and street artists in Santiago and Valparaíso.

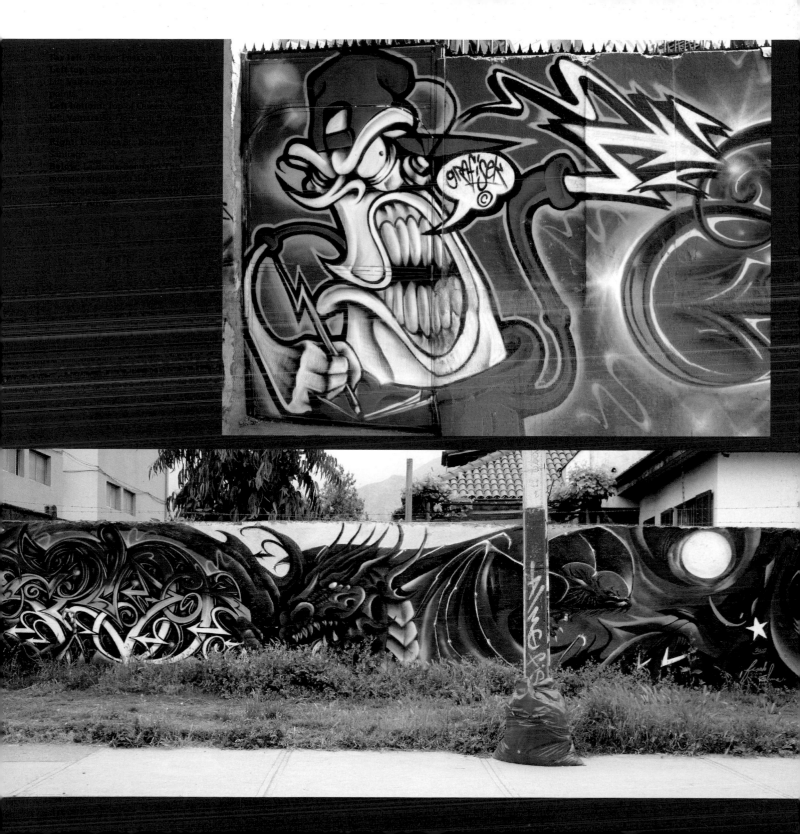

Below Right: Pedestrian foot tunnel, Los Carrera Avenue, Concepción.
Far right: Santo Tomás University, Padre Hurtado Avenue, Concepción. Gigi continues to paint such bare-breasted women.
Right: San Mauricio St. at Departamental Avenue, Santiago. *'EL MUNDO FELIZ DE ACB'.*

ACB

ACB (Andrea Cecilia Bernal; Viña del Mar 1981–Santiago 2006) painted graffiti for the second half of her life. She lived in New York for two years, and initially painted North American-style tags. In ACB's final years, her tags became ever more inventive and amusing, as she aimed her art towards children. By 2006 she coined her 'ACB's Happy World' (*El Mundo Feliz de ACB*) project. ACB's 'Happy World' offered, in her own words, 'a substitute for nature in grey urban areas' (*un sustituto de la naturaleza en grises zonas urbanas*).

ACB combined her love of animals, and enthusiasm for the uplifting potential of psychedelia, in her Alice-in-Wonderland white rabbits. Since Andrea died of cancer in November 2006, ACB's legacy continues in her surviving works; also through her many friends. Gigi develops imagery they initiated in tandem; Dana Pink and Pussyz Soul Food carry the baton of ACB's art for children. In 2007, ACB's tag often appeared on the streets of Santiago and Valparaíso, painted in memory of her by the circle of *graffiteros* around Fisek, and others for whom ACB lives on.

'*Mi arte es para los niños, expresa la felicidad a través de murales vibrantes de colores psicodélicos y de graffiti en los que participant personas de la comunidad, amigos y otros artistas. Quiero transmitir alegría y celebrar la vida y me gustaría que mi arte fuese un sustituto de la naturaleza en las grises zonas urbanas.*'

'My art is for children, expressing happiness through vibrant murals with psychedelic colours and graffiti, and involving people from the community, friends and other artists. I want to convey joy and celebrate life, and I'd like my art to act as a substitute for nature in grey city areas.'
ACB in Ganz *Graffiti Woman/Graffiti Mujer*, 2006, p. 20.

The Happy World of ACB

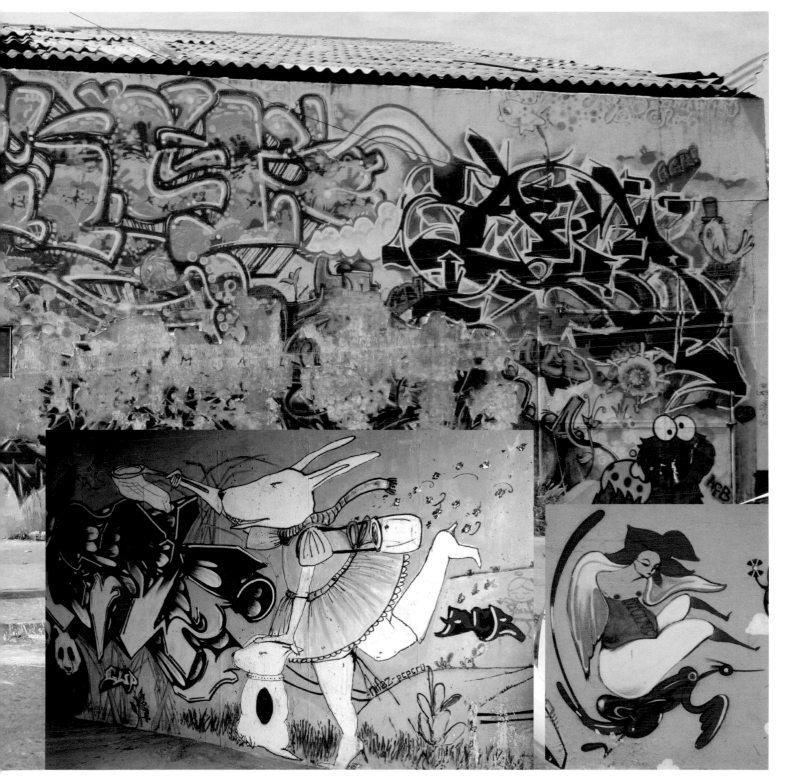

GIGI

Gigi (Marjorie Peñalillo; Valparaíso 1982–) studied painting and engraving at the Escuela de Bellas Artes, Viña del Mar. Gigi has painted alongside others, mainly in the streets of Valparaíso, since 2003; at the same time, she pursues a successful career as Marjorie Peñallilo (in late 2007 Marjorie had a solo exhibition of her engravings at the Fine Arts Museum in Viña). She is a good example of an artist who develops her individual style on her own, while testing and strengthening her art in collective paintings on walls. Gigi has collaborated mainly with other female artists, including ACB, Mona and Pussyz Soul Food (PSF). She also works with Inti of Viña – but in Valparaíso because Valpo is more hospitable to street art. Like Inti, Gigi handles spray cans with virtuoso skill. The motif of a woman with breasts bared over a corset was developed by ACB and Gigi in tandem. Gigi's imaginary bestiary of pink elephant, two-headed mythic cow, and so on, are her own distinctive response to the memory of ACB's 'Happy World', and to PSF's pursuit of art that appeals to children.

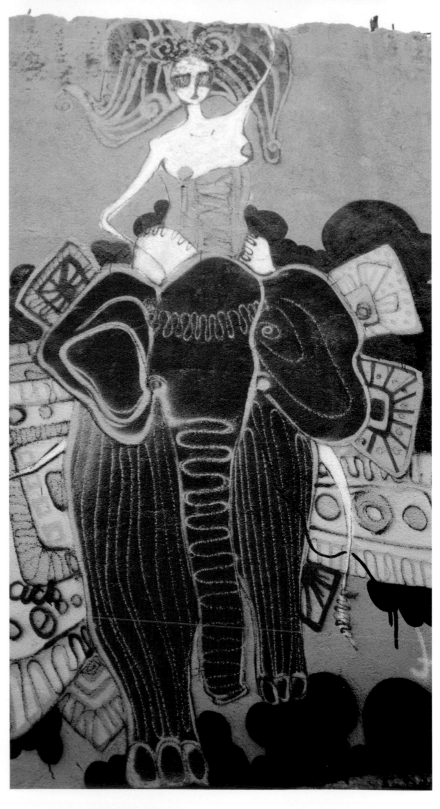

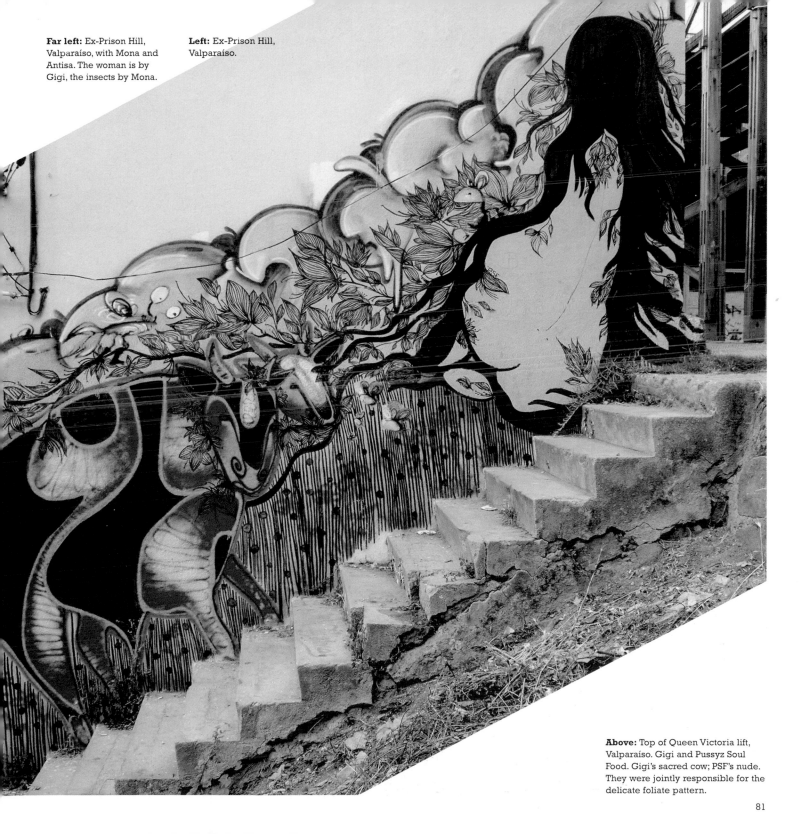

Far left: Ex-Prison Hill, Valparaíso, with Mona and Antisa. The woman is by Gigi, the insects by Mona.

Left: Ex-Prison Hill, Valparaíso.

Above: Top of Queen Victoria lift, Valparaíso. Gigi and Pussyz Soul Food. Gigi's sacred cow; PSF's nude. They were jointly responsible for the delicate foliate pattern.

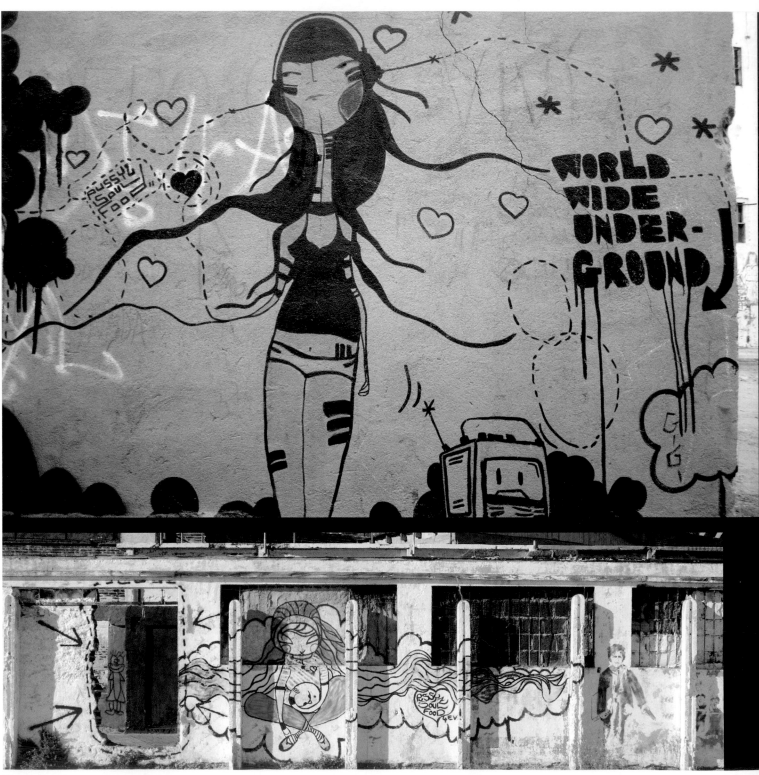

PUSSYZ SOUL FOOD

Pussyz Soul Food (Paulina 'Pau' Quintana Jornet; Santiago 1982–), studied art at FHTW (Fachhoschschule für Technik und Wirtschaft) University, Berlin, and has made street art since 2003. Pau laughs off any misconception of her 'Pussy' name: her feminine art is aimed at children. In 2006, PSF joined ACB and others at a street art encounter in Concepción. PSF now spends most of her time in Chile, and also travels elsewhere in Latin America, frequently to Peru. In Chile, she works mainly in Santiago and Valparaíso. She often collaborates with Gigi, also with Fisek, 25 Crew and others. Like Gigi and Inti, PSF is a painter with a strong identity of her own, who enriches her art through collective experience: she responds to other people's art contributions to walls. PSF has a worldwide vision of street art, and launched her *Miraquí* ('Look here') project at 'Espacio G', Valparaíso, in March 2007.

Far left top: Ex-Prison, Valparaíso. One of PSF's girls alongside a pink elephant by Gigi (*see p. 80*).
Far left bottom: Ex-Prison, Valparaíso. PSF's meditative girl on the same wall as a more troubled child.
Above: Melgarejo Passage, Valparaíso. PSF joins in graffiti.
Left: The Maestranza railway yard, Valparaíso. In the company of 25 Crew, a PSF girl takes to her skateboard.

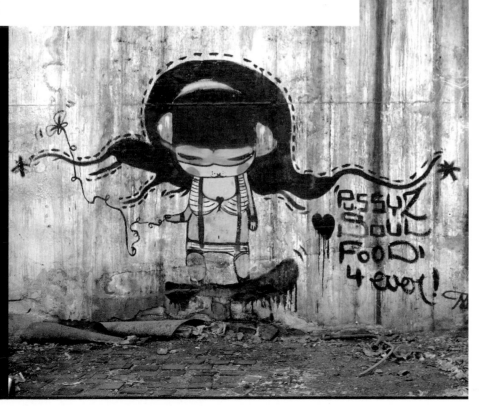

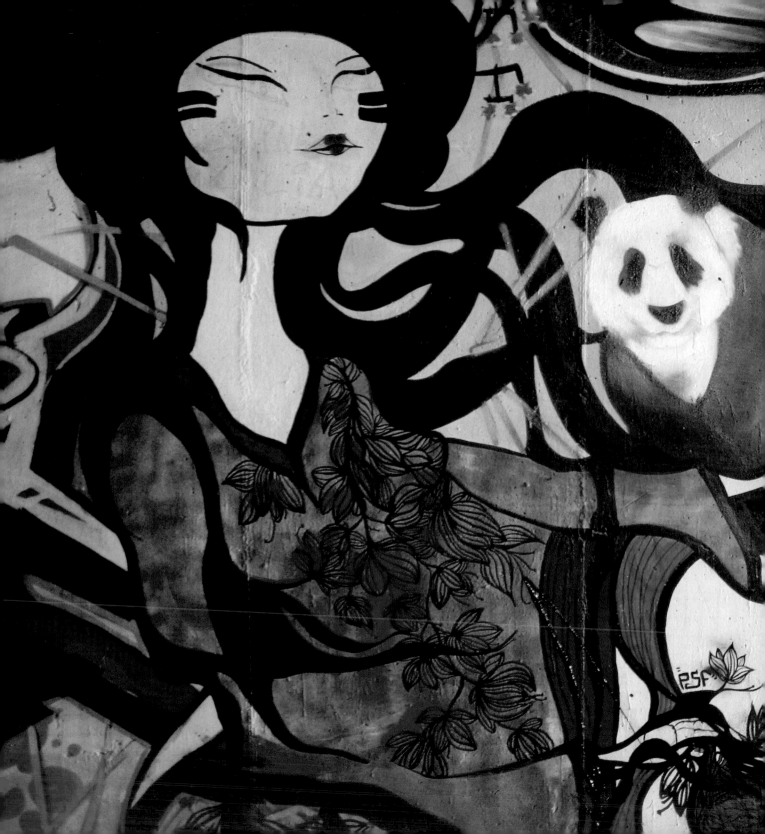

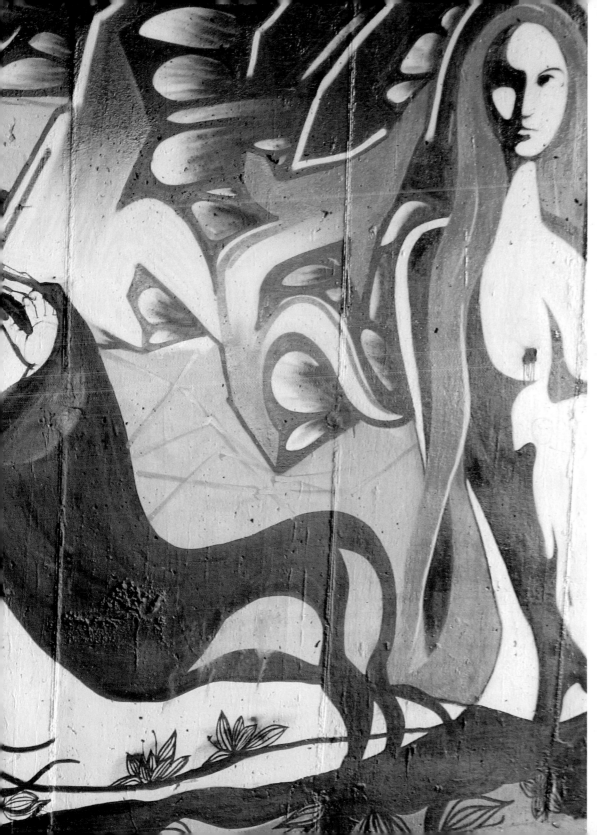

Left: Pedestrian tunnel, Los Carrera Avenue, Concepción. An earlier and less infantile PSF. The freestyle abstract forms are Antisa's, the panda is by ACB.

MONA

Mona (Marcela) shares a room in Santiago with innumerable spray cans. She studied painting at the University of Chile. There she met Ha Crew, whom she joined in 2003. Mona soon realized that painting in the street was for her. She usually collaborates, partly for safety reasons, but mainly because 'painting with others … is what I like most' (*pintar con los demás … es lo que más me gusta*). Mona's insects, which are now part of the townscapes of Santiago and Concepción, work well interspersed with others' work. The hallucinatory effect of huge insects in urban settings is accentuated when they inhabit *flops* or psychedelic landscapes. Mona achieves subtle light effects, especially transparent wings, not normally associated with the spray can.

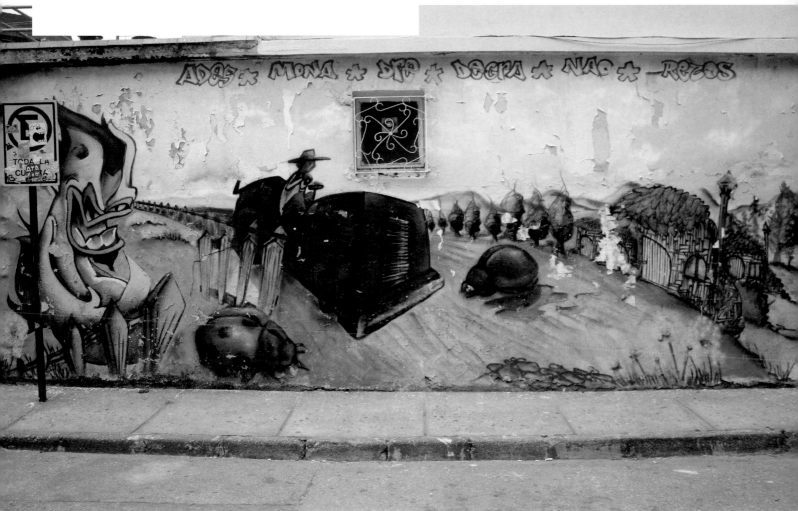

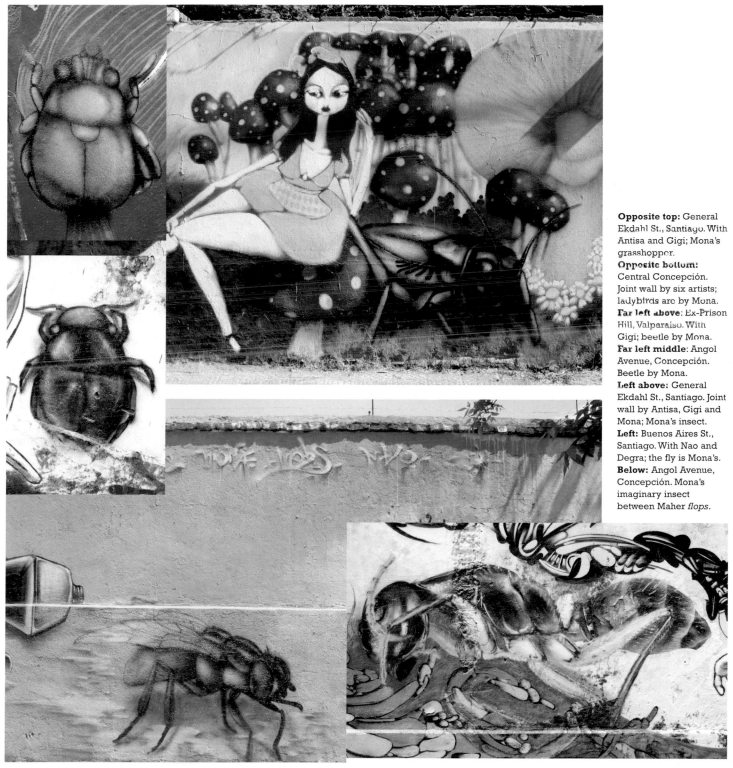

Opposite top: General Ekdahl St., Santiago. With Antisa and Gigi; Mona's grasshopper.

Opposite bottom: Central Concepción. Joint wall by six artists; ladybirds are by Mona.

Far left above: Ex-Prison Hill, Valparaíso. With Gigi; beetle by Mona.

Far left middle: Angol Avenue, Concepción. Beetle by Mona.

Left above: General Ekdahl St., Santiago. Joint wall by Antisa, Gigi and Mona; Mona's insect.

Left: Buenos Aires St., Santiago. With Nao and Degra; the fly is Mona's.

Below: Angol Avenue, Concepción. Mona's imaginary insect between Maher *flops*.

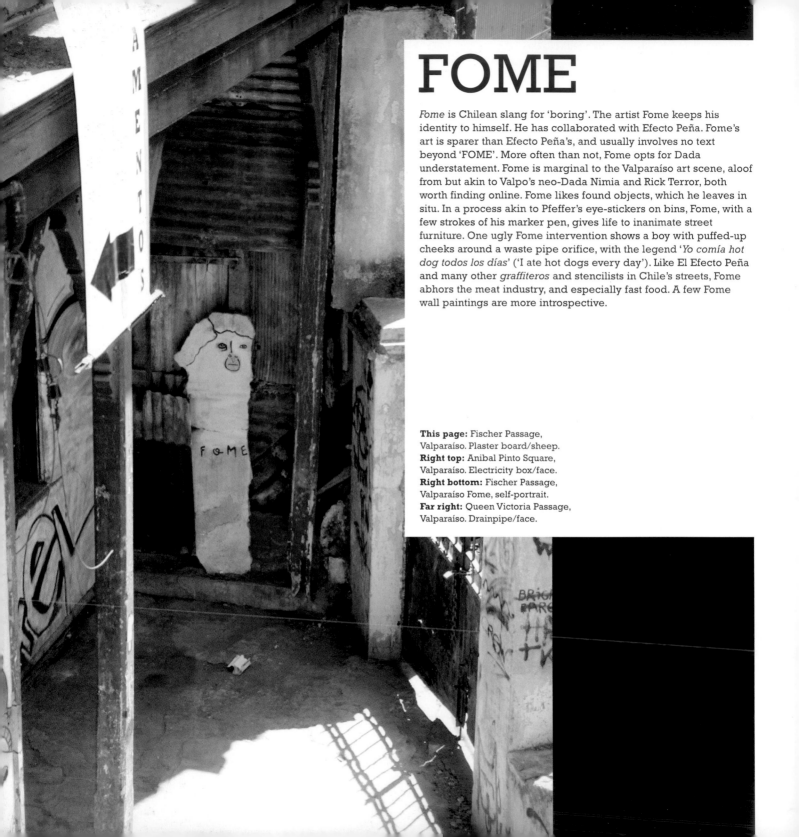

FOME

Fome is Chilean slang for 'boring'. The artist Fome keeps his identity to himself. He has collaborated with Efecto Peña. Fome's art is sparer than Efecto Peña's, and usually involves no text beyond 'FOME'. More often than not, Fome opts for Dada understatement. Fome is marginal to the Valparaíso art scene, aloof from but akin to Valpo's neo-Dada Nimia and Rick Terror, both worth finding online. Fome likes found objects, which he leaves in situ. In a process akin to Pfeffer's eye-stickers on bins, Fome, with a few strokes of his marker pen, gives life to inanimate street furniture. One ugly Fome intervention shows a boy with puffed-up cheeks around a waste pipe orifice, with the legend '*Yo comía hot dog todos los días*' ('I ate hot dogs every day'). Like El Efecto Peña and many other *graffiteros* and stencilists in Chile's streets, Fome abhors the meat industry, and especially fast food. A few Fome wall paintings are more introspective.

This page: Fischer Passage, Valparaíso. Plaster board/sheep.
Right top: Anibal Pinto Square, Valparaíso. Electricity box/face.
Right bottom: Fischer Passage, Valparaíso Fome, self-portrait.
Far right: Queen Victoria Passage, Valparaíso. Drainpipe/face.

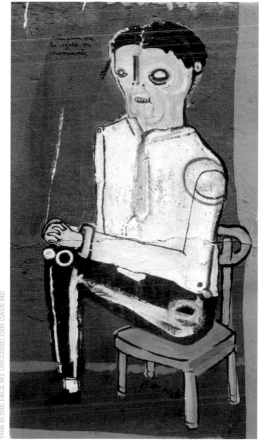

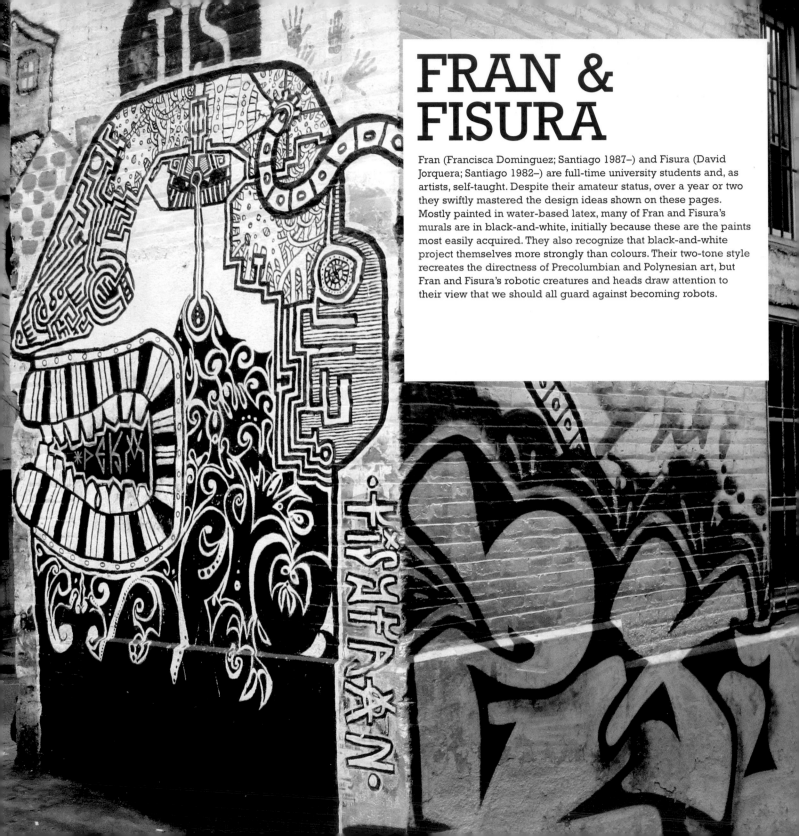

FRAN & FISURA

Fran (Francisca Dominguez; Santiago 1987–) and Fisura (David Jorquera; Santiago 1982–) are full-time university students and, as artists, self-taught. Despite their amateur status, over a year or two they swiftly mastered the design ideas shown on these pages. Mostly painted in water-based latex, many of Fran and Fisura's murals are in black-and-white, initially because these are the paints most easily acquired. They also recognize that black-and-white project themselves more strongly than colours. Their two-tone style recreates the directness of Precolumbian and Polynesian art, but Fran and Fisura's robotic creatures and heads draw attention to their view that we should all guard against becoming robots.

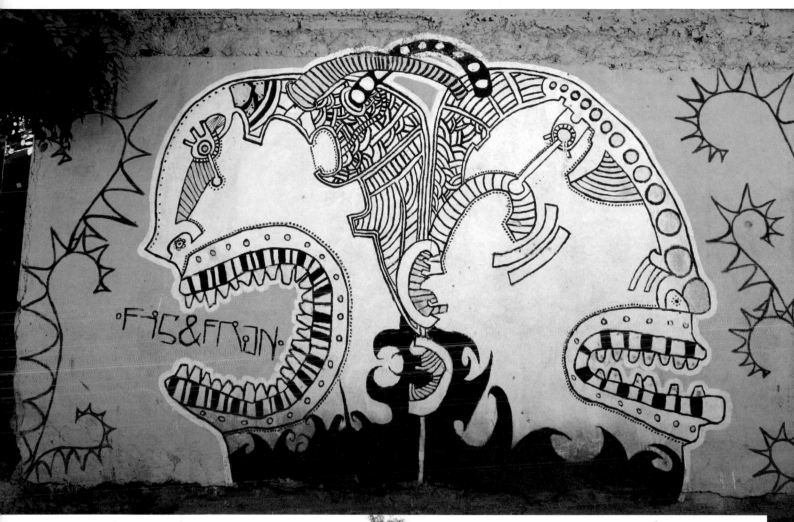

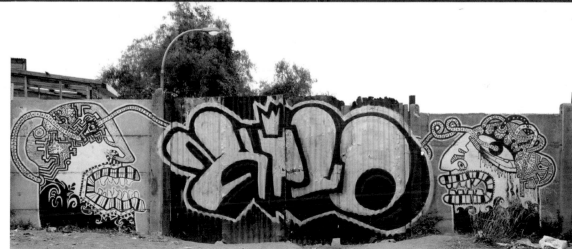

Far left: On a prominent wall at the bottom of Admiral Montt Avenue, Fis and Fran have overpainted an International Socialist Youth (Juventud Internacional Socialista, JIS) mural.
Above: A very early Fis and Fran work in La Florida, Santiago.
Right: A wall and corrugated iron gateway opposite the entrance to the ex-Prison, Valparaíso. Fis and Fran intended to connect the two heads at left and right, but the intervening space was bombed by a hip hop crew opposed to figurative street art.

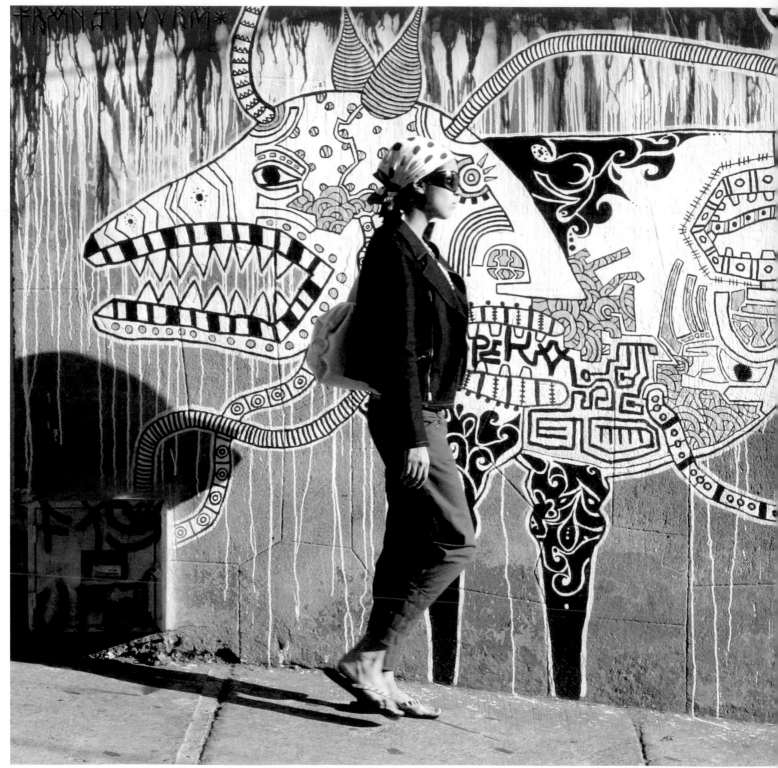

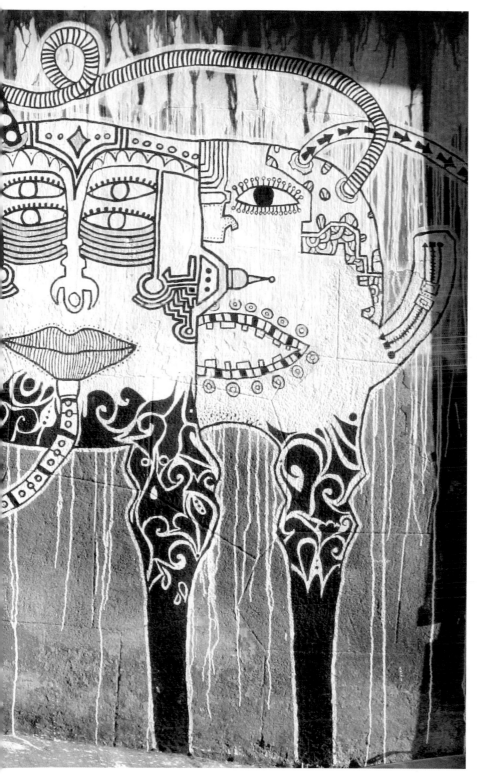

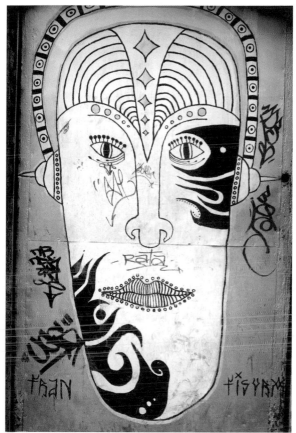

Above: Reina Victoria St., Valparaíso. This Polynesian headphone wearer sums up the range of Fran and Fis's enthusiasms. Fran was responsible for the whirling pattern on this face, as also on the legs, belly and shoulder of the animal to the left.

Left: Montt Avenue, Valparaíso. Here Fis and Fran brought together their self-professed engagement with Picasso, and with Polynesian and Precolumbian art. With technical forethought, they allowed white latex paint to drip, and then painted their creature's clean white outline over it. The mesmerizing four-eyed face towards the right recalls some of Piguan's. In Fis and Fran's case multiple eyes have to do with their sensitivity towards their viewers, whence also stems the idea of PeKa incorporated into this work and the first image in this section (*see also PeKa spreads*).

PEKA CREW

Fran and Fis became PeKa in 2006, until their break-up in mid-2007. PeKa is an acronym for 'Paranoia Kritika'. In vernacular South American the letter 'K', because alien to Castilian Spanish, has displaced 'C' and 'Qu', initially in the words *Inka* and *anarkist*, and thence in anarchic visual statements such as, in Santiago, '*KIEN* [for Quien] *RULA*', or 'Who rules'. Fran and Fis refer their paranoid feeling of being watched to Salvador Dalí, whose mercenary individualism, however, they reject. PeKa's paranoia of being interrupted by the authorities, and dialogue with their audience, echoes the earlier experiences of the brigades. Paranoia is also a theme of street art worldwide, for instance in the Swiss sticker artist jul 33's slogan 'everything is true, be paranoiac'. PeKa's paranoia often led to one of them (usually Fran) keeping *guardia* as the other painted. The personages PeKa have given to Chilean walls are themselves vigilant sentinels.

In 2007, PeKa made lively and informal interpretations of mosaic techniques pioneered in Chilean street art by their fellow *santiguenos* Grin and Nicole (*see p. 20*), and incorporated tesserae of glass into their works so that passers-by are reflected and involved in their paintings.

Below: La Florida Avenue. 'Kachemaiten' was the nickname of Fis' great-grandfather, who was caught having sex (*echandose una cacha*) up a 'maiten' (*Maytenus magellanica*) tree.
Right top: Fis and Fran's first work as PeKa, in La Florida Santiago.
Right bottom: Melgarejo Passage, Valparaíso. A PeKa personage vomits a Picassoid bull's head and other PeKa fragments.

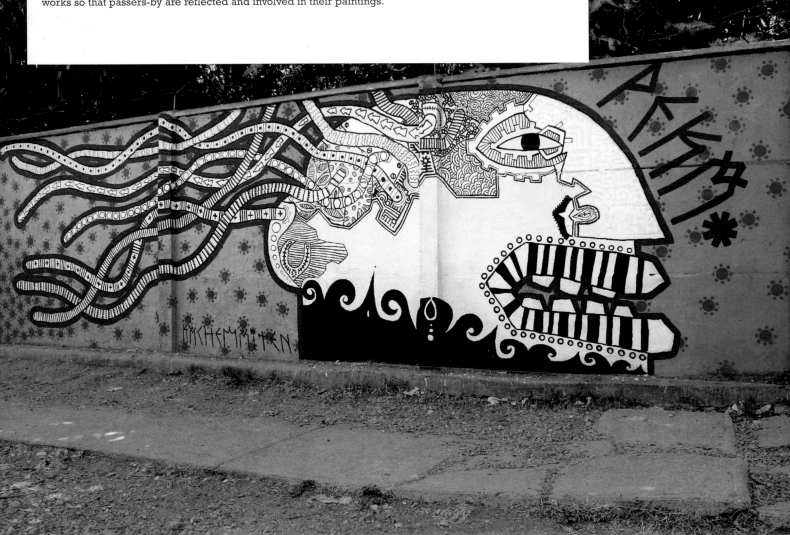

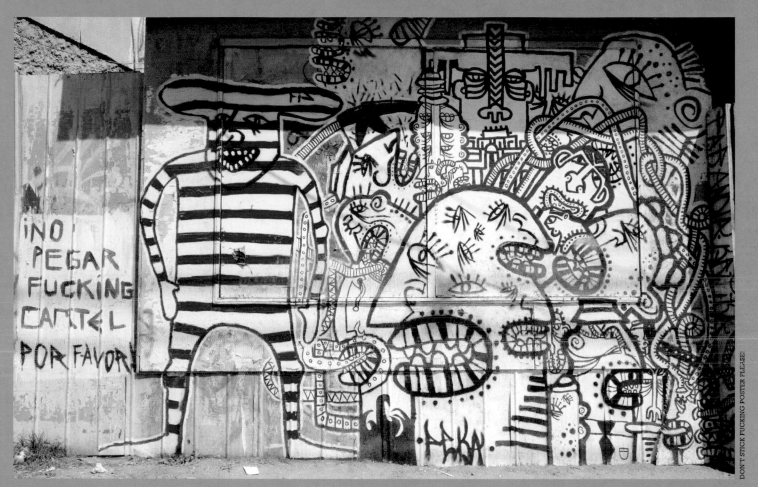

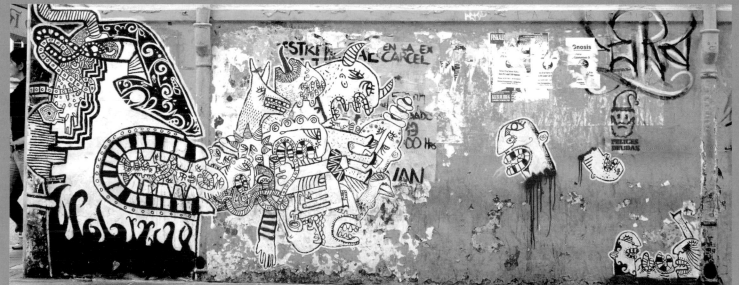

95

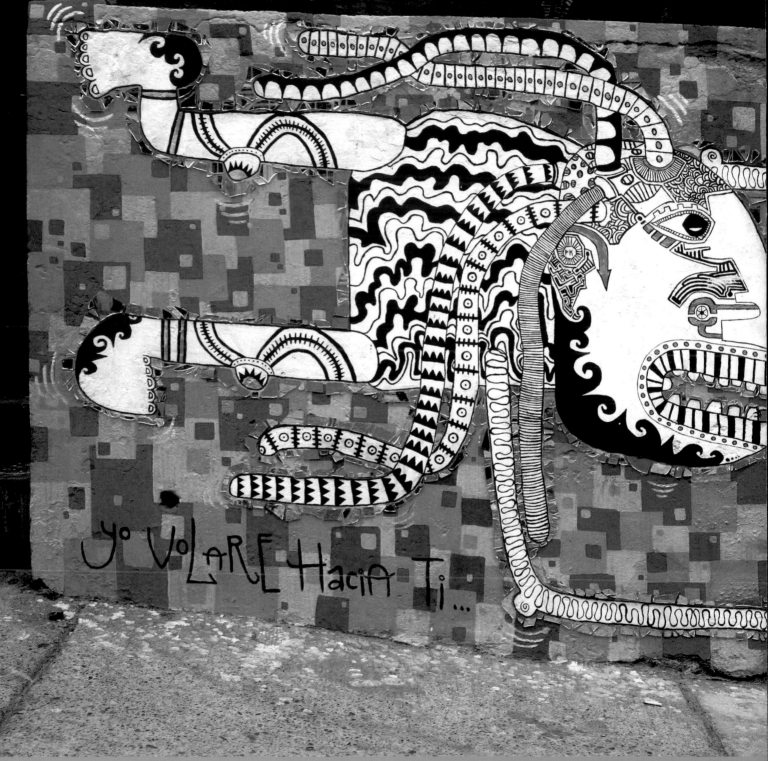

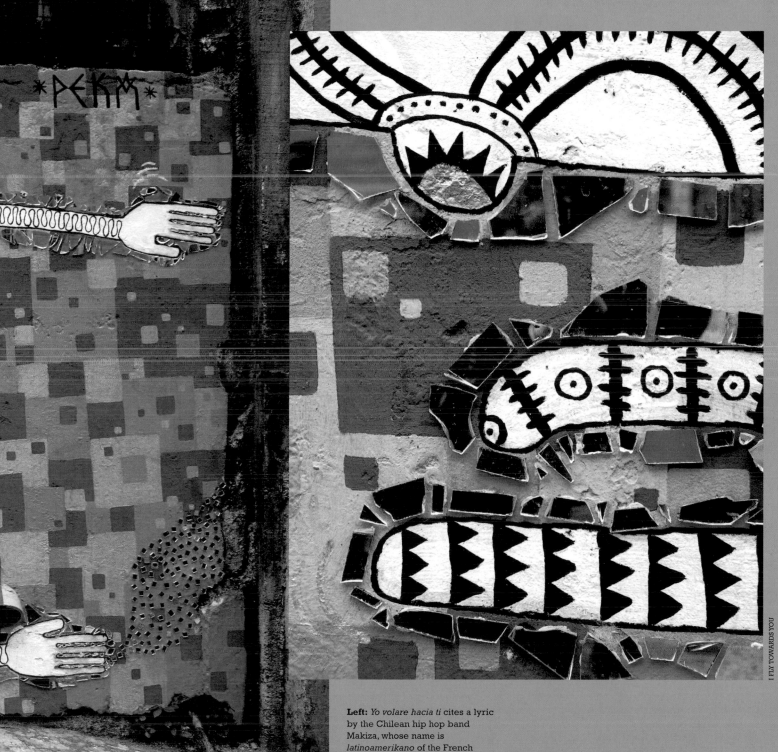

Left: *Yo volare hacia ti* cites a lyric by the Chilean hip hop band Makiza, whose name is *latinoamerikano* of the French *maquisard*, meaning guerrilla.
Above: Detail of broken glass over latex and aluminium paints.

I FLY TOWARDS YOU

97

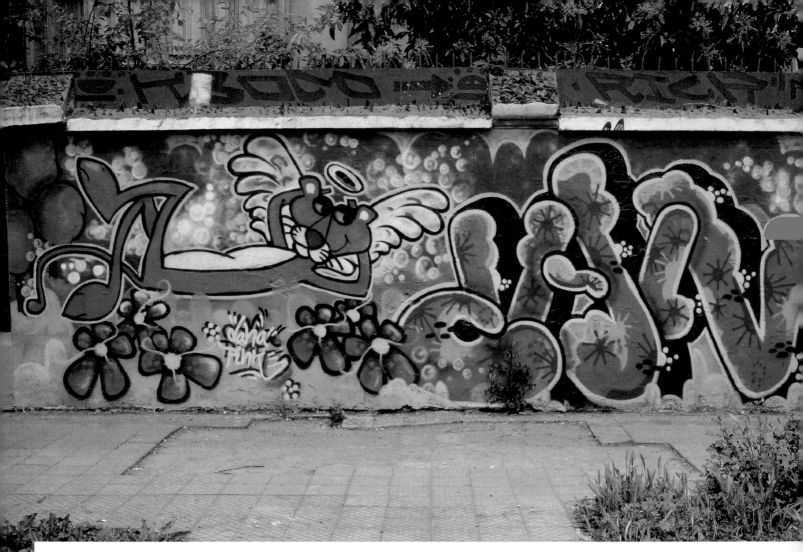

DANA PINK

Dana Pink is a schoolteacher in Santiago, where she paints mainly in Bellavista. She also often paints in Valparaíso. Her art is principally for children. Dana's a Pink Panther fan, and sometimes puts his halo above the first 'A' in her tag. Some works are attuned to her more rebellious pupils' preference for TV programmes such as *The Garbage Pail Kids*, known in Chile as *Las Basuritas*. The constant in Dana Pink's' murals is her very Chilean love of flowers; in Dana's world all flowers are pink.

Above: Andrea López de Bello St., Bellavista, Santiago.
Right above: S Filomena St., Bellavista, Santiago. Heroestencil landed on this wall second.
Right below: Montt Passage, Valparaíso. A slightly darker work.

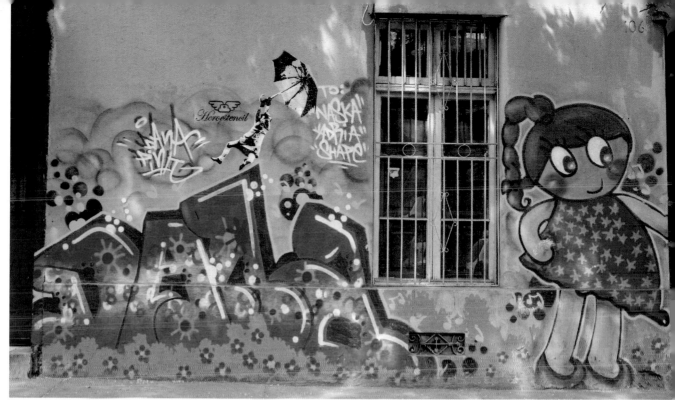
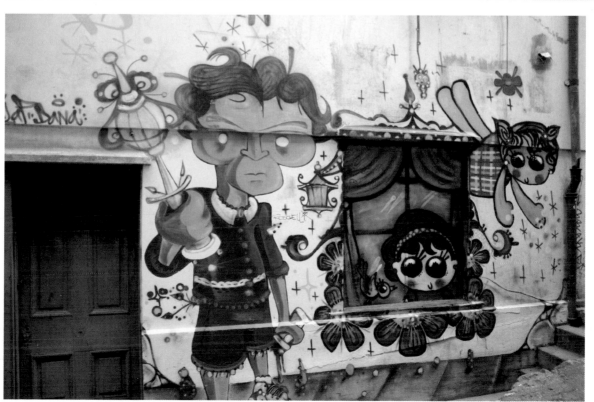

BOMBER WEST

West (Rancagua 1988) is an oddball. A Latin native of Valparaíso, in art he uses an Anglo name. West has thoroughly bombed Alemania Avenue, and parts of Playa Ancha (Wide Beach), the big peninsula on the other side of town. West's running joke of ginger-haired male characters, who bear no resemblance to him, seems random, but West has maintained it with such tenacity that it has an internal logic. West's earlier *flops* are hip hop tags at first glance, but on second look surprisingly figurative. West incorporates ever more stencils into his spray can paintings, and in the second half of 2007 collaborated with the stencil artist Innova. West's work runs implacably against the tide of other Chilean *graffiteros*' moderation of aggressive hip hop chauvinism. While looking to the US, West's art is distinctly Chilean. West incorporates some North American hip hop words into his paintings; but 'YEAH' is not one of these. In one of West's favourite stencils, '*Valpo la yeah*', '*yeah*' is a *chilenismo* for '*lleva*', literally 'carries', metaphorically 'rules'.

Below: Towards the top of Bellavista Hill, Valparaíso, between Pablo Neruda's La Sebastiana and the Open Sky Museum. An early West piece. The small human figures among big letters exemplify 'Latinamericanly baroque' dislocation of scale.

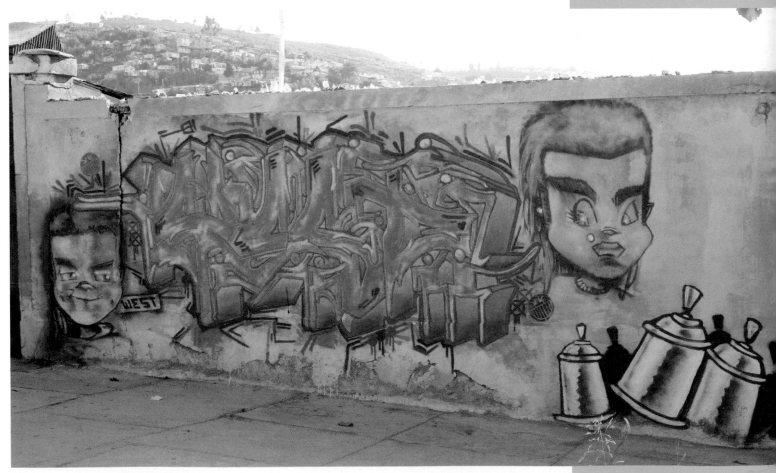

Right: A corner of the block occupied by Valparaíso secondary school. West's professor character teaches his student some North American terms. West likes '*BONCH*' because it half-rhymes with and means the same as the *chilenismo* '*concha de tu madre*' ('your mother's sea-shell').

Below: Alemania Avenue, Valparaíso. Chilean table manners are generally excellent. Hence, some Chileans laugh at *a lo chancho* (piggish) greediness. This dish drips ecstasy pills.

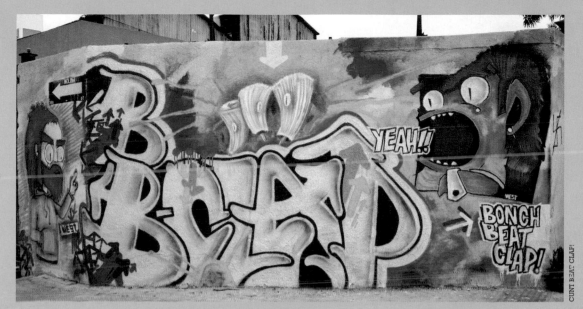

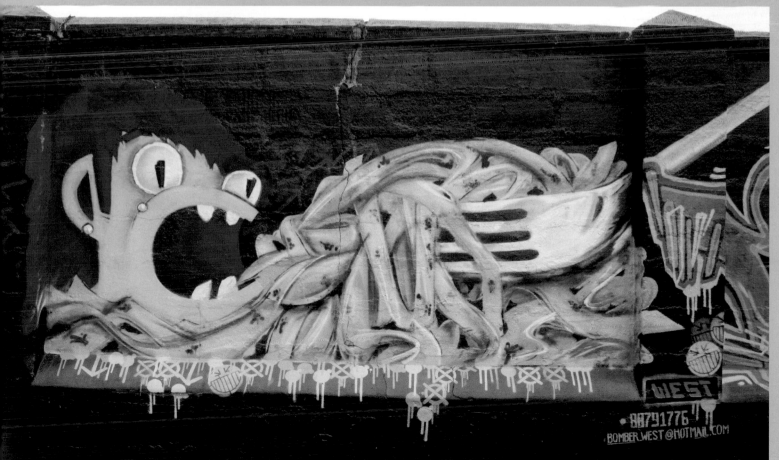

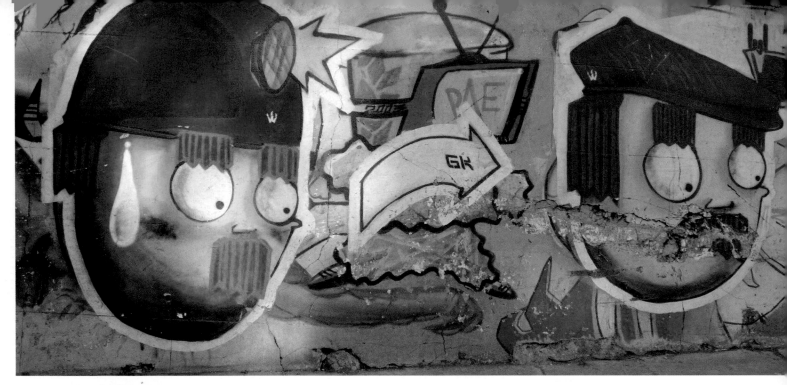

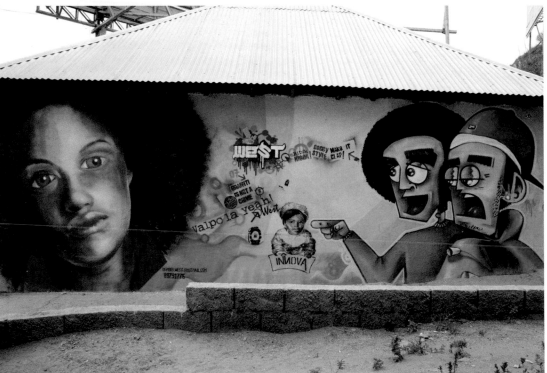

Above: West's ginger character sweating in a miner's hat, and in a townie flat hat.

Left: Portales metro station, Valparaíso. The stencil of a girl is by Innova.

Right top: A street in Playa Ancha. West's ginger bloke in sailor's uniform. Both *flops* on this wall are West's; the right hand one emerges from a printer.

Right bottom: Also in Playa Ancha, the psychedelic toadstools provide the key to West's tag.

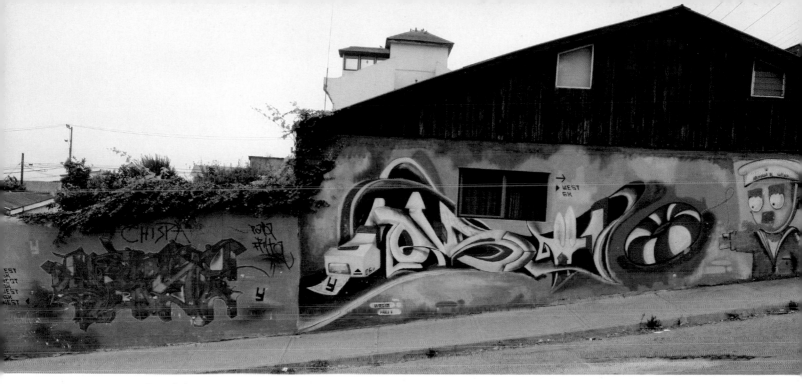

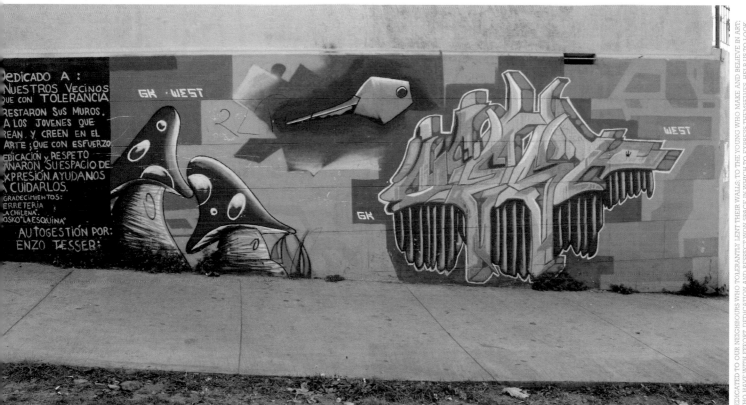

DEDICATED TO OUR NEIGHBOURS WHO TOLERANTLY LENT THEIR WALLS; TO THE YOUNG WHO MAKE AND BELIEVE IN ART; WHO HAVE WITH EFFORT, DEDICATION AND RESPECT WON SPACE IN WHICH TO EXPRESS THEMSELVES. HELP US TO LOOK AFTER THEM. THANKS TO 'LA CHILENA' IRONMONGERY AND 'THE CORNER KIOSK. INITIATIVE OF: ENZO TESSER.

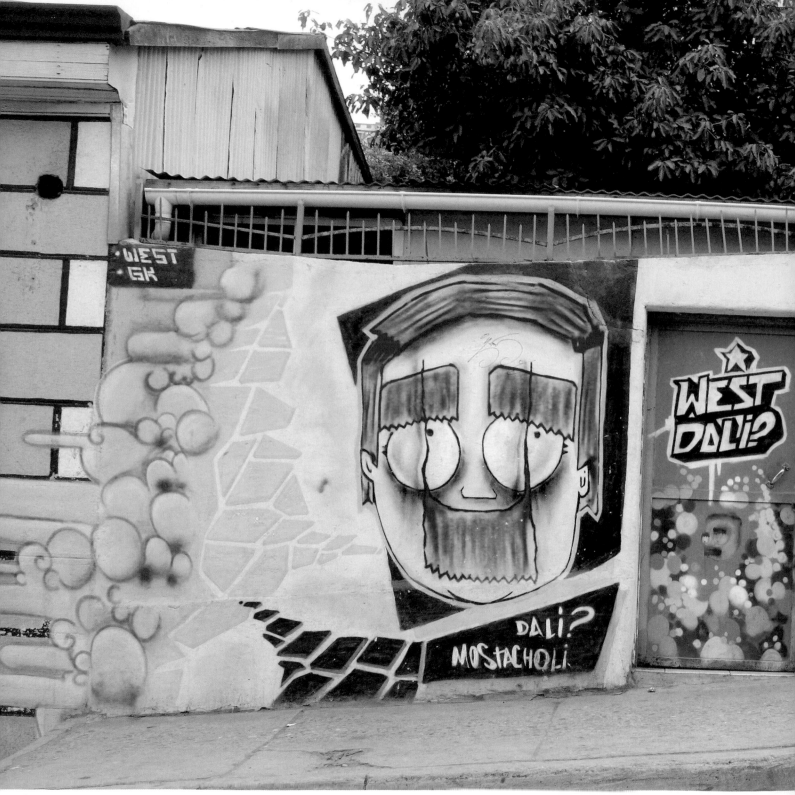

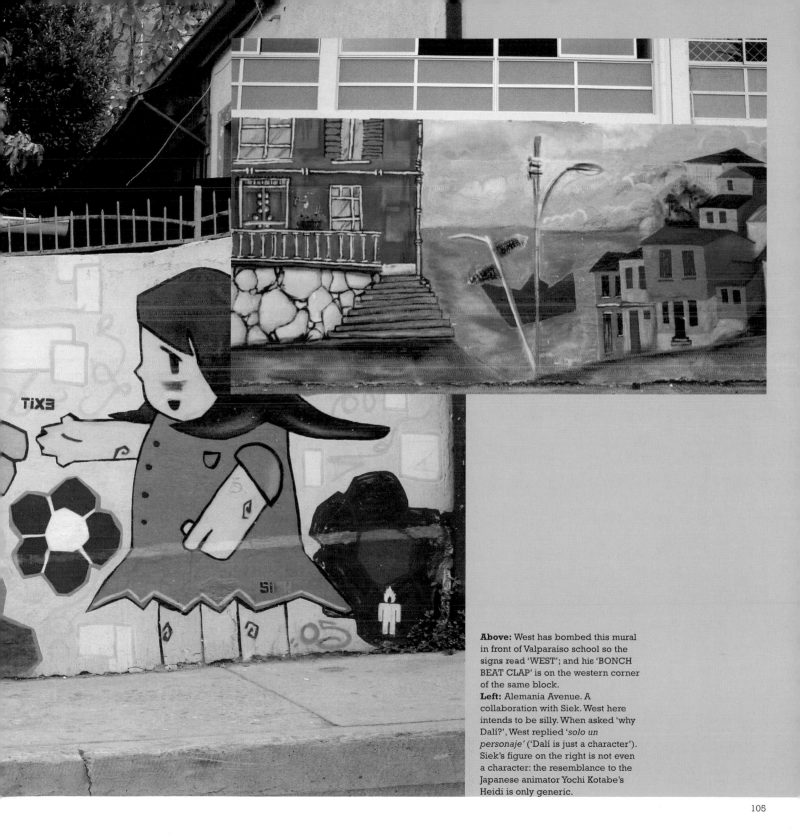

Above: West has bombed this mural in front of Valparaíso school so the signs read 'WEST'; and his 'BONCH BEAT CLAP' is on the western corner of the same block.

Left: Alemania Avenue. A collaboration with Siek. West here intends to be silly. When asked 'why Dalí?', West replied *'solo un personaje'* ('Dalí is just a character'). Siek's figure on the right is not even a character: the resemblance to the Japanese animator Yochi Kotabe's Heidi is only generic.

INTI

Inti is Quechua for the Sun. Inti (Inti Castro) lives on Viña del Mar's upmarket Castillo Hill. Inti Castro is a professional painter who exhibits his near-abstract works in Santiago and Viña. On the streets of Valparaíso, Inti's hairless albino mutants, sometimes combined with bamboo-like vegetation, create a sur-real distopia. He paints in collaboration, over the years with Charqui Punk, latterly with Gigi, and with many others. Inti adjusts his albino leitmotif in accordance with each respective fellow artist. He was in the first wave of those who in the early 2000s intervened uninvited at the Open Sky Museum in Valparaíso. Inti's albinos range in mood between gross-out, the melancholia of Picasso's blue style, primitivist liveliness and touching compassion (*see p. 6*). The anatomies of Inti's albinos show his familiarity with, among others, Francis Bacon. Inti lends weirdness to the streets of Valparaíso, Concepción and Santiago.

Below: 'The Ruins', ex-Prison Hill, Valparaíso. Abstract planes are incorporated into these mutant anatomies. The bodices demonstrate Inti's close control of the spray can and, in the zigzags at bottom right, enjoyment of its looser painterly potential.
Right: Open Sky Museum, Valparaíso. Inti's grotesque woman stands out from others' *flops*.

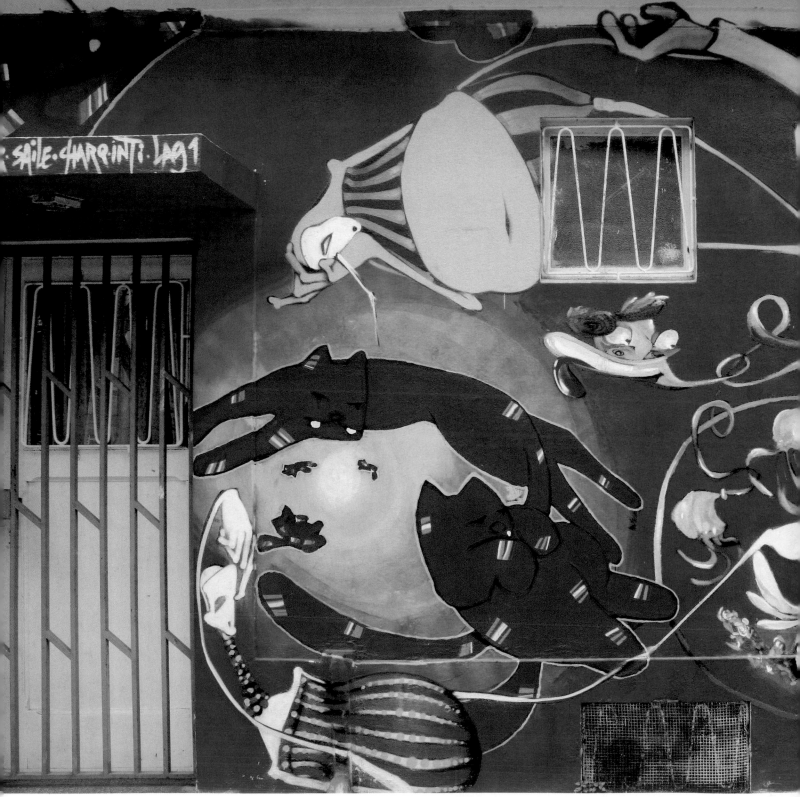

Left: With Charqui above the Queen Victoria lift on Concepción Hill, Valparaíso.
Above: Alemania Avenue, Valparaíso. Inti's tragic albino plays a stringless guitar board the same shape as its distended legless abdomen.

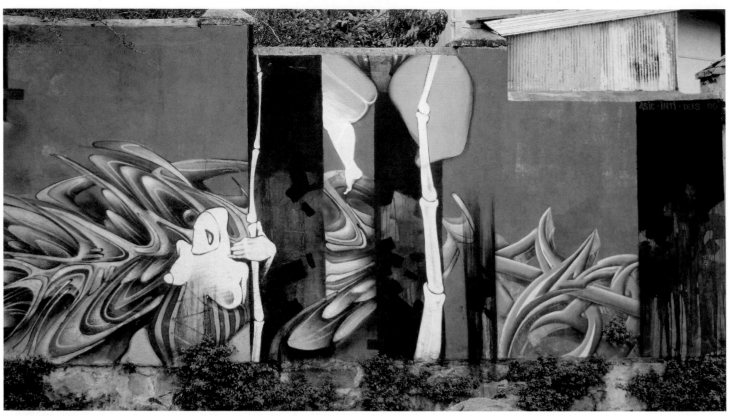

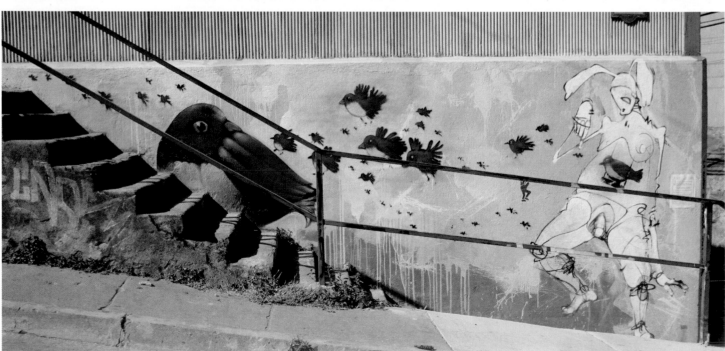

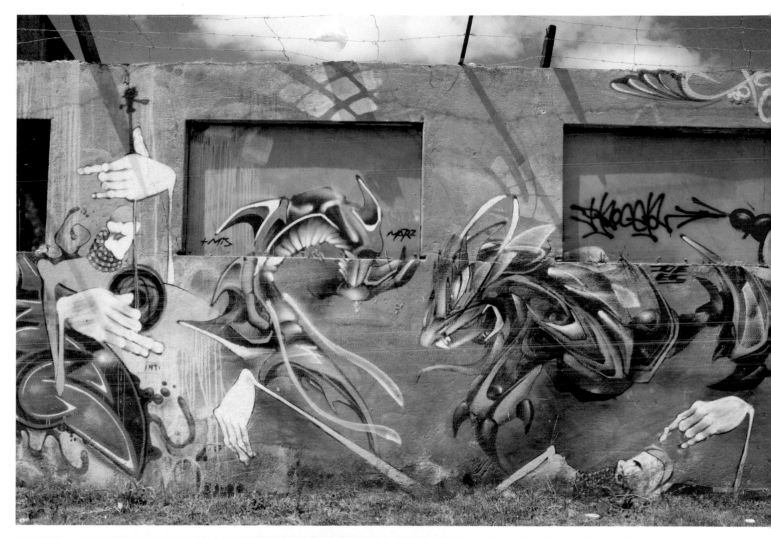

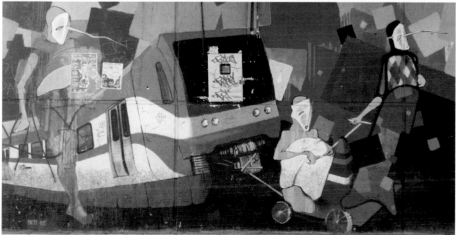

Above: Angol Avenue, Concepción. Inti's mandolin player leads Mis Marz's hyrids' dance. Inti's dancer is mainly underground.

Left: Barón Metro station, beneath the bridge. This is a continuation, to the right, of Charqui's work on Valparaíso Metro as a plaything (*see Barón Metro Station pp. 32-33*). The *commedia dell' arte* figures are wooden dolls.

Far left top: Capilla St., Concepción Hill, Valparaíso. A work with Asie.

Far left bottom: 'The Wooden Robot', Alvaro Besa St., Alegre Hill, Valparaíso. The birds are by Gigi.

111

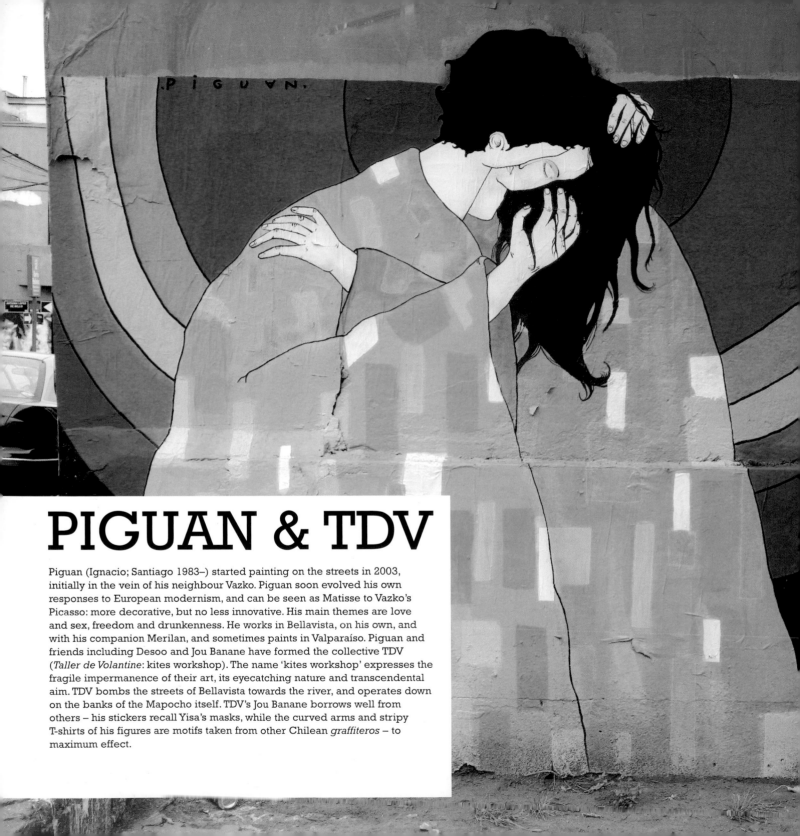

PIGUAN & TDV

Piguan (Ignacio; Santiago 1983–) started painting on the streets in 2003, initially in the vein of his neighbour Vazko. Piguan soon evolved his own responses to European modernism, and can be seen as Matisse to Vazko's Picasso: more decorative, but no less innovative. His main themes are love and sex, freedom and drunkenness. He works in Bellavista, on his own, and with his companion Merilan, and sometimes paints in Valparaíso. Piguan and friends including Desoo and Jou Banane have formed the collective TDV (*Taller de Volantine*: kites workshop). The name 'kites workshop' expresses the fragile impermanence of their art, its eyecatching nature and transcendental aim. TDV bombs the streets of Bellavista towards the river, and operates down on the banks of the Mapocho itself. TDV's Jou Banane borrows well from others – his stickers recall Yisa's masks, while the curved arms and stripy T-shirts of his figures are motifs taken from other Chilean *graffiteros* – to maximum effect.

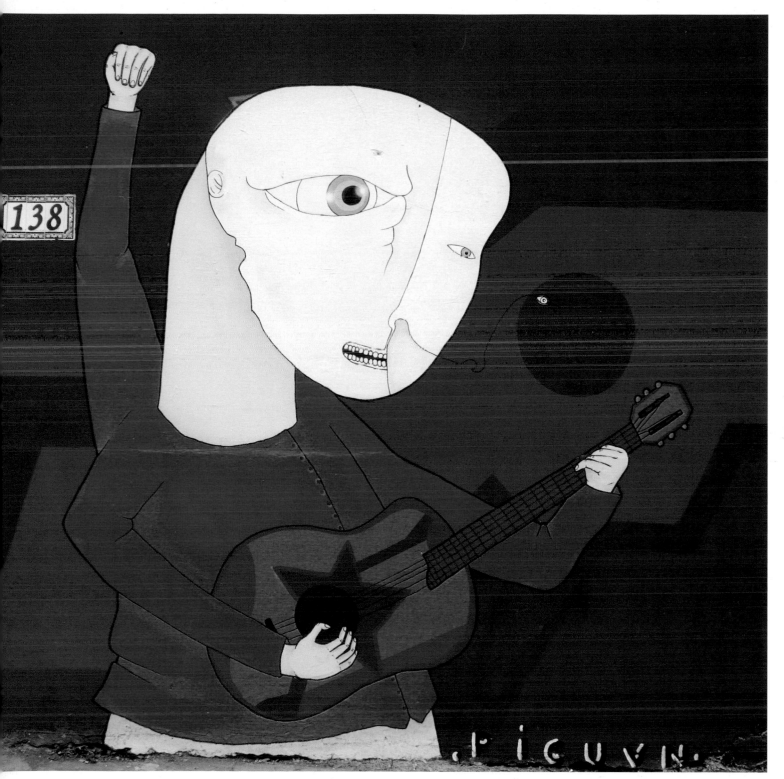

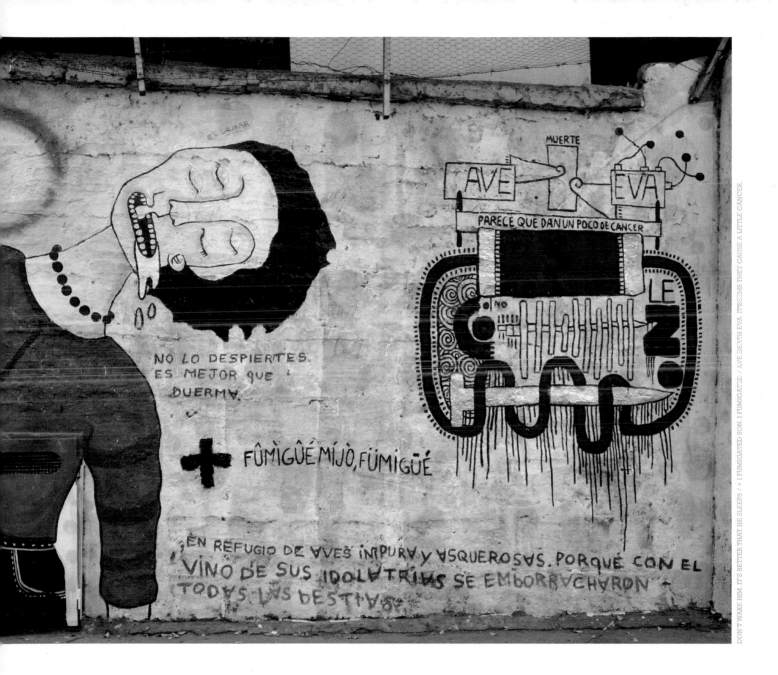

EL GRAÑSH

NO LO DESPIERTES,
ES MEJOR QUE
DUERMA.

+ FÛMIGÛÉ MÍJO, FÛMIGÛÉ

EN REFUGIO DE AVES IMPURA Y ASQUEROSAS. PORQUE CON EL
VINO DE SUS IDOLATRIAS SE EMBORRACHARON —
TODAS LAS BESTIAS

MUERTE

AVE · EVA

PARECE QUE DAN UN POCO DE CANCER

NO · LE · N

Previous pages left: Bombero Núñez St, Bellavista, Santiago. Gustav Klimt's *The Kiss* is many Chileans' favourite European painting. Unlike Klimt's redhead's orderly hairdo, her counterpart's black hair is long and loose, in relaxed Chilean fashion.

Previous pages right: S. Filomena St., Bellavista, Santiago. The weird Piguan head evokes Picasso and ET. In Chile, the guitar and its star recall Victor Jara; the raised and clenched fist: victory. The guitarist's third eye is attached by a guitar string.

Top left: Las Reynas Hill, Valparaíso. Modernity has robbed this veiled, blindfolded and featureless Piguan woman of her senses.
Left: Disorientatingly, this doorway is at 206 S. Filomena St.
Far left: Bombero Nuñez St., Bellavista, Santiago. A Jou Banane figure in a doorway. The man's hands are phallic.

Above: Antonia Lopez de Bello Street, Bellavista, Santiago. An allegory of the ineffectiveness of the false medicines of alcohol and Catholicism. The text at the foot of this image is an *incoerencia*.

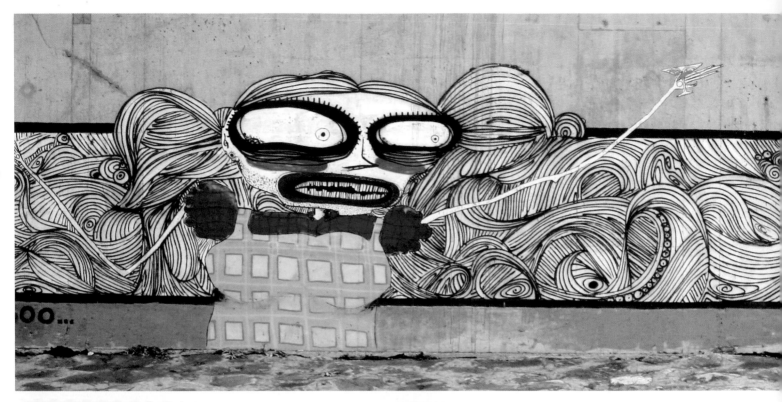

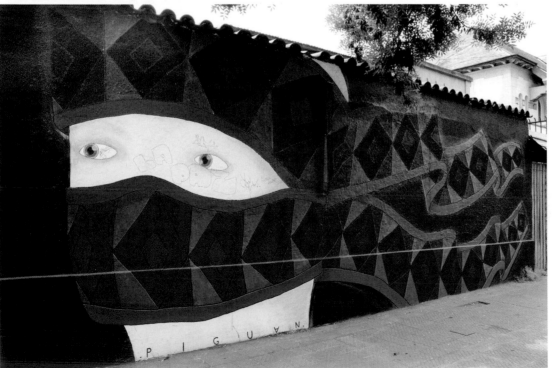

Above: On the northern bank of the river Mapocho, between Loreto and Purísima bridges. TDV's paintbrush logo recalls of that of BRP. Desoo's figure to the left is a transvestite – with amazing neobaroque hair. Curaçao-based blue cocktails are available in Santiago's bars.

Left: Antonia López de Bello/S. Filomena St. On the wall of a locale, a benign variation on Piguan's veil theme.

Right: Antonia López de Bello St. A chaotic concoction by Piguan and Merilan.

Far right: On the same street, Piguan extends his double-vision joke to this figure's headwear.

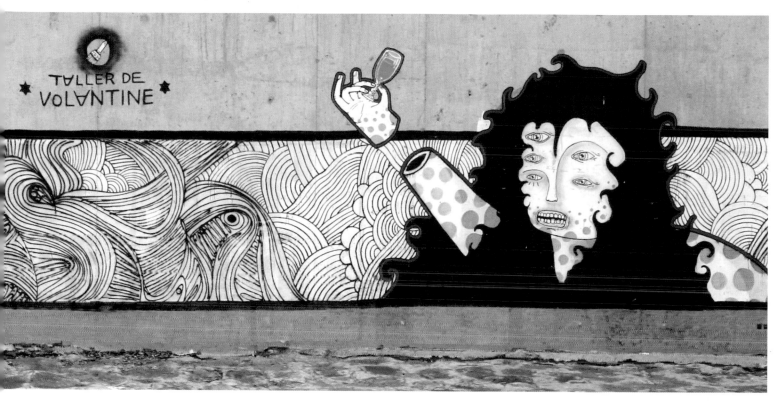

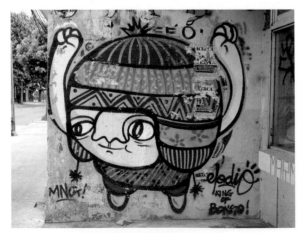

ELODIO

'Elodio' means 'the hatred' (*el odio*). Elodio (Victor Menares; Punta Arenas 1986–) presents himself on www.elodio.tk in a balaclava. A revolutionary, he emulates BRP's black outlines in his cartoon-style paintings and stickers. Elodio uses spray cans skilfully, to achieve, within outlines, painterly textures, especially on his figures' clothes. Elodio follows Wooster Collective of NYC, but is a Latin Americanist Manu Chao fan. Elodio's art can be seen in Concepcíon, and in Buenos Aires, where Elodio collaborated with 'eko system' in 2007, and was based in 2008. Elodio has worked in Uruguay, where he displayed a sticker in central Montevideo with the bubble: '*Annul impunity*' (*ANULAR LA IMPUNIDAD*). Elodio developed such political commentary in Chile. In his 'MEMORIA' work shown here, the figure's *'DONDE ESTÁN?'* ('WHERE ARE THEY?') placard refers to the dictatorship's *desaparecidos* (disappeared). *'DONDE ESTÁN?'* has been a refrain of many Chilean gallery artists, from Carlos Altamirano in 1997 to Iván Navarro today. Elodio reckons such themes belong on the streets. In his *GOL EN EL CAMPO PAZ EN LA TIERRA* (GOAL IN THE FIELD PEACE ON EARTH), Elodio transcends political confrontation.

Top: Central Concepcíon. Concepcíon is capital of Chile's Region VIII. *'Octava estación'* echoes Manu Chao's phrase *'Proxima estación'*
Left above: Justicia Square, Concepcíon. *GOL EN EL CAMPO PAZ EN LA TIERRA*. The stickers are stuck high up, so the ball flies as into the top right-hand corner.

Left: Barros Arana Ave, Concepcíon. KING OF BONGO! refers to the singer Manu Chao. The paintwork on the hat is a good example of Elodio's ability to create painterly textures. 'MNG' stands for *La Manga*.

118

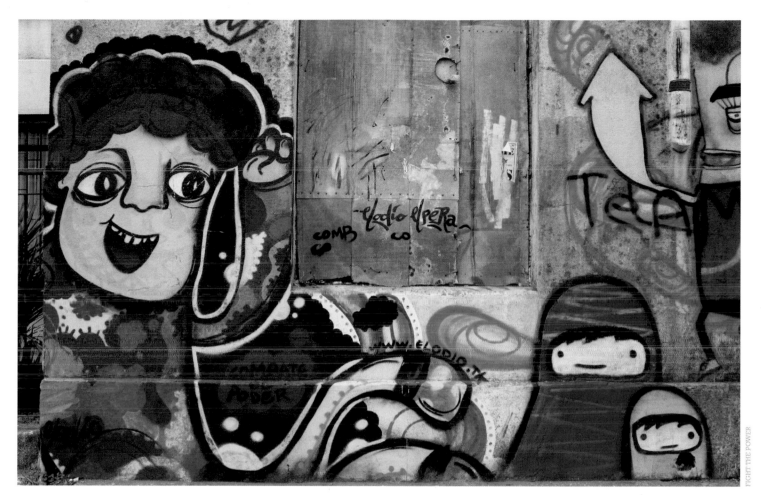

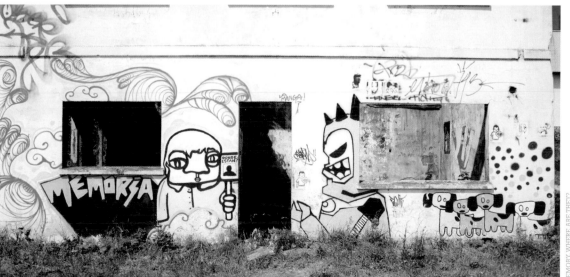

Above: Concepción. With El Pera. COMBATE EL PODER. The green outline around the girl is less BRP, more *graffitero*.
Left: Padre Hurtado Avenue, Concepción. A *La Manga* collaboration; '*MEMORIA: DONDE ESTAN?*' by Elodio.

SIRAK

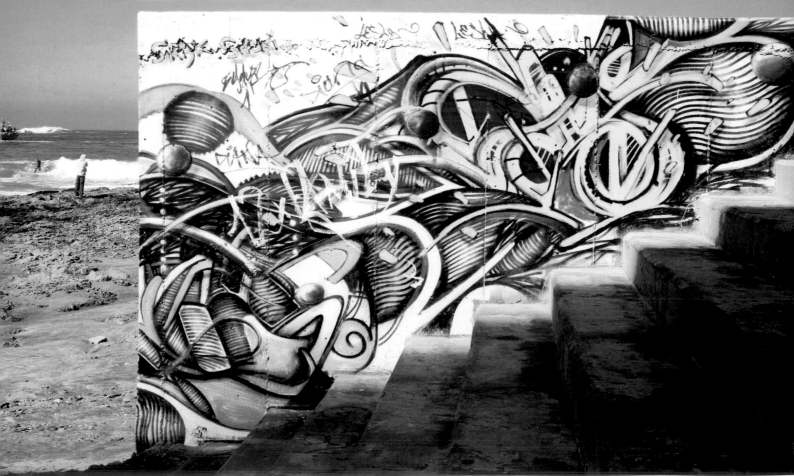

Sirak has been painting in Iquique, and inland at Tarapacà, since at least 2006. He looks less to fellow Chileans – all the other artists featured in this book live 24 hours or more bus journey away – than to California (ThrowPaint) and to France (nahonamekqdp and SethTwo). Sirak has something in common with a Brazilian woman interviewed by Pablo Aravena in the film *Next*. She observed that so great are the distances in Brazil that it is easier to follow developments abroad than to link up with compatriots in faraway centres; the same applies to remoter areas of Chile.

Sirak´s photorealism responds to ThrowPaint's, also perhaps to Peruvian photorealism; his coloured cartoon figures to nahonamekqdp; his *flops* to SethTwo. Sirak's art refers to different developments abroad from those taken up by his counterparts in Santiago and Valparaíso, the common ground with Vazko and Bomber West being that Sirak is knowingly West Coast. For all his cosmopolitan sources, Sirak is very much of his area of northern Chile. Sirak's photorealist works are reminders of Iquique's collective trauma. Sirak's and Snoki's beach *flop* responds to Pacific rollers; and yellow teeth are a running joke in Tarapacà.

Far left: Iquique, market. This woman looks slightly haunted – perhaps by the unhappy historical memory of the massacre at the market in 1907.
Far left below: Cavancha Beach, Iquique. A joint wall with Snoki,
Left below: Iquique, Balmaceda. This stressed-out man, on Iquique's architecturally beautiful Balmaceda, towards its lovely beaches, seems intended to break the reverie.
Below: Iquique. Water storage container at Cavancha.

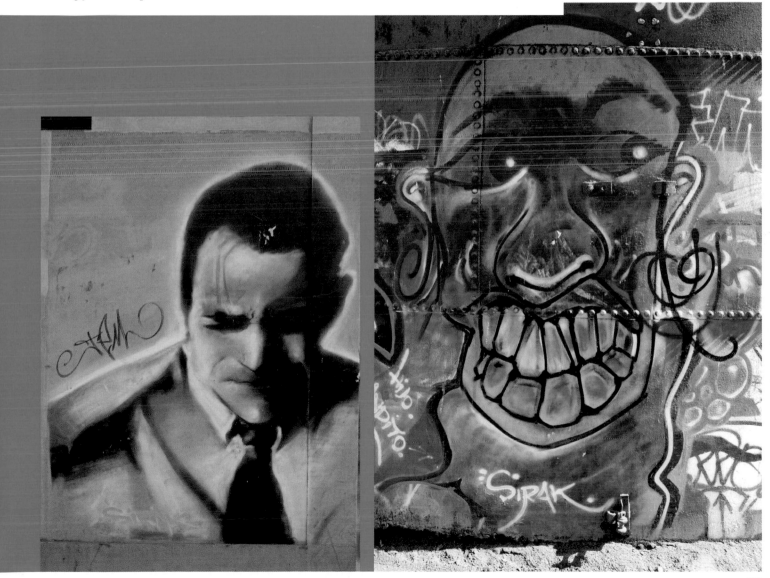

25 CREW

25 Crew of Viña del Mar have for years worked week in week out in Viña and Valparaíso. They chose '25' for the way the numbers '2' and '5' partially and asymmetrically mirror each other. Some of their earlier *flops*, on the ex-rolling stock of the Valparaíso-Viña del Mar metro, are now in the 'Maestranza', next to the metro line between Barón and Portales stations. Without abandoning 'old school' *flops*, or their hip hop roots, 25 Crew's repertoire has evolved to incorporate *nueva figuración* cartoon-style figures and stencils. Of current members, Zisek is hip hop in style and content; Smart stands out for his powerful use of colour, especially yellow for eyes, and arresting design details, some of which recall Vazko; Zade for energetic *flops* that often involve stencils; Dake (Carlos) for his fluidly comic style. Like the brigades before them, 25 Crew are more than the sum of their parts. Dake has explained that, while communicating 'nothing explicitly' (*nada explicitamente*), 25 Crew's graffiti has a 'political and social connotation' (*connotación política y social*). 25 Crew aim to add colour to an environment that is ever more 'grey and boring' (*gris y fome*); to interrupt routine existences; to provoke people's opinions; and to give 'a new face to the world' (*un nuevo rostro al mundo*).

Main picture: Bettina St. off Alemania Avenue, Valparaíso. Dake's easy rider of a Zade *flop*.
Right: Recreo Beach, Viña del Mar. Smart's use of yellow catches the eye from a distance.
Far right: Maestranza, Valparaíso. Smart, for the benefit of those wondering 25 what?

Following pages:
25 Crew *flops* on Valparaíso-Viña del Mar metro rolling stock, and on walls in Viña and Valparaíso.

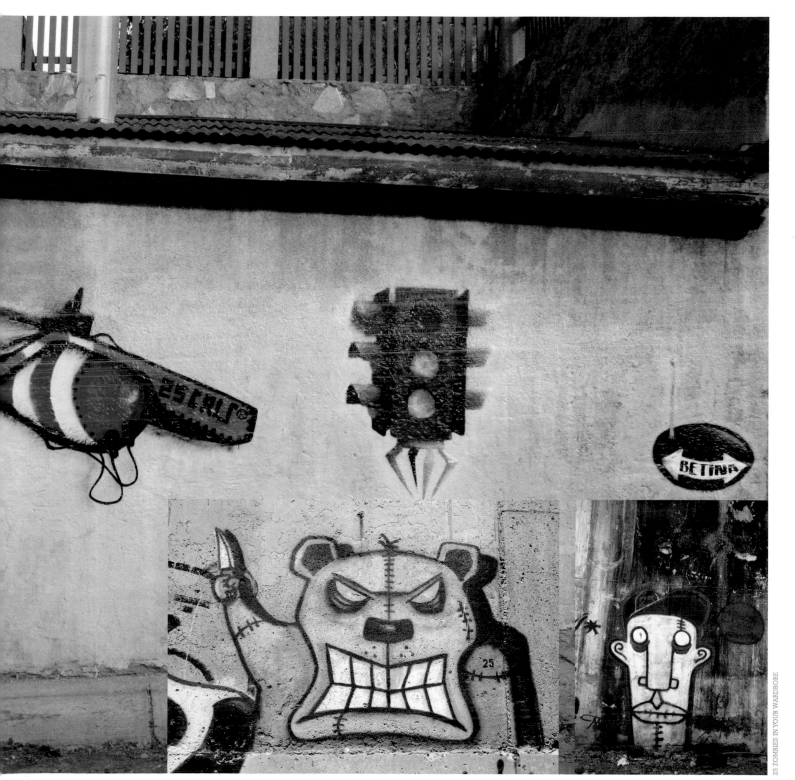

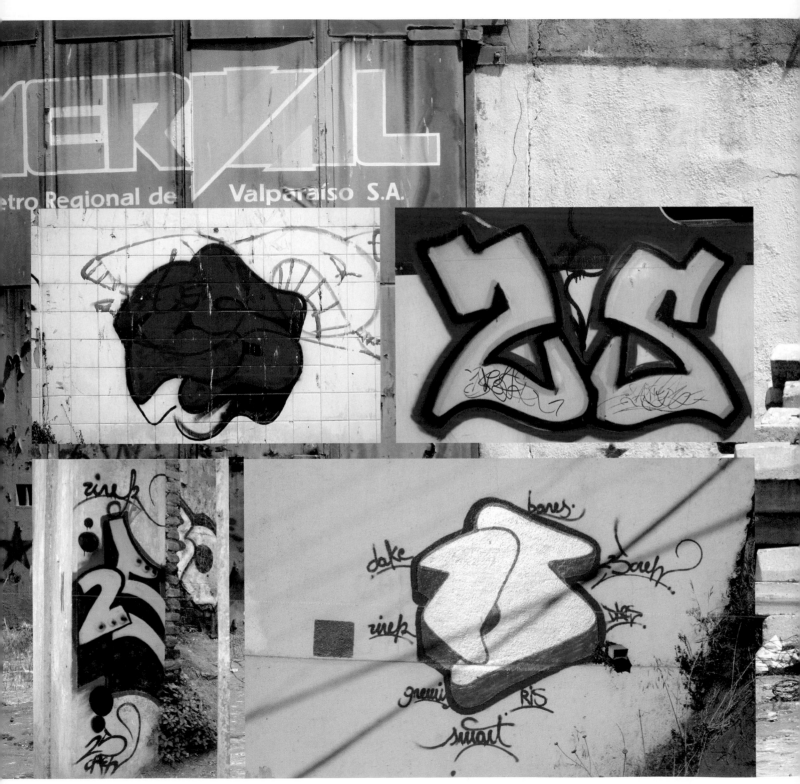

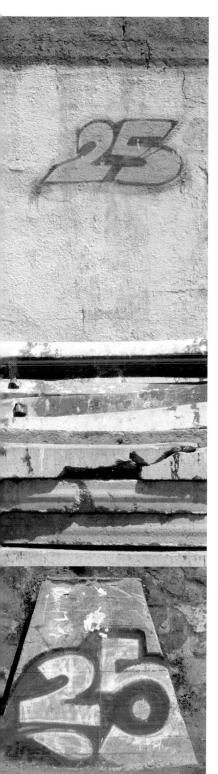

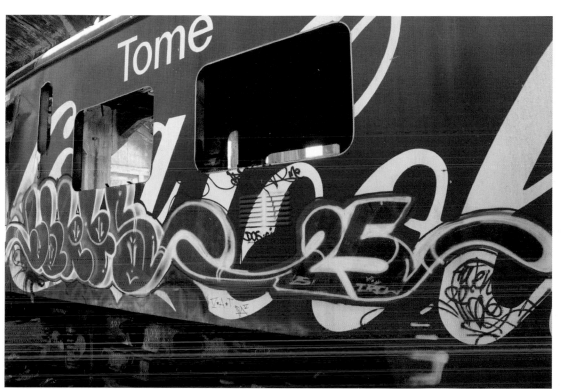

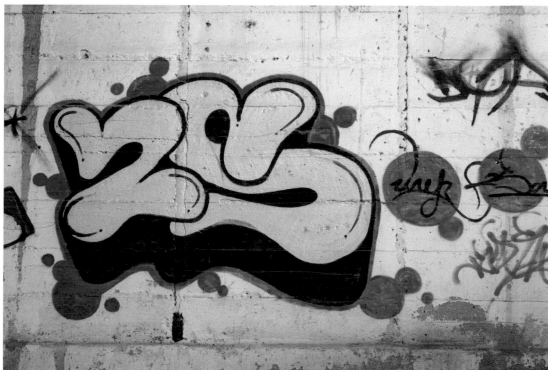

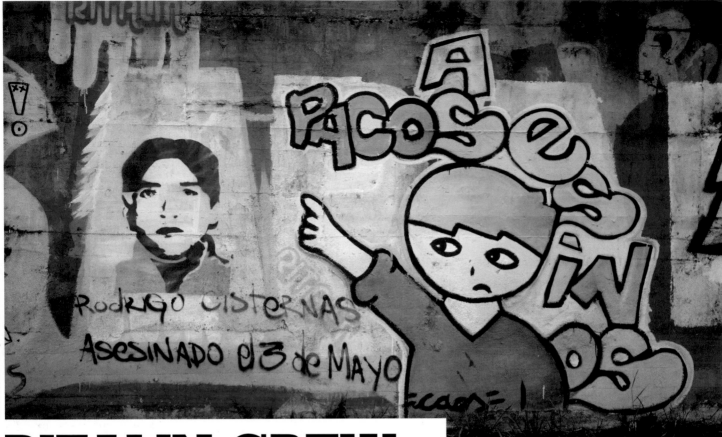

RITALIN CREW

Ritalin Crew has operated in the port of Talcahuano since 2005. In early 2008, there were six collaborators, all aged between 17 and 24: Toto (Gabriel Toso), War (Gerardo), Fer (Fernando Cosio), SDP (Alex), El Peñi and Kaos. El Peñi makes stencils in nearby Concepción (*see pp 130–131*). SDP is also a stencilist, and a publicity designer for local firms, who lends his familiarity with advertising to Ritalin Crew. All current Crew members were all born in Talcahuano, and live in the Libertad, Salinas and Higueras townships; their materials are discontinued paints from hardware shops, and leftovers from political propaganda campaigns. They have two aims: first, 'critical discourse' (*discurso crítico*), to raise awareness of topics such as poverty, pollution and fishermen's rights. Secondly, they offer 'ornamentation' (*ornamentación*), 'so that Talcahuano gets colour' (*en cuanto la ciudad adquiere color*), and becomes more 'habitable'. In pursuit of ornamentation, Ritalin Crew cite Lichtenstein, but are too engaged with Talcahuano's problems, and too alienated by consumerism, to be 'NeoPop'. All the examples here are from the Talcahuano seafront.

Talcahuano that exploits/explodes. CLEAN AIR. DECENT WORK FOR T[ALCAH]UA]NO

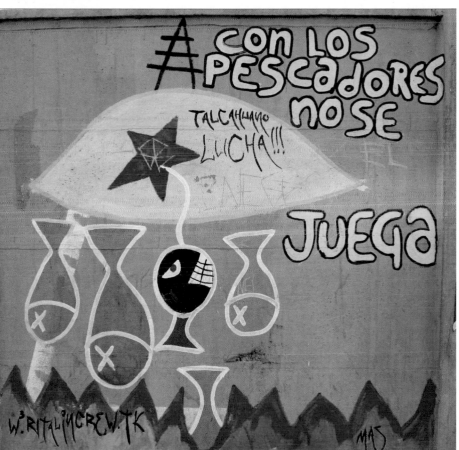

TALCAHUANO FIGHTS!! fishermen not to be played with any more

Left top: Ritalin's earlier style is here combined with Kaos' cartoon-like one, and with a stencil by El Peñi of Rodrigo Cisternas, a forestry worker killed by *carabineros* on 3 May 2007 while protesting for workers' rights at Curanilahue in southern Region VIII.
Left bottom: This stencil, with pink-and-blue painted border, is in the style of Lichtenstein.

Top: The bubble in this mural on pollution and unemployment in Talcahuana puns on '*explota*': exploits/explodes.
Above left: Stencils and block-print dots on painted background within sprayed border. This image is philosophical, not just ornamental.
Above: In Talcahuana, fishing bans are an explosive issue.
Left: An *ornamentación* mainly composed of stencils.
Right: Detail from a wall of Ritalin Crew stencils.

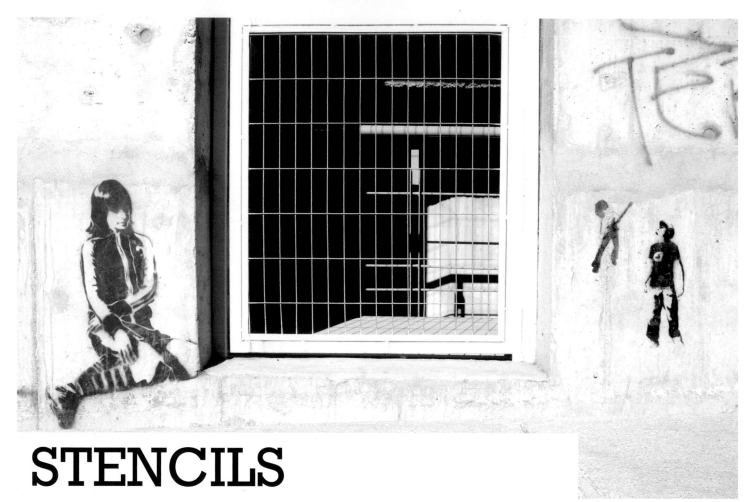

STENCILS

Anti-Pinochet and punk stencils were made in Santiago from 1983. Once the brigades started using spray paints in the mid-'80s, stencils proliferated. Horate began stencilling in 1989, and then as now behind every known stencillist are many anonymous ones. Santiago and Valparaíso both have a good line in prints proposing sex and drugs as quick ways to happiness. Other existential stencils embrace topics of despair and suicide. One of Santiago's leading stencillists, Veggie, looks at old age and poverty, as does Ingapok of Concepción. Conce has for some time distinguished itself for innovative coloured stencils (*see overleaf*). El Pera (The Sonofabitch) achieves virtuoso chiaroscuro effects that defy the fact that his images are composed of only two or three layers of colour. El Peñi (Mapuche for the The Friend) sprays compassionate but challenging violet and grey portaits of Mapuche and other underprivileged subjects. The *Conciencia* (Consciousness) anarchist collective, based at Huapel between Conce and Talcahuano, propose anti-propaganda and anti-advertising tableaux. Anti-ads abound: a simple but effective one, DILER (pronounced 'dealer'), is a spoonerism of a leading supermarket chain. Stencils of TV characters such as Chapulin Colorado and Mafalda (who is to some a lesbian icon) are outnumbered by anti-TV ones.

Valparaíso's burgeoning stencil outfits include artoarte and Innova; and Valparaíso has become a site of Argentine-instigated interventions. Urban Art Crew of Chillán have caught on to experiments with coloured stencils in nearby Concepción, in their own distinctive yellow-orange-red range. Banksy-like figures are seen in several Chilean cities, including Valdivia, where pupils of the Escuela Superior (Upper School) realize stencils such as one that subverts the image on schoolchildren's bus tickets throughout Chile of a school-boy and -girl reading together, by showing them blindfolded. *InZomnia*, seen in Arica, sums up Chilean stencillists' common aim, despite their wildly differing causes: to awaken people.

DON'T WAIT JUST GIVE OUT

MAFALDA

AND NOW WHAT?
EL PERA

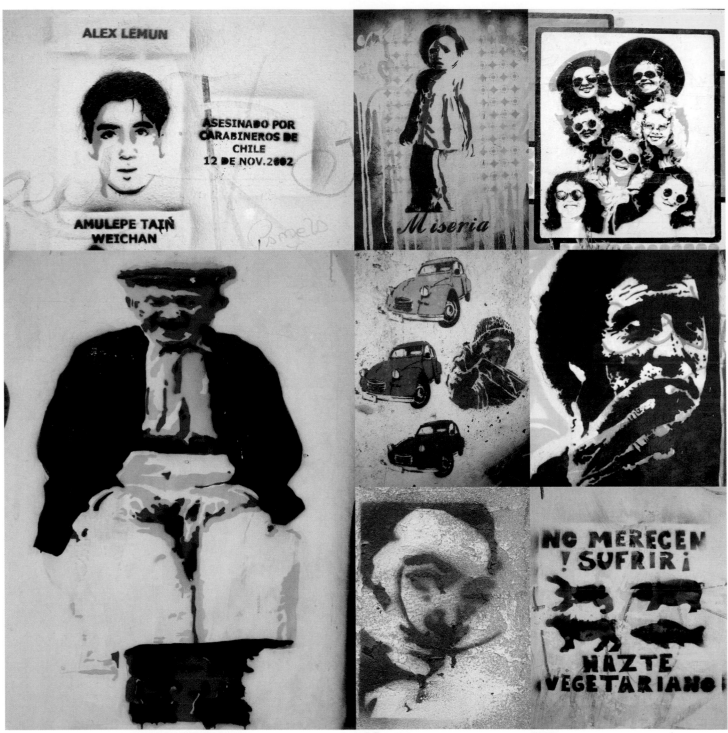

EL PERA: ALEX LUMEN / ASSASSINATED BY CHILEAN CARABINIERI 12 NOV 20002
INGAPOK

EL PEÑI: POVERTY
URBAN ART CREW

EL PERA
VICTOR JARA
THEY DON'T DESERVE TO SUFFER! GO VEGETARIAN

EL PEÑI
ARTERISCO OF CONCIENCIA: DRINK CONSCIOUSNESS

EL PERA
WE WILL WIN / FUCKING COPS

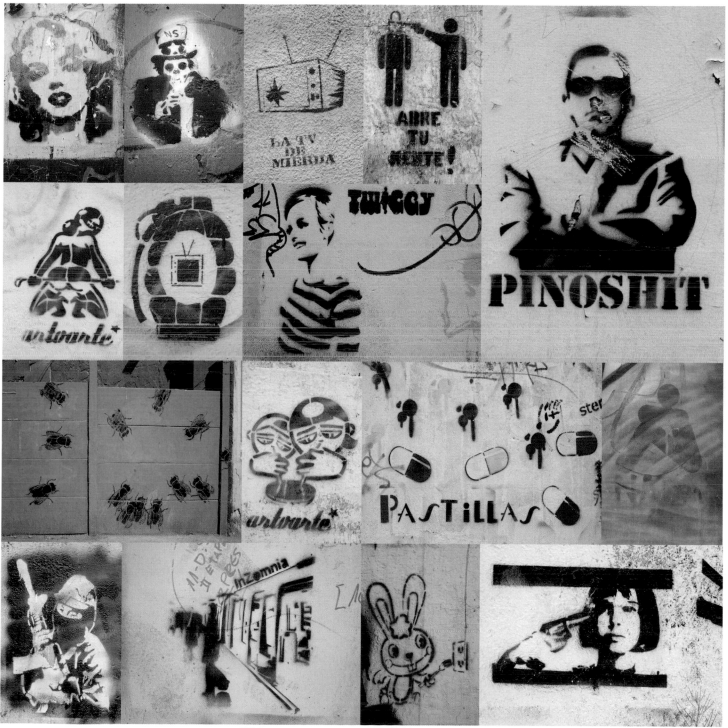

SHIT TV OPEN YOUR MIND

ARTOARTE PILLS

INZOMNIA NOTHING

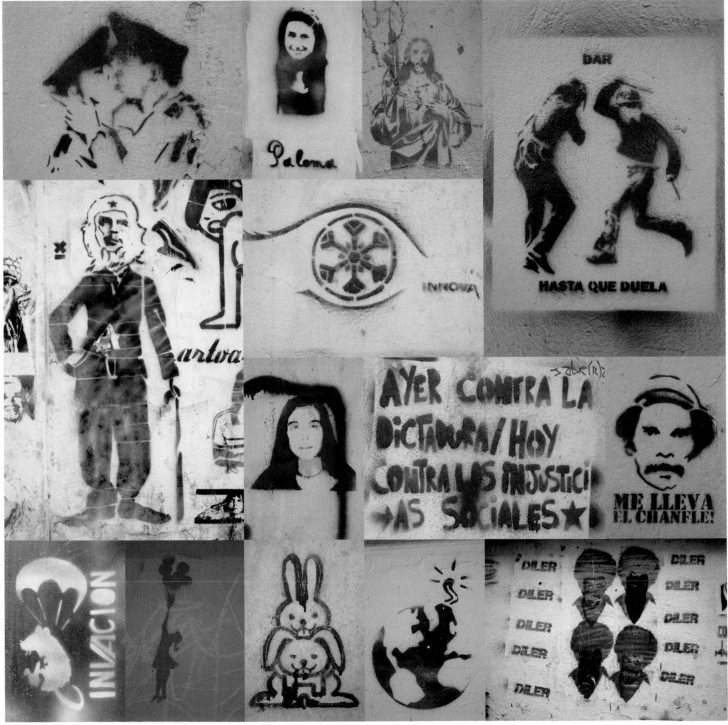

GIVE UNTIL IT HURTS

ARTOARTE
INVASION

INNOVA
CLAUDIA LÓPEZ

YESTERDAY AGAINST DICTATORSHIP / TODAY AGAINST INJUSTICE

EL CHAPULÍN COLORADO RULES

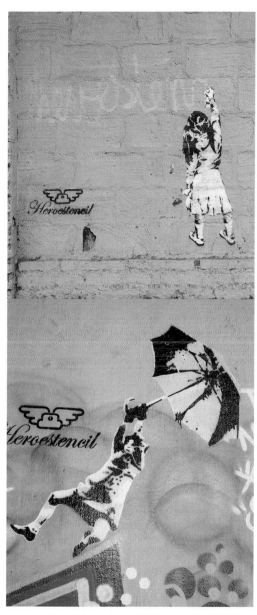

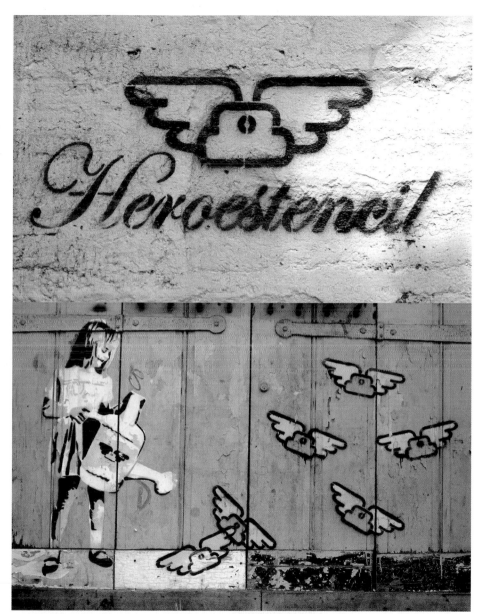

Top: St Filomena St., Bellavista,
Santiago. This ensemble plays on the
immediacy of stencils versus the
discursiveness, always prone to be
interrupted, of painted graffiti.
Below: S. Filomena St., Bellavista. A
reference to the film *Mary Poppins*.
Right above: Heroestencil's tag.
Right below: Antonia López de Bello
St., Bellavista.

HEROESTENCIL

The name Heroestencil elides 'Heroes' and '*estencil*'. Heroestencil is led by 'Kapitan
Koshayuyo', who finds that 'the avant-garde is in the street' (*la vanguardia es callejera*).
Heroestencils show familiarity with Banksy, and make their own jokes on the relation of
stencilling to other street media. Heroestencil visits regional Chilean towns, to teach
stencilling techniques.

STICKERS

Concepción plays a leading part in Chilean sticker manufacture, such as those by Elodio and others in the style of El Pera. Many of Conce's road signs are sticker-affected, as are those of other southern Chilean cities, especially Puerto Montt. In Los Ángeles, one of Pfeffer's ideas has been adopted at municipal level, and the garbage bins have eyes. Rod of Santiago's rock-and-roll approach is here shown by a sticker tableau he left behind on a working visit to Valparaíso. In Santiago itself, music, drug and other counter-culture images are stuck next to political ones, and Jou Banane of TDV's sticker floats high on the wall of the University of Chile's law school.

Valparaíso has many concentrations of stickers, and Rick Terror pastes ironically named '*Movimiento de arte publico*' (Public art movement) collages on the walls of the port's alleyways. *Miaeronautica* (My aeronautical) of Antofagasta make some of Chile's biggest and best stickers. Sergio Valenzuela is Chile's leading sticker (and poster) artist. At top left, Valenzuela emblazons the rainbow, emblem of the 'No to Pinochet' campaign, on the face of Ekeko, Aymara god of prosperity – and thus turns a legacy of Chile's troubled past into an upbeat Andean visual statement.

SERGIO VALENZUELA ELODIO: NO MORE RISES! FAULT OF PIG CHANCELLORS DEMOCRACY?
 FREE / ALL YOU WANT

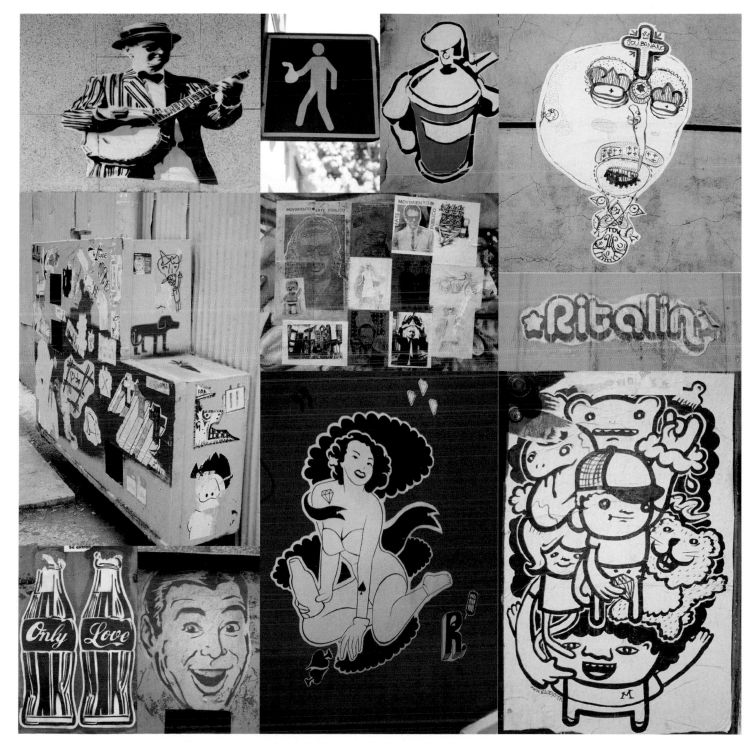

MIAERONAUTICA

RICK TERROR
ROD

JOU BANANE
RITALIN CREW
ELODIO

YISA
"Latex & Zapatera"

Resistir en la pintura se acoge a una esencia romántica de la palabra, la realidad esta superpuesta a esas quimeras de la materia distribuida en el soporte y la idea impaciente de instalar una obra en un sitio donde alguien pueda observarla.

Yisa agrede el sitio del desalojo y esto lo determina a conjeturar que podría ser un pintor, aun, pero que resguarda la esencia de un concepto retraído en la contemporaneidad de todo sentido común, la acción de pintar se plantea en la urbe y solo existe en la medida que define territorialidad, de-marca el acontecimiento de la tela como una señal de propiedad y de existencia en la guerrilla urbana.

Poder definir en el eriazo una forma, una estructura visual reconocible, una extraña aparición icónica formateada a su propia técnica, del agenciamiento de lo precario como único recurso en la oscuridad de lo real, sobre un muro deleznable, que se va constituyendo en la persistencia irracional de la acción mítica de establecer una imagen, en una obligación a la mirada, ineludible a la ausencia de sentido en la fugacidad de la agitación pública.

La propuesta de Yisa logra tocar la medula sin partir el hueso. Aquí la pintura es un medio, lo que constituye la obra es el acontecimiento que la instala, su planificación y su condición efímera en la fragilidad actual.

Asentado en la calle entre los deshechos y los recorridos de la historia de la pintura, esta propuesta sobrepasa la posibilidad de ingresar el graffiti, el rayado y la iconografía de la irreverencia a un espacio establecido, logra constituir una relación entre tribus que producen sentido bajo los mismos códigos que se organizan las tranzas sociales contemporáneas. La ley de la imagen con zapatera y látex – marks of power. -Víctor Hugo Bravo- Artista Visual-

w w w . y i z a s . b l o g s p o t . c o m
jocegza@gmail.com

WWW.SKEEO.CL

YISA
"Latex & Shoepaint"

Showing resistance in painting one takes refuge in a romantic sense: reality is superimposed on the chimeric material of the support, through the impatient idea of installing a work in a place where anyone might notice it.

Yisa likes abandoned sites and this makes him wonder what a painter could be, even, but that hides the essence of a concept rooted in the contemporaneity of all common feeling; the action of painting plants itself in the city and only exists in the measure that defines territorialism, de-designates the canvas as sign of property, and is a sign of existence in the urban guerrilla war.

Being able to define a form in the wasteland, a recognizable visual structure, a strange iconic apparition formatted to its own technique, of the agency of the precarious as only resource in the darkness of the real, on a crumbly wall, that goes on establishing itself in the irrational persistence of the mythic action of establishing an image, is an obligation to the gaze, an unavoidable challenge to the meaninglessness and fleetingness of everyday life.

Yisa´s proposal touches the marrow without splitting the bone. Here painting is a means; what constitutes the work is the event that instals it, its planning and its ephemeral condition in today's fragile present.

Sat in the street among the wreckage of the history of painting, this proposal surpasses bringing graffiti, spray paint and the iconography of resistance into the fold; it establishes a relationship between tribes who produce meaning according to the same codes that shape contemporary trance gatherings. The law of the image with shoepaint and latex – marks of power.
Victor Hugo Bravo, Visual Artist

Nosotr@s / us and them

La calle como soporte.

La construcción de un nosotr@s relata la aventura del cuerpo activo, activado y coordinado en medio de otro gran relato, la ciudad.

Y en esta coordinación de cuerpos abrimos el nombre hacia ese "otro"que proyecta otros flujos y otras miradas. Nosotr@s surge como ejercicio en medio del Taller de Instrucciones del Proyecto Envíos (1), proyecto seleccionado por Espacio G (2), para ser parte de la convocatoria 2007. En este contexto y durante esos días, circuló un flujo de personas que fueron activando a través de propuestas colaborativas lo que sería el Taller de Instrucciones propuesto por Envíos.

Una de estas instrucciones proponía un ejercicio de intervención callejera, que consistía en invertir a través de la borradura de la señaletica urbana oficial, cinco puntos de la ciudad de Valparaíso.

Una vez propuesta la intervención comienza la puesta en tensión entre diversas miradas y modos de hacer, cada uno provenía de diferentes contextos, ya sea geográfico, estético u/o metodológico y frente a la propuesta la problemática se vuelca hacia que índices abrir la calle. **Nosotros** fue el verbo en común, simple y anónimo.

La borradura como primer gesto (pintura) y la refundación de una calle con el texto Nosotros a través del Stencil (grabado) se puede entender como dos gestos que se desmarcan de la visibilidad o de la lógica de la representación que domina el mundo del arte, para reconocer nuevas practicas o desplazamientos en el arte contemporáneo.
El poder del nosotros encarna la fuerza creativa de los gestos mínimos de un grupo de individuos que por un instante coordinaron una nave.

We / us and them

The street as support.

Our construction of 'nosotr@s' (us) is a story of bodies-in-action, activated and coordinated in the midst of another bigger story, the city.

And in this coordination of bodies we opened ourselves up to that 'other' which provokes new flows of thought and new ways of seeing. The 'Nosotr@s' exercise arose as part of the ´Envíos´ (Sendings) Project's ´Instructions Workshop'(1), chosen by Espacio G (2), as part of its 2007 programme. In this context, for a matter of days, a flux of people circulated and activated through collaborative proposals what would become the 'Instructions Workshop' put forward by 'Envíos'.

One of these instructions proposed an exercise in street intervention, which consisted of subverting five points in the city of Valparaíso, through erasure of the official urban signposting.

The intervention once proposed, tensions began between different ways of seeing and doing, each person coming from different contexts, be they geographic, aesthetic and/or methodological – in response to the problematic of what indices to return to in order to open up the street. **Nosotros** (we) was the common word, simple and anonymous.

Erasure as the first act (painting) and the renaming of the street with the text ´Nosotros´ through the stencil (engraving) can be understood as two acts that distance themselves from the visibility and from the logic of representation that dominate the art world, to recognize new practices and displacements in contemporary art.
The power of 'us' embodies the creative strength of the slightest actions of a group of individuals who for an instant are at the helm.

1 – Proyecto Envíos, trabajo en proceso, activado por cinco artistas de Córdoba , Argentina.
Sus impulsores son : Emilse Barbosa, Antonio Gagliano, Juan Paz, Florencia Pumilla y Natalia Vargas.
Tejidoenvios..blogspot.com
2 – Espacio G Laboratorio de arte y reflexión social. Espacio-g.cl

1 – Envios Project, work-in-progress, by five artists from Córdoba, Argentina.
They are: Emilse Barbosa, Antonio Gagliano, Juan Paz, Florencia Pumilla and Natalia Vargas. Tejidoenvios..blogspot.com
2 – Espacio G Laboratory of art and social reflection. Espacio-g.cl

GLOSSARY OF CHILEAN STREET ART TERMS

bombardeo (bombardment): campaign to spray an urban area, and obliterate others' work, in order to boss it.
bombardero (bombardier/bomber): graffiti- or street-artist intent on *bombardeos*.

cap: term for spray can nozzle borrowed from Anglo-American.
crew/cru: group of graffiti- or street-artists.

equipo: team of propaganda- or street-artists.
escritor (writer): graffiti or street artist.

fapcap: *chilenismo* for 'fat cap', i.e. wide nozzle attached to a '*lata*' (spray can) for a broad, highly visible line.
fileatador (outliner): BRP brigade member responsible for outline drawing.
flop: *chilenismo* for the hip-hop graffiti term 'throw-up' i.e. quickly done tag.
flop analítico: analytical throw-up. Termed coined by Mauricio Román M. to describe *flops* that have a figurative dimension.
fondeador (backgrounder): BRP brigade member responsible background colour.
freestyle: abstracted *wildstyle* without lettering.

graffitero: Spanish for practitioner of graffiti.
graffiti: text and/or imagery on wall or other public space; since the 1970s largely associated with hip hop.
gringismo: phrase in intentionally bad English, to draw attention to the US influence on Chilean culture.
guardia (guard): look-out for brigade or crew.

incoerencia (incoherence): illogical and intentionally meaningless text.

lata: can of spray paint, sold, to discourage shoplifting, without '*boquilla*' or nozzle.
latex: water- or casein-based paints, widely used by 1960s and '70s brigades, and today's street artists.
latinoamericanamente barroco: latinamericanly baroque. Term coined by Jocelyn Muñoz B. in *Nimia* 2006.
libro negro (black book): sketchbook, not necessarily black, in which graffiti- and street-artists develop their ideas.

máscara (mask): stencil screen. Medical x-ray photographs are good *máscara* material.
muelde: mould, usually of a childish shape, painted over to create negative image.

nueva figuración (new figuration): figurative street art, often in cartoon style, associated with the open-minded *nueva generación* (new generation) born in the 1980s. Ever more *nueva figuración* pieces involve stencils.

Otra Vida (Other Life): graffiti shop and information centre, Lastarria St., Santiago, late 1990s to early 2000s.

NeoPop: term for fresh-looking and funny art coming out of Chile, Colombia, Spain and elsewhere.
NoPop: riposte to NeoPop by Sergio Valenzuela of Ekeko. 'No' has overtones of the anti-Pinochet 'No' campaign, and hence the affirmation of freedom.

outline: the outline of figures and shapes on murals. BRP outlines are black; outlines around current graffiti and street art are often white or brightly coloured.

papelógrafo (papergram): long paper poster with a didactic or ironic text sometimes with a partisan emblem, such as the red star of the Chacón brigade.
personaje (character): character, often generically derived from cartoons, recurring in the work of a given artist or crew.
pichaçao (asphalt-style): lettering invented by striking Brazilian asphalt workers in the 1980s; *pichaçao*, in Spanish '*pinchaizon*', has become a defining feature of South American street art, not least in Chile.

reggaetón: Latin American hip hop.
rellenador (filler): BRP brigade member responsible for colouring figures.

tag: as in American English, graffiti- or street artist's signature.
toy: street artists' term for unoriginal or defective pieces, and those that break unwritten rules of conduct.
trazador (planner): BRP brigade member responsible for a mural's initial design.

Vieja Escuela, la (Old School, the): Brazilian graffiti and responses to them in Santiago in the 1990s.
Vieja Escuela chilena (Chilean Old School): current term for Santiago *graffiteros* of the 1990s.

wildstyle/estilo selvaje: expressive North American graffiti style, especially in tags/*flops*.

zapatera: shoe paint favoured by some street artists because cheap and hard-wearing.

SELECT BIBLIOGRAPHY

MURALISM, GRAFFITI AND RADICAL ART IN CHILE

Álvarez Vásquez, Raúl, *Muros Susurrantes: graffiti de Santiago – Chile y Sao Paulo – Brasil*, Arthus Ediciones, Santiago 2006.

Bellange, Ebe, *El Mural como Reflejo de la Realidad Social en Chile*, LOM Ediciones, Santiago 1995.

Campos, Edwin, & Meller, Alan, *Santiago Stencil*, Editorial Cuarto Propio, Santiago, 2007.

Castillo Espinoza, Eduardo, *Puño y letra: movimiento social y comunicación gráfica en Chile*, Ocho Libros, Santiago 2006.

Chile venceremos!!, exh. Kettle's Yard, Cambridge, Oct.–Nov. 1975.

Echeverría Cancino, Albino, *'Presencia de América Latina': Apuntes para la historia del mural*, Universidad de Concepción 2005.

Figueroa Irarrázabal, Gricelda, *Sueños enlatados: El graffiti Hip hop en Santiago de Chile*, Editorial Cuarto Propio, Santiago 2006.

Inoxidable Neopop, exh. cat., Gasco Arte Contempóraneo, Santiago 2006.

Ivelic, Milán, & Galaz, Gaspar, *Chile: Arte Actual*, Ediciones Universitarias de Valparaíso/Pontificia Universidad Catolica de Valparaíso, 1998, repr. 2006.

Ivelic, Milán, Sommer, Waldemar, Valdés, Celia & Galaz, Gaspar, *Pintura a Chile 1950–2005: grandes temas*, (2005), 2nd edn., Editora Cecilia Valdés Urrutia, Santiago 2006.

Mario Toral: Memoria Visual de una Nación. Parte Primera El Pasado, Banco de Santiago, Santiago 1996.

Méndez Labbé, Francisco, *Museo a cielo abierto de/Open sky museum of Valparaíso*, Pontificia Universidad Católica de Valparaíso, 1995, repr. 2003.

Mosquera, Gerardo, *Copiar el Eden/Copying Eden. Arte reciente en Chile/Recent art in Chile*, Ediciones Puro Chile, Santiago 2006.

Muralismo/Wandmalerei/Peinture Murale/Mural Painting/Pittura murale: Arte en la cultura popular Chilena, ed. Comité de Defensa de la Cultura chilena, Edition día, Berlin/St. Gallen/São Paulo 1990.

Navarrete, Carlos, *Mario Toral: Memoria Visual de una Nación*, Publiguías, Santiago 2002.

Nimia: exposesiones, exh. cat., Espacio G, Valparaíso, 2006.

No Gratos, 1–4, Otra Vida, Santiago 2000–2006.

Palmer, Rodney, 'Chilean street art on paper', *Varoom*, vol. 6, March/April 2008.

Pastor Mellado, Justo, 'The Critical Painting of José Balmes', *Inverted Utopias: avant-garde art in Latin America*, exh. Museum of Fine Arts, Houston, cat. Yale University Press, New Haven 2004, pp 403–09.

Richard, Nelly, *Cultural residues: Chile in transition*, University of Minnesota Press, Minneapolis 2004.

Ruiz, Carlos, ed., *Políticas y estéticas de la memoria*, Editorial Cuarto Propio, Santiago 2006.

Sandoval, Alejandra, *Palabras escritas en un muro: el caso de la Brigada Chacón*, Ediciones del SUR, Santiago 2001.

Siquieros, David Alfaro, *Como se pinta un mural* (1951, 1977, 1979), Ediciones Universidad de Concepción 1996.

Toral, Mario, *Tanai y el resplandor de Eros*, Editorial Andrés Bello, Santiago 2007.

Vazko, *Donde está mi corazon?*, Upper Playground, San Francisco 2008.

STREET ART WORLDWIDE

Bou, Louis, *Street Art*, Instituto Monsa de Ediciones, Sant Adrià de Besos, Barcelona 2005.

Bou, Louis, *BCN NYC Street Art revolution*, Instituto Monsa de Ediciones, Sant Adrià de Besos, Barcelona 2006.

Chalfant, Henry, & Prigoff, James, *Spraycan Art*, Thames & Hudson, London 1987 (repr. 2006).

Cano, Genís, & Rabuñal, Anxel, *Barcelona Murs*, Ajuntament de Barcelona, Barcelona 1991.

Dawson, Barry, *Street Graphics Cuba*, Thames & Hudson, London 2001.

Dawson, Barry, *Street Graphics New York*, Thames & Hudson, London 2003.

Delannoy, Pascal, & Grzesowiak, Jean-Luc, *New York Street Art*, Relié, Paris 2001.

Fernández, Juan José, *La piel de Barcelona: graffitis y murals/Barcelona's skin: graffitis and murals*, Ediciones Glénat, Barcelona 2006.

Ganz, Nicholas & Manco, Tristan, *Graffiti World*, Thames & Hudson, London 2004 (repr. 2006).

Ganz, Nicholas, *Graffiti Woman: Graffiti and Street Art from Five Continents*, Thames & Hudson, London 2006.

Gastman, Roger, *Enamelized: graffiti worldwide*, Gingko Press/R77, Corte Madera CA/Bethesda MD, 2004.

Indij, Guido, ed., *Hasta la Victoria, Stencil!*, La Marca Editora, Buenos Aires 2006.

Indij, Guido, ed., *1000 Stencils: Argentinian Graffiti*, La Marca Editora, Buenos Aires 2007.

Macdonald, Nancy, *The Graffiti Subculture: Youth, Masculinity and Identity in London and New York*, Palgrave, Basingstoke 2001.

Manco, Tristan, *Graffiti Brazil*, Thames & Hudson, London 2005.

Manco, Tristan, *Street Sketchbook: Inside the Journals of International Street and Graffiti Artists*, Thames and Hudson, London 2007.

Marschall, Sabine, *Community mural art in South Africa*, University of South Africa, Pretoria 2002.

Rahn, Janice, *Painting without permission: hip-hop graffiti subculture*, Bergin & Garvey, Westport CT 2002.

Scholz, Alberto, *Scenes, graffiti in Barcelona*, Index Books, Barcelona 2003.

Stickers. From the first international sticker awards (Berlin 2005), Ullrich, Andreas, intro., Die Gestalten Verlag, Berlin 2006.

Waterhouse, Jo, & Penhallow, David, *Concrete to Canvas: Skateboarders' Art*, Laurence King, London 2005.

FILM

NEXT: A Primer on Urban Painting, Aravena, Pablo, dir., Canada 2005.

INDEX

Page numbers in *italics* refer to picture captions

ACKNOWLEDGEMENTS

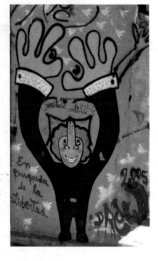

The author first disembarked in Chile at Antofagasta in 1964, en route to Bolivia with his exemplary parents Andrew and Davina, to whom this book is dedicated with much gratitude and best love.

The idea of a book on alfresco Chilean art arose during a walk across Valparaíso with Adita 'Sitaram' Goycolea, via the Reina Victoria staircase and Drew's 'In pursuit of freedom' (*left*), to the Open Sky Museum. It is thanks first and foremost to Mauricio 'Schisma' Román Miranda that the idea has been realized. Mau shared his knowledge of the Chilean street art scene, and, often with his companion and co-founder of 'Espacio G', Jocelyn 'Metaverba' Muñoz Báez, showed me areas of Valparaíso which I would never otherwise have found, and one where without them and José Pepe my camera would have changed hands. The artists Alejandro Delgado, El Pera, Fran and Fis, Pussyz Soul Food, Rick Terror, Vazko and Yisa showed me their, their friends' and their rivals' art in Santiago, Valparaíso, Concepción and Talcahuano. In Santiago, Manuel Arias, Rick Matthaeus and Fernanda Yannucci Iduya took me to new *barrios*; Francisco Xavier Yannucci, Bernardita Yannucci Iduya and Maria José 'Coté' Yannucci Iduya helped on many levels; and Catalina and Inés 'la Ratona' Scott shared their knowledge of stencils. Writing in Chile was a joy, thanks to the lighthearted kindness of Chilean hosts: Claudia 'La Maga' Iduya Landa in Santiago; Nancy Gewolb, Mau Román and Joce Muñoz in Valparaíso; Alejandro Delgado in Concepción; Carlos and Teresa Catalán in Los Vilos.

Alice saw no point in a book without pictures. Mark Fletcher and Damian Jaques of Eight Books enabled lavish pictures on every page: an approach perfectly suited to today's Chilean wonderland.

One preternaturally generous friend, Mike Dunphy, bankrolled the camera; another, Edward Peake, and his lovely wife Camilla, offered idyllic shelter in which to start to write. In Europe, Sandrine Baume, Melissa Calaresu, Elisabeth de Bièvre, Katharine Eastman, Mark Fletcher, Thomas Frangenberg, Adam Grunfeld, Lucian Harris, Briar Harvie, Damian Jaques, Karen Lubarr, Simon O'Sullivan, the Padmaloka crew, Sallie-Anne Peterson, Yolanda Pinto Medina, Joan Pau Rubies, James Willis and Sarah Wilson all provided vital insights.

The text came together in Chile, in conversation with Claudita and Mau; with Delgado, Fis and Fran, Pau, Terror, Vazko, Yisa; and with Pablo Aravena, Felipe el Mono, Elodio, Fisek, Nancy Gewolb, Gigi, Bruno González, Román González, Yanet López A., Julio Lamilla and Liz Munsell of *Nimia*, Natalia Monsalves, Pamela Navarro, Cristian Nuñoz Bahamondes, Victor Ramírez, Adolfo 'Andres' Romo, Evelyna Selahrye, Trafic, Sergio 'el chino' Valenzuela of *Ekeko*, and Bomber West. Any survey of contemporary Chilean art as a whole will definitely feature Delgado, *Ekeko*, El Pera, Gewolb, *Nimia* and Terror.

Los Vilos, Region IV, Chile, January 2008